OF EARTH AND ELDERS

VISIONS AND VOICES FROM NATIVE AMERICA

SECOND EDITION

First Edition 1998; second printing, 1999; third printing, 2000; fourth printing, 2001.

SECOND EDITION 2002.

ISBN 0-9528607-7-5
Library of Congress Control Number: 2002103752

ALL PHOTOGRAPHY. COPYRIGHT © 1996/97/98/99/2000/01 BY SERLE CHAPMAN except:
Sonny Skyhawk photographs © by Brian Davis.
Apesanahkwat photographs supplied by 'Coast to Coast'.
Photographs of Larry Sellers from *Dr Quinn, Medicine Woman* supplied by the artist.
Photograph of Steve Reevis from *Last of the Dogmen* supplied by Macile Reevis.
Photograph of Floyd Westerman from *Dances With Wolves* supplied by the artist.
Photograph of Serle Chapman © 2001 by Alistair Devine.

Design and artwork by Serle Chapman, John Parker and Ken Bond.
Project Manager and International Coordinator: Sarah Gilbertson.
Proofreader: Ken Blower.
Photographic hand prints: Peter Casey and Jon Frost (black and white).
Graphic Reproduction: John Parker.
Printed in Hong Kong by MANTEC.

Produced by Bear Print International Limited.
bearprint@tiscali.co.uk
www.gonativeamerica.com

Mountain Press Publishing Company 1301 S. Third Street W. PO Box 2399 Missoula Montana 59806 USA.
Toll Free 1-800-234-5308.
mtnpress@montana.com
www.mountainpresspublish.com

Cover shots: Front – Semu Huaute (Chumash).
 Back – Serle Chapman © by Alistair Devine.
Frontispiece: Eddie Bautista (Laguna Pueblo).

MOUNTAIN PRESS
PUBLISHING COMPANY

OF EARTH AND ELDERS

VISIONS AND VOICES FROM NATIVE AMERICA

SECOND EDITION

WRITTEN, PHOTOGRAPHED AND EDITED BY

Serle L. Chapman

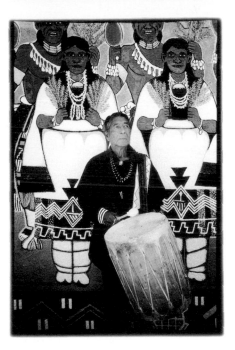

IN MEMORY OF ANNA MAE PICTOU-AQUASH
(March 27, 1945 – December 12, 1975)

IN HONOR OF THOSE WHO KNOW THE BLOOD, SWEAT, TEARS AND PAIN

CONTENTS

OF EARTH AND ELDERS – SECOND EDITION utilizes
both standard English and American-English

ACKNOWLEDGMENTS

Of EARTH AND ELDERS: VISIONS AND VOICES FROM NATIVE AMERICA – SECOND EDITION is truly a collaborative effort and would not exist were it not for all of those whose knowledge, creativity and passion have defined its content and whose names distinguish its pages. Without them, this book would have remained a vague idea, as it would without all of those whose names do not appear but in their own ways have contributed as much as any. It is my good fortune to be able to call some of these people friends, or at worst acquaintances, and either way I am indebted to them all: Guy and Kathy Tillett for their generosity of spirit, support and encouragement through the 1990s. Sarah Gilbertson, beyond words or expectation. Marley Shebala and Elsie Kahn, strong hearts and beautiful friendship. John Parker, a fine artist and an even better human being. Peter Casey, Ken Bond, Ken Blower, Paul Wilson and Eric Tomlinson for their technical excellence and humour. Karen Testerman, Steve Reevis, Mary Hunwicks, Johnnie Walker, Wilmer Mesteth, Lisa Standing Elk, Christine Farrell and Charles Towers – valuable human beings, one and all. Josephine Fierro, Joseph Medicine Crow and Johnson Holy Rock, great memories and lessons. Scott Momaday, Joy Harjo and Simon Ortiz – inspirational.

It's said that you shouldn't have heroes but what the hell – to Vine Deloria, Jr and John Trudell.

For such willingness to help: Gary Avey, Dr Jack Utter, Faye Brown, Arigon Starr, Bob Flynn, Macile Reevis, Lois Smith, AJ, Bronson and Felicite McDonald and mom, Margaret. Sarah James, Joanne Shenandoah, Alistair Devine, Jean Rafferty, Ann Meyer @ the Mckenzie Group, Heather Rae @ the Sundance Institute, Mark Heckert, the Alvarado family and Mr & Mrs Jack Bailey. *Indian Country Today* newspaper. Tim Giago and Avis Little Eagle for their invaluable assistance. Darlene Pearl. Paul DeMain. Sara Crazy Thunder. Representatives and individual staff members at the tribal offices of the following nations: Mashantucket Pequot, Navajo, Nez Perce, Swampy Cree, White Mountain Apache, Cherokee, Muskogee, Crow and Morongo. The First Americans in the Arts. Montoya Whiteman @ Native American Rights Fund. Seathl @ National Indian Child Welfare. John Tippeconnic @ The College of Education, Pennsylvania State University. Wenda @ the Confederated Salish & Kootenai Tribes' People's Center. Lennie Foster @ National Native American Prisoners Advocate Coalition. James Kirk. Jill Johnson @ Borders Books & Music. All @ the Inter-Tribal Bison Cooperative. For arranging permissions: Tessalin @ Silver Wave Records, Jeff Skillen @ Warner Western, Charlotte Baron @ Fulcrum Publishing, Fred Cortright @ W W Norton, Diane Edwards @ University of New Mexico Press. The Real Bird family for re-enactment photo access. Black Eagle.

My thanks and appreciation to Rob Williams, John Rimel and Ingrid Estell @ Mountain Press.

I would like to offer my sincere thanks and admiration to the late Fern Mathias – a great leader and fighter whose magnanimity and dedication defined values to strive toward. Fern you were undoubtedly one of this generation's true Warrior-Women.

For my parents, Margaret E. and Thomas H. Chapman, there aren't enough words or ways to thank you for everything.

To Henri – Nea'ese! Epeva'e, nepevomohtahe.

For Vóhpáhtse Náhkohe.

OF EARTH AND ELDERS is a book about contemporary Native America. A collection of thoughts, explanations, opinions, prose and individual perspectives shared by American Indians. Native people do not seek converts to their spiritual beliefs or philosophies, but the right to practice the former – and should they wish to – express the latter, freely. A century of religious prohibition upon Native Americans only eased in 1978 with Public Law 95–341, the American Indian Religion Freedom Act, but this joint resolution was still deficient as it contained no provision for enforcement. The purpose of this book is not to stack guilt upon Anglo-Americans or Anglo-Europeans whose forefathers virtually invented colonialism, it is an attempt to remove the oft-applied cultural filter and hear Native voices tell it like it is in their experience, instead of relying solely upon an author's interpretation of how *they* might *like* to think it is. The people who have contributed to create this book draw attention to historic points of reference and often ignored fact to demonstrate the circumstances Native people find themselves in today. Any 'anti' sentiment is directed toward the institutions, religious and secular, that have imposed and contributed to the policies and systems that continue to fascilitate oppression.

AS HE ENTERED his 94th year, Semu Huaute was thought to be the oldest surviving Chumash elder and the preface to *Of Earth and Elders* is his story; or rather, how *he chooses* to tell *his story*. What follows here is how another might summarize it. Born into the Owl Clan, Semu underwent a forty-year tutelage with Chumash, Yaqui and Aztec medicine people. Following the Meeting of Religious Peoples at the Hopi village of Hotevilla in 1956, Hopi messenger Craig Carpenter encouraged Semu to join with him and Thomas Banyacya to spread Hopi philosophy. In following his interpretation of that message, Semu organized 'inter-tribal' and 'inter-racial' gatherings, including the Red Wind Foundation and community near San Luis Obispo, California. The American Indian Movement's 'Camp 13' property was inherited from Semu, who as an activist rose to prominence during the 1960's fishing-rights protests of the northwestern tribes, including the Puyallup, Nisqually and Yakima Nations. During one of the demonstrations near Frank's Landing, Semu was caught in the line of fire and he carries a scar from that bullet wound on his right cheek. Variously referred to as a medicine man, healer and shaman, to some Grandpa Semu is a controversial figure; his involvement with inter-racial community projects, seminars and ceremonies have led to 'New Age' accusations and, possibly because he declines affiliation to any Chumash band, some Chumash tribal members do not recognize him as a spokesman. However, others in the Native community hold him in high regard. Semu is the subject of Leonard Peltier's painting, 'Medicine Man', and of him Peltier says, 'My respect and love for this man transcends the years'. In 1985 Semu attended the World Peace Conference with the Dali Lama, where he lit the opening fire and sang the Chumash welcome song. During the 1990s Semu was active in attempting to foster unity between the Chumash and Native Hawaiians, citing ancient links between their peoples. 'The time has come for Native peoples of the world to unify as one people, one voice', he said after being adopted into a traditional Native Hawaiian family. 'If Native peoples continue to speak to the world as many voices we will not be heard and could, in the coming century, die out.'

SEMU HUAUTE

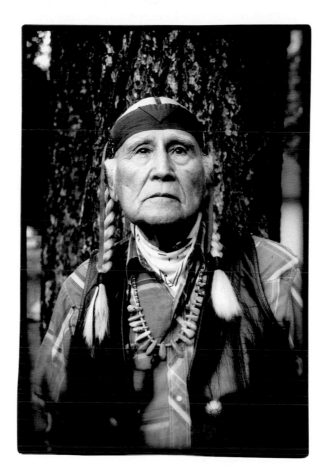

Reflections of an Elder

*"I was born in the Painted Cave and it is said that an old one came out from the storm that was raging to deliver me. She was completely dry and when I came into this world she foretold how my life would be and even now I am trying to fulfill her prophesy.
The paintings on the ceiling of that cave were not done by our people, they were created by the Star People when they were here . . ."*

I was born in the Painted Cave and it is said that an old one came out from the storm that was raging to deliver me. She was completely dry and when I came into this world she foretold how my life would be and even now I am trying to fulfill her prophesy. The paintings on the ceiling of that cave were not done by our people, they were created by the Star People when they were here but they left and so we don't really know what they mean. Today there is a barrier across the cave because of vandalism and desecration but mostly the paintings are as bright and pretty as they ever were. There is a trail that winds by the cave and the Chumash used to travel back and forth along it and it was on one of those journeys that my mother went into labor. The others looked for the best place for her to give birth and decided upon the cave. It was not unusual, they say that our women would give birth in such circumstances and then just keep moving. Men weren't allowed to see the birth and so the grandmothers were there to wrap the baby and then after the correct period of time had passed, the father could rejoin the mother and child. So I was born that way in 1908 and, in the tradition of our people, after that first month, I was taken to my grandfather.

They contend that the minute I was born my subconscious smiled because I was so alert. As was the way, my grandfather held me and, in our language, gave me instructions for life: 'You will live in two worlds and you will not hate. You will learn foreign languages because you have been born among foreign minds. You will be able to distinguish what they are saying or if they talk with a double tongue. You will know the truth but you will say nothing for your own protection. You will learn not to hate people because of the color of their skin because the day we are born we begin to die and death does not discriminate, we are all equal.' And then my grandfather said the ancient prayer for me and now I'm the only one left who knows it. I was being told that the minute we are born we do not know how to hate and the minute we are born, we are prepared to die. We come in with nothing and we go out with nothing so regardless of social status or color, we can't escape from being the living dead. Between birth and death our people had strict values, a way you were supposed to live, and that was to respect and care for all other living things and not kill anything. We could only take the life of an animal for food and usually it would be small game that we hunted with throwing sticks.

When I was three years old I was captured by the Catholics and they baptized me. Afterwards they kept telling me that they had saved my life because before that I couldn't have gone to heaven and my spirit would have been left in a state of limbo. So I guess I should consider myself lucky because now I can go to the white-man's heaven! The first Europeans that came here, the Spanish, were very cruel people and then if you really examine the story of the pilgrims and the puritans you'll find that they were outcasts who made it over here instead of being sent to Australia with the convicts. After the American Revolution, Congress passed a law that an Indian couldn't testify against a white person and that law helped them to take our land and everything else because we had no recourse against them. Among our people, many of our elders starved. We took care of our old ones

"When I was twelve years old some strangers came for me. They were Medicine Men and *Paxa*, ceremonial leaders . . ."

but after the invasion we couldn't look after them because we could no longer fish around the coast. Most of them came into California for the gold and I recall the time when white-men would go into any Indian settlement, even after they were government reservations, and take whatever Indian women they wanted. There was one man who picked out twelve Indian girls and used them as prostitutes and then when they were all pregnant he had them scrape through the dirt and gravel looking for gold at his claim. They say he would sit back in a chair and smoke his pipe as he watched them, but they could not testify against him. Of course, these people that came over here and did this were Christians and that's why they could do it, because they could repent when they were dying and still make it to heaven. Or that's what they told us. I don't know how to lie, otherwise I might have made it as a preacher too!

When I go to Mexico and see how the poor are exploited by the Church it reminds me of how our people were when the missions were here and how all of the tribes in California were enslaved by the Franciscans. Jesus Christ never built a church and he never said he was God. I say Jesus was a holy man and a great healer and they killed him because he said a lot of things that exposed their hypocrisy. Look at the hypocrites who have used his name throughout history; look at them today, all of these making millions from the poor, yelling 'Hallelujah'. I don't think Jesus would have liked these guys. You look at these people who all want to save souls and they never want to save their own people, it's always the Indians they want to save! When I was a boy we used to live near the Santa Clara River and there was always one house around there that was vacant. We moved into that house and found out why it was always empty; it was because a Jewish family lived next door. There was one school near there, a Catholic school for the white kids. Me and the kid next door, Benny Cohen, had to go there. Everyday the other kids would throw rocks at us; they threw them at me because I was a heathen who scalped people – so I went and looked up what 'scalped' was because I had no idea! And they threw rocks at Benny because he killed Jesus! One day they were throwing rocks and chasing us and this one kid shouted, 'You damned Jew! You killed Jesus', which is what they were teaching us at school. As I ran past Benny I yelled, 'Benny, why did you kill him?' and he said, 'Kill him? I didn't even know the guy!' There's a lesson in this: Don't repeat malicious gossip. We know Jesus wasn't killed by the Jews but people start that off and then others believe it. We call that the 'Echo Society' and among my people it is an insult to be called a member of the Echo Society so traditionally we never repeated malicious gossip.

Very few of the traditional Chumash ways are practiced today, mainly because of that mission period and the lasting influence of Catholicism upon our people. One of the first parts of our culture the Church destroyed was our clan system. We were born into our mother's clan because all of us belong to the women, there's no mistaking that the women are everything, our mothers and life givers. Every baby knows its mother but it takes a very smart baby to recognize its blood father.

"We were to follow their guidance, like tutors and students. I was initiated there through purification and entering what is like a dream."

A man had to prove he was worthy of a woman; that he would be a good provider, protector, father and husband. Marriages could not take place within the same clan and so if the next clan was in a village down the valley, the man would have to make contact with the elders of that clan before he could marry a girl from that clan. It remained the girl's choice, not the man's, but if she decided she did want to marry him then her clan and his would get together and provide what was needed. The home that was constructed belonged to the woman and after the marriage ceremony she would enter the home and the man would stay outside. If she was satisfied, she would go outside and open the gate for him to enter. If at any time she wanted rid of him she would just place his belongings outside of that gate and that was the end of the marriage. If the wedding vase was broken and they wanted to get back together, they would have to retrieve all of the pieces and with the prayer of forgiveness make the vase and themselves strong again. That vase has two spouts, one male and one female, representing their union and at the top is a hole that symbolizes the eye of the Great Spirit watching over them. The Chumash had flutes that had an energy for healing. It's a long time ago now, but when there was singing there might be people there with these flutes and at a certain time and place in the song they would blow them and out would come that wind song or spirit song. In our way your body is the church and with those flutes it didn't matter if you were isolated or didn't know the others in that group because that wind song united all. Nobody uses them anymore because they don't know about it.

When I was twelve years old some strangers came for me. They were Medicine Men and *Paxa*, ceremonial leaders, who brought me and some other boys from Soboba, the Cahuilla and Luiseño Indian Reservation, up into the wilderness, to a rock that stands as an altar to one of our deitys. We were to follow their guidance, like tutors and students. I was initiated there through purification and entering what is like a dream. The Spanish called Chumash sweatlodges, where we purify ourselves, 'Temescal' and the drink that is like the doorway to other realms is *toloache*. *Toloache* was important to the Chumash and had to be drunk at certain times and in accordance with ceremony and ritual. Today some call it a hallucinogenic but they don't know what they are talking about, they don't know how and why it should be used. *Toloache* can even revive those near death, those whose souls have even begun the 'journey of the soul after death'. The souls of the dead go to *Similaqsa*, one of the three lands to the west, and the journey will begin on the fifth day after death. The soul visits the stormy place, *Humqaq*, and *sawil*, which is like a great altar, and near there will bathe and prepare for the rest of its journey. People in some of the villages in the surrounding areas would see these souls as they travelled through. Traditionally, in life, as you went into Chumash country, you would see numerous small shrines or altars that were places of prayer where offerings were left for *Chupu*, another of our sacred ones who resides in the peaks around Santa Barbara.

"You look at these people who all want to save souls and they never want to save their own people, it's always the Indians they want to save."

We speak what is called a Hokan dialect and even among us, every fifteen miles or so, in different villages or groups, how these names were pronounced could differ because of the variance in our dialects. What is called 'nature' in the English language has always been important to the Chumash. In our way, we see the world in three layers. Above is *Kakunupmawa*, the sun, who lives with his daughters, along with others up there like the moon and morning star. The wings of a great eagle carry the heavens and below is the next layer where the human beings are. In the beginning the First People, who were not humans, lived here but after a great flood some of those went to live above and became Star and Sky people, those who left the paintings in the caves. The other First People stayed and became the animals and all things in nature. Below is *Nunashish* and because of references to darkness there, when the Catholics came they told our people that this was a place of evil and that *Torquish* was a 'devil god'. Well, excuse me, we never had any devils! *Snilemun*, 'Coyote of the Sky', watches over the Chumash in this middle layer, here on *Hutash*, our Mother Earth. In the beginning there were Dolphin People and one of them was blessed by the spirits and bore a child who was 'Woman'. One from the Shark People was also blessed and the shark woman's child was 'Man', and from there is really where our story here begins. Dolphins and sharks have always been a part of us. In the old days, when you went out on a boat, the dolphins would swim alongside and protect you. We would sing to them and they would answer as they guided us to the best currents and kept the sharks away. That's the secret of living with nature, to understand where we come from and that we are one. These were our laws. Just as we knew the dolphins, they knew us and we could read them. We have to heal Mother Earth and protect nature, the animals, all that are alive and were created like you and I. Without them there is no balance.

The dolphins guided our '*tomols*' or 'plank canoes'. In the old times, there was prestige attached to owning a tomol. These were our traditional craft and they weren't dugouts or rafts, they were crafted from planks that were split from driftwood. It took about six months to make one and involved sanding, sealing, binding and decorating. Tomols were scaled with tar and there is a mountain near Ojai where they collected that. Before they reached that stage they would rub the wood smooth with shark skin which was used like sandpaper and then shark skin could be used for binding because it's waterproof and stays taut. Tomols could go fast but our way is to recognize that there can not be a first without a last. Today everybody looks out for 'number one' and is only interested in the winner but you can't race by yourself. There can't be a winner without the one who brings up the rear. The one who wins today might make the history books but the one who is last guards those in front and makes it possible. That's how we were taught. I have been here a long time in this race and I'm still going, attempting to fulfill the prophesy from my birth. My wife says that I have died many times and that once the Old Ones came and took out my heart and cleaned it up, and then put it back inside me. Maybe that's why I have to keep running here.

"My wife says that I have died many times and that once the Old Ones came and took out my heart and cleaned it up, and then put it back inside me."

Crazy Horse

JOHN TRUDELL

we hear what you say

CRAZY HORSE
WE HEAR WHAT YOU SAY
ONE EARTH ONE MOTHER
ONE DOES NOT SELL THE EARTH
THE PEOPLE WALK UPON
WE ARE THE LAND
HOW DO WE SELL OUR MOTHER?
HOW DO WE SELL THE STARS?
HOW DO WE SELL THE AIR?

John Trudell

CRAZY HORSE SAID we live in the shadow of the real world and we really do. The coherency of our future depends upon us knowing who we are – and truly understanding who we are – because our relationship to reality and our relationship to power is based upon that understanding. Today we live in an industrial society and this technological perception of reality, this shadow world, presents a serious crisis: it is a reality where we don't remember who we are, so therefore we don't know who we are, we speak a language we don't understand and because of this, we don't know where we are. We are part of an evolutionary reality but part of the purpose of this technological civilization is to erase our memories and erase our identities.

Growing up, I lived between two worlds, the Native and the non-Native, and in this day and age I think they are both part illusion and part reality. When I moved between the reservation and off the reservation, some things were more real to me in my Native world than they were in the non-Native world; things of the human essence; and this relates to our overall perception and how our perceptional reality is altered. We now live in a time when it's harder to know who we are and so it's harder to understand our purpose, meaning that the *real* problem *is* the erasure of our identities. Genocide erases identities; all technological reality does. If we truly recognized who we are, this society we exist in and the way we live would be different. We all live on a reservation now, an industrial reservation that stretches across the world, and the alienation you can find in extreme forms on an Indian reservation – the loneliness, alcoholism, drug abuse and violence – is being replicated more and more throughout industrial society.

Severing our relationship to power continues to be the objective; to cloud our coherency and shroud our intelligence in the perceptional reality of this shadow world. But our relationship to power and reality is remembering and understanding who we are – *we are the Human Beings*. We know how to say the terms because they programed them to us, just as we've been programed to seek answers and not understanding, like we're programed to believe rather than to know. So this goes back to our identity: it's crucial that we know who we are – we're the Human Beings, we are shapes of the earth – and our relationship to reality is in that definition.

Our physical reality, our form – the bone, flesh and blood – is made up of the metals, minerals and liquids of the earth. The DNA of the human is literally made up of the metals, minerals and liquids of the earth. All of the things of the earth have the same DNA as the human does; everything is made up of the same metals, minerals and liquids of the earth but the shape is different and the purpose is different. We have 'being', which is our essence, our spirit, and all of the things of the earth have the same DNA, so all of the things of the earth have 'being' and spirit. Nothing will ever change that reality, but what has changed is our perceptional relationship to reality.

We are this form of the earth and we have 'being' and we have to understand that because that's our relationship to the reality of power. As human beings we are part of an ancestral lineage –

Predator's face he possessed a race
 Possession a war that doesn't end
 Children of god feed on children of earth

our DNA comes through the millennia – so our relationship to power is in the earth because that's where we physically come from, and our relationship to power is in that DNA ancestral lineage because that's where the 'being' part of us has been all this time. Our relationship to reality is in that; that's who we are; and all of the programing that has taken place has been to erase that identity.

We all share a common collective experience: we are all the descendants of tribes. Back in the time of the original dreams we were all members of tribes and we were all the earth's children and we all knew that the earth was our mother. We were part of a spiritual reality. We were physical in a spiritual reality. Whoever we are today, we carry the genetic experience of our lineage from the very beginning, encoded within our DNA. It's like our genetic memory and somewhere hidden in there we all come from a people that understood that we lived in a spiritual reality and because of that realization everyone of our beginning ancestral peoples understood that life was about responsibility; so we were responsible for the past and the future as well as the present. So we knew who we were, we understood what we were saying, we knew where we were and we knew our purpose, and this reality lives in our genetic memories. The purpose of technology is to erase our realities and make us powerless but ancestral power is real.

This technological perception of reality is like a disease and as it spreads it infects the spirit of the people and it affects our perception of reality. Separating everybody from any ancestral understanding and teachings, and erasing our identities, severed us from our spiritual power and I think that is one of the principal reasons why people feel powerless, because that power is being diverted over into something else. We live in a reality where we understand that uranium can be taken out of the earth and put through a mining process that converts the 'being' part of uranium, that DNA, into a mutation of power that is called energy; electrical energy that can be controlled by man; and we recognize that a consequence of that mining process is toxic waste. We know they do it with fossil fuels; they take that dinosaur DNA out of the ground, put it through a mining process and convert it into gasoline, which is then converted into another electrical energy system that leaves behind its pollution. And what I'm saying is that they are doing this to us. They are mining the 'being' part of the human through our intelligence.

This technological civilization is predatory upon our lives. Today, how many people feel that something is missing from their lives, like purpose or understanding or self-worth? The 'being' speaks to the human through feelings and the way most people feel is powerless because the 'being' part of human is being mined and converted into a form of mutated power called energy that is used to run the authoritarian, material, technological systems of this industrial society. We're the gasoline that runs it just like the dinosaur runs the internal combustion engine. And the pollution that is left from mining the 'being' part of human is every doubt, fear and insecurity that we have and that pollution keeps us from seeing clearly and so every thought becomes reactive; a reaction to this haze.

John Trudell

Everybody is indigenous to the planet. We're indigenous to different land bases and our DNA physically comes from those land bases and somewhere in each and everyone of us there is a collective genetic memory that goes back to the beginning of the original dream – to the origin of our stories – and our relationship to power and reality is connected to us understanding that, but we are in a technological perception of reality that does not want us to understand that. If we understand that we're the *human beings* we'll know that we're physical entities in a spiritual reality and our purpose is to perpetuate and maintain that spiritual reality. And the spiritual reality of life is about responsibility. The gift we've been given to protect ourselves as humans is our intelligence. Our intelligence is our medicine. We were not put here, defenseless, to be eaten up by this mining process. This mining process takes place through our intelligence, so if we understand the value and power of our intelligence we can influence our evolution.

To me, the mining process is the colonizer's civilizing process. This predatory behavior pattern never really changes, it just outlasts the generations so after five generations have passed the behavior pattern can be as predatory as it ever was because after that long, who is going to remember what was there before? This is why it is important for them to separate us from our ancestral power, and in order for this to continue they have to neutralize our intelligence by creating this confusion in our perceptional reality. Going way back, at some point in the evolution of the human beings, this other perception of reality appeared that took the spirit away from the animals; from nature and the elements; and started changing spirit into human form, the gods and goddesses. With the coming of industrialization, the way many people prayed changed and religion emerged and became a mining tool for the technological reality that was manifesting itself through industrialization.

All human beings want to know where they come from, where they're going, and what their purpose is, so you have to go there, to the very beginnings and the heart of the spiritual realities, to possess them. So the 'God idea' emerged – a god removed from the earth who owned everything because he made it – and at that point in our common collective ancestral memory, every one of our relations rejected this concept because the earth was the mother and the sky was the father and balance was maintained; the Great Spirit. As long as the human beings considered themselves to be children of the earth and a part of the earth they would not plunder the earth, so their perception of reality had to be changed; they had to be turned against the earth. They had to be turned against their mother to promote the 'male God' theory in which all spiritual value is removed from the earth; so the earth isn't your mother anymore, the earth is the dominion and property of this new god and you are to subdue it. That's a completely different perception of reality, going from caring to dominance – that the earth is no longer your mother – the land is something you claim, subdue and possess.

Red white perception deception
Predator tries civilizing us
But the tribes will not go without return

Genetic light from the other side
 A song from the heart our hearts to give
 The wild days the glory days live

By about AD 1000 the descendants of the tribes of Europe didn't know that they had come from tribes because they didn't have that tribal memory anymore; 1,500 years had passed in which they had been turned into serfs. Landlords and royalty had been created and they were now their property. Then in about AD 1100 the Church decided that it was God's government on earth and it launched its war for the possession of the souls of the 'heathens' – the Inquisition. If you thought differently to how the Church wanted you to think, you were guilty of heresy and you were tortured and executed and the Church took your property. This was a religious ritual that ran for 500 years in Europe. This war was waged against the descendants of the tribes of Europe to get them to perceive reality differently – they had to love what they feared and what they feared was now possessing them – so love, fear and possession became one and the Western perception of reality has been unable to unweave that thread since then. What happened to the Indians here at the hands of the descendants of the tribes of Europe, happened to the tribes of Europe and their descendants, which is why they behaved the way they did when they got here.

There are many opinions about Columbus but whoever he was, he was like 'the virus'. When Columbus and his followers got here and we told them who we were – 'We're the people'. 'We're the human beings' – they didn't understand because, as descendants of the tribes of Europe, that concept was no longer a part of their perceptional reality. When Columbus arrived in this hemisphere we had no protection against this disease of the spirit; there was no immunity to the virus because it came on the wind and on the water; this disease just took the shape of a man rather than something you can't see. By the time Columbus got here, the descendants of the tribes of Europe had been through about twenty generations of having their spirits attacked, so Columbus had become physically and spiritually the possession of something else; he didn't know what it meant to be a human being anymore. We are still the Human Beings. We're The People. We are not Indians and we never were Indians. Only in our oppressor's terminology and language, for the past 500 years, have we been Indians.

Religion has imposed its bondage but it's all part of the economic bondage. What's destroying us is economic manipulation and the lack of recognition of our sovereign natural rights. This is the thing that's trying to alter our identity and alter who we are. The State, along with the corporations, are paranoid of people who think differently. The Church waged its war of Inquisition to stop people thinking differently and that seems to be the nature of the State now. The spirit hunters – those who hunt free thought – come after us. We live in a reality they do not want us to see clearly so we won't act coherently. And 'they' are the spirit hunters; the colonizer; the industrial ruling class that is basically colonizing this planet and operating and creating a class of 'ethnic rich'. When they talk about 'ethnics' the smallest number are the rich – they are the minority – in a majority system the minority is the richest.

John Trudell

As a Native person, democracy means nothing to me. Democracy is supposed to be about the majority rule, but at the birth of democracy on this hemisphere if you were Indian – and the majority – you were automatically the enemy, so you didn't get to participate. If you were a woman you were considered to be mentally inferior, so you didn't get to participate. If you were black you were somebody's property, so you didn't get to participate. And if you were a white male who didn't own land you had no taxable value, so you didn't get to play either. This is the reality of the seed called democracy that was planted here: the smallest number of people, the ethnic rich of their day, decided what the institutions of democracy are here. It's not about freedom either. The lie I see in freedom is that if I believe in my freedom, that means that I make the rules, which means that I have to accept everybody's interpretation of freedom; so a racist has the freedom to be a racist, and so forth. It's about responsibility not freedom. If we take our responsibility and exercise our responsibility then we will be free and our rightful place will be manifested. Every generation has the responsibility to create the living reality and way that they are going to live with the earth. It is irresponsible to keep ourselves chained to Dark Age controlling thoughts that distort the lineage of our genealogy.

If you participate in this system, will it get better? You can see in the common collective psyche that people feel powerless; they allow this lie and they and accept this lie. We are told that the more money we make the more powerful we become, but that's not true. The more money we make the more access to authority we have but it has absolutely nothing to do with power, it's about authority. In actuality, authority represents an absence of power, that's why it is needed. If we call authority power then we do not see ourselves clearly. Our relationship to power is connected to our relationship to the earth and the use of our intelligence. Everything that has been done to us is to make us believe them, but if we don't believe them they can't mine us.

Pragmatically speaking, I think as Native people we can express the realities of our situation now more accurately through our culture and our art because our culture and our art addresses the truth and the reality of who we are as a people. That's better for us than to be chasing a lot of political activism because it's not our politics, it's not our political system and it's not our structure. By expressing who we are and our situation through our culture we don't have to relinquish our identities. Our struggle didn't start with wanting the right to participate in their system, our approach to America has always been, 'We want to be different. We want to be who we are. We just want you to honor our treaties and the legal obligation you have to us'.

We are the result of 500 years of genocidal policies against us and in an evolutionary context, many of us speak English now. If we don't speak our Native languages it doesn't mean we're not Native anymore, it just means, 'Here is who we are today'. Part of the problem is that others want to keep us in the 1800s. Some of us speak a different language now and there are different artistic forms but that doesn't diminish who we are. We are the Human Beings; shapes of the earth. We are the land.

Crazy Horse
We hear what you say
We are the seventh generation

WINTER COUNT

WRITTEN BY
Serle L. Chapman

With the exception of *A Life In An Hour Of Anita Half Moon*, the individuals mentioned and the events relating to them are actual. Any name changes are indicated. *A Life In An Hour Of Anita Half Moon* is a compilation of situations that have occurred in the lives of others – they are real experiences but the account has been structured, and the characters created, in a novella format.

Of Earth and Elders

PASSING THROUGH

DUSK WAS BUSY confiscating the day's last shadows as they slid along benign brakes towards the arc of the Moreau river. The sun reclined upon a blanket of cloud, blushing red when exposed and bleeding into the river, the light simmering on the water as one by one each fickle suitor sloped across the sky with the wind to the last place on earth where they waited for nightfall to fan softly over the plains. Horses dotted around the prairie connected the space to security and took turns to raise their heads and glance at the show in the west to check that the drama was the same and the promise made by the wind to the clouds was that which it whispered every night. The black of the highway seeped on to the black of its shoulders with the question of distance and darkness until two figures stuck like bookends in candlelight on a vacant library shelf appeared before either or the answer.

"Do you need a ride?"

"You bet! Yes sir, we sure do."

The weather-beaten face emptied the car window and clambered into the back seat with the assortment of parts that bulged from a grimy plaid shirt and a pair of loose jeans.

"Real glad ye stopped there for us. Real glad", he hissed through bits of teeth, spit and gums, the woman at his side nodding with such enthusiasm that I hoped we might only be travelling together for a few miles save her head might fall off during a long journey filled with conversation.

"Where ye headed?"

The answer required consideration. It wasn't just that they smelled like a farm yard in August that concerned me, it was more the question of why they were stood on the roadside in what to them must have appeared to be the middle of nowhere.

"Well, I'm going through Eagle Butte and whatever has happened to you I'm sure you can call somebody from there."

"Hell, we aint from here", he spluttered with a combination of panic and offence. "Fact we needs to git back to Rapid so I can git back here afore mornin."

I looked in the rear-view mirror. He had the kind of eyes that enabled a man to sit centrally at a table and look interested in two separate conversations without diverting his attention from the speakers at either end. I assumed that the woman was his wife and that the world reflecting off her coke bottle bottomed glasses was his as she surely couldn't have been his mistress and he couldn't have been her lover. They had to be married. Maybe I had picked up the perfect couple? A marriage survived by memory.

"Actually I'm going pretty close to Rapid but . . ."

"Much obliged. Be much obliged", he interjected. "You aint from any place here is ye? So you just passin through?"

For a moment I wondered how many people 'just passed through' the Cheyenne River Indian Reservation and then decided to leave that thought and ask the thorny question.

"So what happened to you and why are you in such a hurry to get back to Rapid and then back here?"

"Indians! Gotta git back coz of Indians", he replied, cuffing a string of saliva drooling over his bottom lip from where once some teeth might have been. "If I don't git back afore daybreak won't be nuthin left of my truck. Sonuffabitch breaks down on a Goddanged reservation. Shit, if that aint it."

I asked him what was so pressing about daybreak and what Indians had to do with it. He was convinced that the local residents, the Cheyenne River Sioux, would locate his vehicle in the moonlight and dismantle it for spare parts.

"Hell, I even got some beehives up yonder. We gives em every damned thang and they don't do nuthin. They aint never happy. Aint no pleasin em less their drinkin or gittin some damned thang for nuthin. Like my goddanged ve-hic-le."

The drive to Rapid City was going to be further than I thought. I asked him if he included disease, slaughter, theft, deception, subjugation, poverty, alcoholism, low life expectancy, fetal alcohol syndrome and, in a word, genocide, on the list of gifts entitled 'every damned thing'.

"Geen-o-side?" he drawled, at which point I realised that he probably thought genocide was something you sprayed on crops.

"Anyways," he continued, as if he and I had sat at the same bar for years, "what in the world you doin on this rez?"

"I've been to Green Grass to see a man who one day I would like to call a friend", I replied through tight lips.

I HAD SET out that morning with a clean white shirt, a plate of home cooked brownies, a Trisha Yearwood cassette and a head full of apprehension. As Trisha sang *The Song Remembers When*, I couldn't. For the first hundred miles everything did 'make perfect sense' but then the seconds of doubt trooped onto parade and the Whys? and Whats? overwhelmed Trisha. I was approaching Cheyenne River. I was meeting the Keeper of the Sacred Pipe for the Sioux nation. I was late. I couldn't remember why I was doing this. Yes I could but I couldn't remember how I was going to say what I thought I needed to say. And I had a plate full of brownies carefully wrapped in foil to present as a gift. The empty road feasted on what little time I had and the Oldsmobile groaned as I kicked it past a small red car ambling north of Eagle Butte. I had been told that if I missed Arvol's trailer I would probably be in the river as it sat on the left, last at the end of the track.

The brownies said 'please' but I still refused to take them and scampered for the door. Between deep breaths and knocks there was nobody home. The whine of an engine

caught my attention and from the corner of the trailer I could see the small red car surfing the hard muddy waves of the road.

"Hello. I'm the guy who called from Rapid and arranged to meet you", I said, as the driver unfolded from the small red car.

"That's not too far", he observed. "But it's good we've arrived at the same time." He smiled as we shook hands. "I've just got back from town. Come in."

He left the door ajar and people wandered in and out as they pleased and he made himself and what he had been to town for available to them.

"Excuse the water", he cautioned. "Had a problem with the septic tank."

A small pool of water had oozed through the floor of the living area and he handed me a coke and a fly-swatter before flopping onto the couch opposite, his posture and demeanour encouraging me to relax.

"So, you know who I am?"

"Yes I do. You're the Keeper of the Sacred Pipe for the Oceti Sakowin", I spouted with the confident authority of a pan-Indianism toting anthro who had read *Black Elk Speaks: Being the Life Story of a Holy Man of the Oglala Sioux*, Dee Brown's *Bury My Heart at Wounded Knee*, a book on Lakota 'religion', and a copy of *Indian Country Today* newspaper. Or more accurately, I had a copy of *Indian Country Today* in the car. I knew I sounded like somebody who had bought a piece of Navajo jewelry from a roadside stall on the way to Monument Valley and instantly become a fountain of Native knowledge and awareness. I wanted to start over but instead I spilled my coke and waited for the water to reach a depth in which I might comfortably drown.

"Maybe you'd like to watch this", he offered, holding up a video called *Wiping The Tears of Seven Generations*. "And then we can talk."

I nodded while wishing I had a cloth for the coke and then suddenly remembered the brownies.

"My friend has made you some brownies", I mumbled. "I'll get them for you while you put the video on."

The gift was appreciated. I sat alone to watch the video which was more than a documentary about the 1990 Bigfoot Memorial Ride, it was a history of the people. After four previous commitments, from the knowledge shared by Curtis Kills Ree nearly three hundred riders of the Oceti Sakowin endured temperatures of thirty below zero for two weeks to retrace the two hundred and fifty miles Chief Bigfoot's band of Mnikowuju and Hunkpapa Lakotas crossed on their tragic journey to Wounded Knee. The undertaking was *Washigila*, Wiping the Tears of Seven Generations, and it did lay Lakota foundations for the following seven. '*My name is Arvol Looking Horse and I'm the Keeper of the Sacred Pipe for the Teton Sioux nation. I'm the nineteenth generation keeper of the pipe . . .*' I looked over at the man sat chatting at the kitchen table and then back at the man talking on the video. I couldn't imagine what a wind chill of eighty below zero must feel like day after day for two weeks. Lashed by blizzards they flickered across the screen towards that distant December on the killing field. In a close-up of a rider's face the world appeared to have altered and his expression had become suspect to that world in the evidence he had witnessed, now as before. His memory was his own but my sight was mine and I saw a blizzard and I saw a lone horseman and I saw the wind and I saw death wail in his face, even if I wasn't there to hear it.

AT A SOMBRE gait the solitary horseman picked his way through the unarmed corpses strewn below the foot of the hill. Bulging eyes still filled with youth stared at the ground where they had fallen. Emaciated bodies cut down as they had run lay contorted in step and blood. Crossing westward into a frozen gulch he dismounted. But for the snow flurries that ruffled the pony's mane, the pinto stood motionless with its neck bowed and reins trailing on the ground as if lame from the stench of death. Through wayward strands of hair that whipped his face in the chilling gusts the rider surveyed the carnage. The remains of families he knew, dismembered women and children, littered the coulees like debris from

a barbarous hunt. He moved toward a pile of sheltering bodies, his shuffling feet in the bitter frost echoing the dance of the ghosts. Stooping over the huddle he brushed at the drifting snow to uncover the blood spattered head of a victim. He held the body and stroked the matted hair to sooth his sister's silent greeting. With gaping eyes and open mouth she screamed of the slaughter. Her back had been torn by bullets and his nephew lay dead at her side.

I DIDN'T KNOW the man's name. I didn't know if he was really a man. The video played and I asked it if a name made it real or just harder to forget? A lot of people seemed to have forgotten Raymond Yellow Thunder's name but the people on the film brought it back to me. I remembered how four citizens from Gordon, Nebraska had beaten him, kidnapped him, stripped him from the waist down and kicked him onto the dance floor of the town's American Legion hall. They danced the night away. Somewhere, in some far away place, maybe Raymond left his jail cell and danced that night away. A week to the day after his release on the morning after the night before, Raymond Yellow Thunder was found dead in the cab of a pick-up on a used car lot, he had suffered a cerebral haemorrhage. I remembered the name of Wesley Bad Heart Bull whose assailants, like those of Raymond Yellow Thunder, were only charged with manslaughter. Sarah Bad Heart Bull, Wesley's mother, was convicted of assaulting a police officer when she attempted to attend a meeting to protest the second-degree manslaughter charge handed to her son's killer. She was sentenced to three to five years. The man who took the life of her son received two months' probation. I remembered that around the first anniversary of Raymond Yellow Thunder's death the American Indian Movement began the occupation of Wounded Knee.

"The Sacred Hoop", Arvol said flicking the TV off. "Sacred Hoop of the nation, it has no beginning or end."

He sat down and Chante blew in with a flurry of giggles and questions. She laughed at our answers and we shrugged our shoulders and grinned along with her before she

bounced over to her mother. Carol Anne introduced herself and lugged a black plastic sack on to the kitchen table as she smiled. She rummaged in the bag and proceeded to produce a pair of Dutch clogs, a ludicrous piece of evening wear and a garment that wouldn't have stood out from the wardrobe of the *Rocky Horror Picture Show*.

"Look at these", she said, piling the charity hand-me-downs back into the sack. "Not only do they think we are poor little Indians, they think that we're poor little Indians without any taste!"

In the irony there was truth but in knowing was strength.

"Did you see the *Life* magazine article?" she asked.

Life had run a feature about Arvol, the Lakotas and the Sacred Pipe but even before their published description of the White Buffalo Woman as a 'beautiful squaw' it had appeared that they wanted to take photographs of Arvol that were pure Hollywood. Carol Anne had provided the interference and the benefit of her style as an educator. I told her that I had seen it and that I'd also heard a rumour that *Life* had called *Indian Country Today* and asked them if they would recommend 'a good Indian' to interview. It was all a disappointment if not a surprise. Carol Anne left to go on her daily run and that was the last I saw of her. All I know is that her dad was Yankton and her mother Sicangu and her great-grandfather was Horn Chips, a man from whom Tashunke Witko sought advice. I remember her as being a strong woman who was committed to her people and that's probably all I need to know.

Carol Anne had gone. Chante had gone. The others had left to ride horses. Now it was just Arvol, me and my anxiety.

"We're having a sweat tonight. You ever been in a sweat?"

I shook my head.

"You can join us if you want to."

I regretted my answer without knowing if it was right or wrong, or even if there was a right and wrong. I had gone for a reason, I told myself, and that reason was what needed

to be said – or what I believed I should tell. I didn't want to look like a weekend Indian who would dine out on the experience for the next fifteen years. I started to talk about dreams for it was up to somebody else to provide the explanations, wasn't it? I managed to say what I thought I had to. He looked out of the window and when he returned he began although he hadn't moved.

"You have to learn the balance. When you walk this balance in life you must pray for direction. You know that four is a sacred number to us. We should live four stages of life. We learn to be humble. We learn from the animal nations – the two-legged, the four-legged, anything that crawls or flies, we are all related. There's a lot of things that were spoken of a long time ago about dreams coming back so everything we do comes from our heart. When you pray you always give thanks."

He spoke of those that come to us and the meaning and what it was to be part of it. We talked about words and I left him with some that I had clumsily written. We stood together and I gripped his hand and hoped that at last I had started to learn. I wanted to remember the moment. The scar that at some time had wept across his face. The shield he had painted glinting in one lens of his glasses. Abstract images that in the man were one with humility, generosity and respect. He might not remember, why should he when you hear where he goes with such responsibility? But to me it matters that I do. If I forget then there is no part of it in me and I was only passing through.

WITH A SHALLOW sigh I reached Stage Barn Canyon and after a couple of hundred miles with the window open my windswept passengers wobbled out of the back seat. With the wind roaring in one ear and my discourse of American history BEFORE WAYNE and AFTER WAYNE in the other, they were probably as relieved as I was to be parting.

"There's a phone in the store", I said, pointing to the door to avoid any confusion.

"Well, we sure do appreciate it. Kinda funny I aint never got'ta thinkin 'bout them things with Indians afore."

About four years later I saw the two hitchhikers again when a journalist from a South Dakota newspaper thought I might agree that the majority of the non-Native population of the Black Hills had a great deal of respect for Lakota spirituality and history. The tense was all conveniently past and not present and the estimate wider than oblivion. But respect isn't necessarily a birthright and honour isn't always pulled from the pocket of inheritance, just as spirituality isn't inherent or passed with exclusivity through one race's genes. Fallibility binds and the search for values divides. Colour is only the reflection of light. Interview over. My time with Arvol had influenced me to write the book I was promoting. It's about three hundred and sixty miles from Green Grass, South Dakota to Sheridan, Wyoming.

IN PLACES THE land between Sundance and Sheridan has curled itself tight, roll after roll of crumpled expanse clenched beneath the steps of the Bighorns that are stacked and shining toward the moon. The moon was weak and halved and slouched in the snow that was resisting June in the mountains. Its trickle of light braided stands of cottonwoods where stars dangled and waited to be found in the lights of a distant town. A white-tailed deer burst from the car headlights, her tail raised and quivering as she sprang from the highway to the shelter of darkness sagging between the slopes of ravines. I watched her evaporate and then looked south to where Fetterman died. Fetterman always reminds me of the reason. Somehow he manages to reassure me that I might actually be Earl Holy Elk's* brother. Earl tells me I am every time I stop to fill-up with gas at the store in his one horse town. He walks like the first man on the moon and he always looks surprised to see me standing up there with him and I half expect him to shout 'Shit! We've come all this way and you forgot the damned flag!' But when he gets up close I can see that he's forgotten it too. Earl always enquires about my health and my family as he squeezes my hand and I thank God that someone's pleased to see me and then I think that if we were really brothers he wouldn't need to ask. But it's alright, Earl and I are brothers on Mondays and Fridays and he has a lot of other siblings to remember between then and the weekend. He's often

* Pseudonym

hungry and I always offer to buy him something to eat but his appetite wanes in the heat and it gets so hot he's stoked a thirst. On his breath I know how hot it is even at ten below zero and he forgets that I'm a son of a bitch until the tank is full. Earl could have killed Fetterman. Maybe some nights he does. So what if he's forgotten, one day he might wake up and remember counting coup on Fetterman with the flag.

Sheridan's annual parade was passing by. It was overcast but nobody cared and it came and it went and kept going. I watched it through the bookstore window as I signed a few books and joined a debate as to whether one of the assistants should chance a fairground ride on a contraption I had never seen but I forgot about the ride and opinion when I turned to find an elderly man leaning over a bookcase right behind me.

"I'd like to introduce you to Mr Joe Medicine Crow", said the owner of the store. We shook hands and I confirmed that I had seen him before at Crow Fair but that we hadn't been introduced and we started to talk about his book, *From The Heart of Crow Country*, and its follow-up.

"Has your book got wolves in it?" he asked. "They tell me there's a big market for wolves. I've got some wolf stories in my new book", he chuckled.

He left and my tongue was dragging from the weight of the words I hadn't said that were now stamping around on its tip.

"I don't think I can explain this", I babbled. "But I really need to talk with that man."

The owner of the store hurried after him for me.

"He's already on his way to the gallery", she said, half in and out the door. "He said he'll meet you there."

I scribbled on a pile of books and scurried out. I had a small exhibition in the gallery down the main drag and sure enough the old man was headed there. Bobbing and weaving through the onlookers I could see his diminutive frame wrapped in a red shirt, blue trousers and topped with a cowboy hat, his bow-legged pace rocking him from sea to shore like a barrel on a ship's deck. Dodging children and balloons and impatience because the day

wasn't quite what it was supposed to be and the kids weren't as pretty as the neighbour's, I caught up to him by the entrance. We wandered to the back of the gallery and he perched on a stool surrounded by pieces of picture frames, easels and boards.

"I don't know how or where to start", I said. "But I've been thinking about you for four days straight."

I had become involved in one of those well intentioned struggles with authority that rarely lead further than sympathetic noises and 'we'll see let's discuss that further maybes'. What the Department of the Interior had called a National Monument for less than one hundred years had been a sacred site to Native peoples for thousands of years but there was scant recognition on display and nothing about cultural survival and the area's continued significance as a place of sanctity and prayer. At least I tried, I told myself as I stepped down from the saddle of my big white horse. I had suggested that the words of the people themselves should represent their perspectives and for the Crow interpretation I had sought but had no way of contacting, Joe Medicine Crow.

"Well," he said, as he pushed his hat back and rubbed one of his temples and then let it slip back over his forehead and neatly cut hair, "something brought us together today", a hint of a smile twitching the corners of his mouth. He calmed the whistle from his hearing aid and I told him my story. Looking up he nudged the shiny black plastic frames of his glasses and demonstrated a sequence of events from long ago that he said he thought I would already know. When he was finished he talked about spirits, not ghosts, and I could still be there listening.

"You know," he announced before leaving, "we might have something else in common. One of my ancestors was Scottish."

Thunder and hail had covered the parade and we shimmied through the rain past crowded shop doorways and the smell of wet but drying dogs to the shop where his wife was waiting. I walked back down the street and peeled my shirt from my skin in wet patches to show willing to those who were sheltering.

"Who was that old Indian?" the proprietor of the gallery asked.

"Joe Medicine Crow. One of the most respected elders of the Crow nation. He's the tribe's historian, 'Living History'."

"I knew a lady who took some photographs of the Crow in the old days", she said, and brought out a copy of *Bozeman Trail Scrapbook* by Elsa Spear, a woman born to the Bozeman in January 1896. She could only find one original photograph and she set the sepia print down on the table.

"He was a Crow Chief. I think his name is on the back."

"It's White Man Runs Him", I said.

"That's what it says", she confirmed.

"You know the elder who just walked out of here? Well, White Man Runs Him was his grandfather and he was one of the scouts who told Custer not to enter the valley of the Little Bighorn and that if he did they would all die that day."

I DROVE WITH the pencil notes he had written for me stuffed inside my shirt pocket. Every fifty miles or so I prodded the pocket to hear the paper rustle and then I would think that it was all alright. The rain stoned the car and every rock was a thought and each throw a decision that splattered with memory and stuck and could not be wiped clear. I drove on but not away and their names ran down the windshield. The riders. The murdered. The humble. The generous. The alcoholic. The dying. The addicted. The survivors. The prayers. The traditional. And each seemed to be part of a ceremony. It is three hundred and sixty miles from Green Grass, South Dakota to Sheridan, Wyoming and I am haunted by part of it. Their words are on those rocks and the ceremony is theirs and whenever I wake all I have done is pass through.

A Life in an Hour of Anita Half Moon

THE COLOURS WERE pretty. The reds and yellows skimming off the windows with continual flashes of white splattered a blur of pink and orange into the deserted corners of the parking lot and scraped the night from the nine-to-five buildings. Anita was slumped on the curb with her hands clasped between her knees rocking backwards and forwards. She stared at the floor and her hair hung heavy and lank, hiding her face from the onlookers reflecting in the sheen of the patrol car. Faint strands of breath billowing warm in the frigid air betrayed her to the shoppers as she blew and laboured to suppress her sobs and whimpers of 'No, no, no'.

"Why did they try to get away if they had nothing to hide? That woman was caught stealing, no question about it."

"She weren't doin nothin", insisted a tall Indian man swaying without a breeze but standing upright. "Weren't doin nothin but wann'in to smell the food. The McDonalds. Feel a little warm, you know. I'm tellin you man, Indian can't walk in here without being followed. She aint done nothin."

The young police officer's partner strode toward the Indian whose arms instinctively snapped open with raised hands.

"She aint done nothin", he said again as his feet went opposite ways to his knees in the policeman's do-ci-do.

"Jimmy. Jimmy", she mumbled without changing her posture. "Jimmy, I need a smoke."

Jimmy didn't answer.

"Jimmy!" she hollered, startling herself. But Jimmy still didn't answer.

Anita's life crackled in fits and starts over the police radio for the night and anybody who wanted to listen. She rocked faster. She was dying for a cigarette. She would have died for a drink but more likely from exposure. The cold had stripped her raw and abandoned her in a soaked but drying daze. For a few seconds she was still, listening to the store manager and the young police officer. She heard their voices and knew what they were saying without deciphering their words.

"Powwow songs", she said. "I know what you're sayin about me", she screamed and then forgot, distracted by the lack of stars on such a clear night. The city lights had sucked them in but carefully spat out the moon.

"The wonderful thing about Tiggers", she whispered, "is Tiggers are wonderful things."

Winnie The Pooh was the one and only story her mother had ever read to her and she would skip to school singing that song. 'Slow down Nita you'll fall', her mother always warned four steps behind. One day she did. Her back leg slipped on the dirt and sand and she landed in a tearful heap. 'It's okay baby', her mother had said, wiping her nose and eyes and spitting on a tissue to clean the graze on her elbow. She would sit in the chapel of Benedict Joseph Labre and wonder if Jesus ever wore feathers like the ones wafting around the cross.

"What did you learn today baby?" her mother asked first, as always, on their two and a half mile walk home.

"That Jesus loves me and I love you and daddy."

Lena Mae smiled and they swung each other's arms hand in hand.

"And who is Saint Labre, Nita?"

"Our Beggar's Saint", she bubbled. "Helper of the poorest of God's poor children."

"Careful of that arm baby." Lena Mae winced as Anita twirled in front of her and squeezed her other hand. "Mommy hurt it at work."

It wasn't really a lie, she told herself. The mission's craft factory had closed down

but tart wine and Hey I'll Pay You Back Next Time Wild Turkey had convinced Austin Half Moon that there must have been something she could have done to keep her job. They were separated by welfare requirements but Austin came around everyday or when he realised that tomorrow wasn't yesterday and today was different from the one before. He was an expert with a chain saw and whiskey but he gave one up when the sawmill closed and concentrated on forgetting and the other. One more refugee among the Ponderosa-pine on the Ashland - Lame Deer divide.

"I wish daddy would be waiting at home", Anita twittered.

"We'll see baby", Lena Mae said. Thinking that if wishes were horses beggars would ride.

Austin was crouched over the small wood stove in the centre of the sparse one bulb, one rug, one crucifix, one table room insulated by dreams of better days.

"Husband. You don't need to do that. It's pretty warm outside."

"Might not be tonight", he snapped in rejection before standing up. His jeans fit where they touched and nestled around his ankles above a pair of flagging once white sneakers. His T-shirt wasn't clean but his faded red cotton shirt wasn't dirty.

"How's my morning star?" he asked grinning at Anita, his hair springing up like short black quills as he pulled his baseball cap off and sat it on her head.

Anita perched on his knee and snuggled into the security of second hand cigarette smoke, soft skin and the hint of warm beer. He swopped glasses with her which always brought a laugh, his covering most of her face and hers barely reaching his ears. Austin was born Northern Cheyenne and grew a child of the mission. Only once had he thought he wanted to be Indian because thought and want usually appeared at different times and spoke unintelligible languages. Lena Mae brought them together, albeit fleetingly, as she sat head bowed in a diner in Torrington, Wyoming and Austin saw her and remembered and thought and wanted. They were the only two Native people there and she said 'Yes' to his offer of a ride to Rosebud, South Dakota, but in the end they didn't turn east, they just kept going.

"Remember the morning star lights the morning sky and shines brighter than all them other stars", he said, gently pinching the end of her nose. "They say it's special to Cheyenne. Now say your prayers before you go to sleep and get some water to wash your hands and face."

"Daddy. Will you be here in the morning?" she asked, as she slid off his knee.

"Maybe. It's up to mommy. Don't forget your teeth."

She woke to the sound of horses and then floated away on the security of knowing that her mother and father would still be together in the morning. If you played horses with someone it meant you loved them, her father had told her one Saturday night when the anxious patter of her footsteps surprised the riders already in the saddle. A crack rattled the wall covered by her father shouting words she was never supposed to hear or say. A sound like a half-full trough of water being dropped brought her out of bed crying to the door.

"Help me Nita", her mother gasped, popping a scarlet balloon of blood and snot covering her nose and mouth.

Their naked bodies looked pale and brittle in the harsh light seething from the bare bulb, her mother crumpled on the floor with her head suspended by a handful of black hair twisting through the white knuckles of her father's grip, his other fist clenched and purple and blotchy.

"Go back to bed Nita. Mommy and daddy are only playing horses", her father assured her. "Go on now", he instructed softly.

She looked at her mother all limp and lifeless, splayed without grace the way a dead deer flops broken and bleeding over the back of a pick-up truck. She looked at the half dead half alive yellowing branch of skin and bone standing over her and she looked at Jesus who hadn't fallen from the cross and she wondered how He could still love them if He had seen it all. She rubbed her eyes and snivelled and froze and then bolted back to bed, curling up so small that nobody would ever find her and all there was in the darkness was lost and the

slaps were thuds and the screams only moans and it would stop if she went to sleep. And it would stop if she could pull the sheet up tight enough. And it would stop if she could press her hands hard enough over her ears. And it would stop because the most wonderful thing about Tiggers is Tiggers are wonderful things.

A wail of distress swelled inside her head and she went from sleep to fear to sitting bolt upright in her clammy night dress as the cicadas whined and she slowly recognized the sound of morning. Her mother was sat at the table draped in the gray light the gauze curtain allowed. Her arm trembled as she raised a cigarette and she flinched as she drew on it through the only space available between swollen purple lips. She covered the eye that had nearly bruised closed when she realised Anita was there and she whispered, "No school today baby. Daddy's left his car and we're goin for a ride."

Anita never saw her father again and often she wasn't sure about her mother.

I I

"LOOK OUT FOR the Enterprise", Lena Mae said as they clattered down Highway 212. "It's coming up here pretty quick."

"Mommy. Is Mr Spock an Indian?" Anita asked as they passed the sandstone hoodoo.

"Well let me think about that", she laughed. "Yeah. Sort of, I guess he might be!"

Anita already thought he must be, or at least part, because he was different to everybody else on the space ship but somehow he tried to be the same until they wanted something he had that they didn't.

"Where we goin Mommy?"

"Home baby. We're goin to mommy's home. And you'll meet a new grandma and grandpa and lots of aunts and uncles."

They went close but they never made it. Lena Mae hadn't seen her family for eleven years. She had left it so long and blamed it on everything else so often that she was ashamed but mostly afraid. Her family were different. Or that's how she remembered them. Hell, they weren't progressive, she wrestled. They hadn't taken Jesus into their hearts. If they are

at the fair it's meant to be, she told herself. But she didn't see them and she didn't look among the bustles and bells and beads and jingle tin cones. Anita knew that Indians did this on the Fourth of July but she had never seen it and she didn't believe it was supposed to happen at any other time. She had never seen so many feathers or felt the drums or instinctively stepped to dance without moving. It was a pool of colour she could paddle in and mix faster and faster with her hands or feet until it spread in ripples and blended and whirled around her in a sherbet swarm of a thousand flavours of ice cream she had never tasted. She could hold her palms open and let the paint run down her arms and spill over her clothes and press her hand prints to her cheeks and it would be okay. Eagles, so many eagles flying, she thought.

They drifted over to the rodeo on the smell of fry bread that became bitter sweet with used straw, horse shit and tension. Bennie Tso had a face as wide as his belt buckle, chubby cheeks sketched out with a wispy moustache that he twisted at alternate tips as he spoke. He wore dark blue Wranglers with pressed white creases, cowboy boots that didn't look wide enough for his feet and a purple shirt bundled up with big green diamonds that a country singer might wear for a bet but a politician in a Western state would button up to exhibit their affinity with the Native cause. Bennie's lips rolled back, he smiled broadly and tipped his flat brimmed straw cowboy hat and in between the glint of black pearl in his almond eyes and the turquoise dripping from his bolo Lena Mae saw Arizona.

"I guess it could be I'm with them guys", he said, cocking his head toward a line of horse-trailers with the names of winners and glory days blazing in the prairie sun.

"Mine's right there. Says *'Navajo Nations Finest – Ride Hard! Don't Weaken!'* Says that so it must be true, right?" he chortled.

"Don't listen to him sister", sang the stocky shadow resting his head on top of his arms on the perimeter bar next to them. "Everybody calls him 'Sevens'. Ask Bennie here how long he stayed on a bull. You know, how many seconds, and it don't matter how long he always says 'Bout seven'. Seven my ass!"

The two Navajo cowboys barged shoulders and belly-laughed, the shadow continually spitting as if he had a wasp on the end of his tongue.

Lena Mae didn't care how many seconds. He looked kind and had gentle eyes. He was pedal-steel in a George Strait song when it's finally over but your love isn't gone and you're lost and found and the nights don't matter and the days don't matter. And the miles didn't matter. This time they would make it.

THE HORIZON GREW old and faint and dithered over its last request. Blowing and panicking as handfuls of stars pierced indecision it sucked for a final breath but there was nothing at all and nothing to do but wait for the resurrection. It rushed in and a precious three quarter moon pulled back its pattern and there were mesas stood in folds of sky that were long and tepid and fraying pink at the edges, shooing unruly shadows from their claims on clusters of mountains. The landscape was a carnival with one or two distant trees and galleries of rock that somebody had started but didn't know how to finish. Valleys were filled with outlaws who had surrendered then fallen from the gallows and sunk in the desert until all that was visible were enormous hands above the ground, pointing and shooting imaginary guns that time and punishment had turned to stone. Turtle shells and sleeping bears had been hurriedly arranged in ragged lines and sprayed mauve and orange with shadow and light in layers of painted desert and bouquets of colour that Anita had never seen. Hogans rose sporadically with eight cribbed sides covered in earth and sky and from the car she watched an old lady with a head scarf knotted tight, a long dress and thick socks rumpled below her knees, hustle across the highway with a flock of pigeon toed sheep in a cloud of orange sand and bells and bleats and tap dancing feet.

Four things reminded her of Ashland and Lame Deer, Montana. Bennie's home could just as easily have been theirs, they could have loaded it into his trailer and nobody would have noticed the difference. The hunger in faces and poverty in B.I.A. cheese. And the long steep sky disappearing over Canyon de Chelly.

III

THE OLD DOG lifted his head in appreciation and stretched his neck so Anita could tickle him from chin to chest and then he flicked his head, pricked his ears and scampered out of the yard and past the launderette to dance on the corner of the street. The dog shook its backside and a long curly tail that must originally have been intended for a bigger dog followed in motion. Milt fumbled around his knees to pat the dog and lumbered up to the porch with the dog mesmerising his heels.

"Bennie said you might have that fifteen bucks from a couple of years back", Anita announced without expectation and Milt patted her head as awkwardly as the dog's before she got up off the step.

"Grown a little, Pretty", he said without looking at her and she blushed.

She had seen 'uncle' Milt about three times in as many years but had heard about him nearly every other day. Bennie always concluded that one day they would see him go and he'd never come back. It seemed that the only thing Milt had going for him was that he always woke up breathing but sometimes even that wasn't much of a start. He was a commuter. One of despondency's colonised executives, working a twenty-four-hour shift from liquor store to bar to pen to hospital and back again. There were days when he couldn't remember his dog's name and how it survived without him there but in the Turquoise Bar he couldn't forget the *Book of Mormon* he read on every beer bottle label, '. . . *after they [the Indians] had dwindled in disbelief, they became a dark, and loathsome, and a filthy people, full of idleness and all manner of abominations.*' Latter Day Saints, or at least those who had appointed themselves as their official representatives, had read from the *Book of Mormon* to his parents and told them that they could send Milt to a B.I.A. boarding school in Brigham City, Utah, or submit him to the LDS Indian Placement Programme where he would be embraced by a Mormon family. He would eat at their table, live in their home, share in their love and be schooled by their book, '. . . *many generations shall not pass away among them*' recited the bilagáana. '*Save they shall become a white and delightsome people.*' But Milt's

parents neither spoke nor understood English and his skin never turned white. No matter how many beatings he took to earn their love, or hours he slaved to earn their love, or days he starved to earn their love, or secrets he kept to earn their love, or times he read the book out loud to earn their love, or drinks he swallowed to forget that 'love', his skin still looked closer to brown. On his journeys back to Chinle he would swear that he'd never leave again, but after waiting for two days for death alone because nothing else was going to call, he would hitch a ride to Farmington where he could drink what he had and drink what he hadn't and piss and sleep and be battered all up against the same wall. At least when he bled he knew he was alive.

Anita looked at him and thought that he might not be the poorest of God's poor children but he had to be one of them. She said it was nice to see him and that she would tell Bennie that he would take him the money later. He asked for a hug and she responded like twelve-year-olds do when they don't know if it should be a reserved squeeze or a child's cuddle, but she knew if she didn't offer either nobody else would. Her face nestled into the stale sweat and flab that ransomed his chest and she knew that she had done her duty. His heart was thumping her face and she pulled back but his clutch remained. She tried to speak but there was nothing and then Milt's hand clamped over her mouth and there was salt and nicotine and today's cheap beer every time she tried to breathe. Her glasses clicked as they hit the floor. She was cold. She was on fire. She was leaving without going and she tried to kick as he grappled with his pants. And she tried to kick when he knelt on her legs and pulled at her dress. And she tried to kick when she couldn't breathe and he was crushing her. But then she couldn't even try. And it was pain and it was darkness and she closed her eyes because she didn't want to see but in darkness nobody can hear you scream and in silence nobody can see you bleed. And her body gave because his mind wouldn't. He heaved himself off her and threw a grimy towel on the floor between her legs and on it she wiped colours that she'd never seen.

"This can be our secret", he said, suppressing a belch as he fumbled to button his

shirt over his paunch but quickly gave up. "I won't tell no one you came here and did this. I won't tell the kind you really are. People find out you a Joe Babe and old Bennie's gonna get a line at his door. I won't bring that shame on him and your mom but you will if you tell. Now give your uncle a hug and go before you get into trouble."

She tripped down the step and as fast as she swallowed there wasn't enough air so her heart filled her throat and exploded in her mouth.

"Pretty. Don't forget this", he called, waving a five and a ten dollar bill as she faltered into the road.

Mrs Begay called Hello from across the street and she took the money knowing others had seen her there. The choice was stay and collapse or walk. The dog danced on the corner and her hips were no longer her own and the insides of her thighs were burning. She was thin but her stomach felt bloated and heavy, and she had no behind but it hung to her knees. What she had allowed him to do to her must have been the greatest sin, she thought, if God made her hurt so much so quickly.

"Bennie. Here's the money."

He turned from his conversation and saw her outline trembling in the doorway of the cabin where he tethered his horses and waited for tourists who wanted to ride through the canyon.

"You sick?" he asked, placing his hands on her shoulders and guiding her to a chair. She grimaced as she sat down and he noticed the stains but not the bruises on her legs.

"Is it that time?" he asked quietly. "Have you Walked Into Beauty?"

There was no Kinaalda. No songs from the Yeis. She'd heard about Changing Woman and she knew enough to know that this wasn't her time at Precious Stones. There was no Blessing Way. There could be nothing and nobody would know.

IV

SHE WAS AN otter cutting through clear water. Sleek and lithe and twirling in the current and around the current before bursting from the surface with her arms wide and

silver cascading over her skin and silver dripping from her body. She was a dragonfly blue in a rainbow. Blue above the river. And there were colours reflecting in her wings that she had never seen. It was a dream she had before Milt and a place she visited every day after. Her head bumped the window at the back of the school bus as the brakes huffed and screeched and the door clapped as it opened. The driver raised his voice and stuck 'What the hell' to the roof of his mouth as he remembered his job. And it was too late anyway, the kid had passed him. Whistles and cheers fell as they rose. Anita was pasted into the corner of the back seat. The boy stood in the aisle and held out his hand. She blushed. She looked up at him and sixty saucer wide eyes balanced on their seat backs. He smiled and nodded and offered his hand again and she took it and the saucers cracked and cheered and wolf-whistled and the driver muttered 'I'll be damned' and shook his head sniggering 'Son of a bitch'.

"Don't slam the door real hard 'else you wanna ride in a convertible", Manny said with a smile. He made the back wheels spin and the dust cloud orange and her heart skip two steps forward and one back. The girls liked Manny because he had all the parts for the car even if some were random and weren't meant to last. They giggled around him because they knew he had and most of the boys envied him because he'd been where they hadn't.

"Powwow songs", he chuckled, as Dwight Yoakam struggled to be heard through the hiss of a worn out cassette. "Don't know all that he's sayin but man I know I've been there", he said with premature authority, flipping the tape over to Joanne Shenandoah. "Love songs", he smiled.

Anita just scratched a fingernail nervously along the edge of her seat.

"Listen. I'm . . .". He paused and thought about asking her what was happening in school but quickly decided that was worse than the weather or sitting in silence. "Well I just wanted to say too bad about your uncle."

Her nails dug into the palms of her hands. Her heart stopped and a bone lodged in her windpipe.

"Lotta folks die out there on Slaughter Alley. It's sad", he sighed.

She relaxed momentarily. Bennie was borne out. Milt had been killed trudging along Highway 550 from Shiprock to Farmington when a drunk driver slowed to pick him up and then swerved to miss a stray dog and piled into a head-on. The impact ploughed the car into Milt, the driver onto the road, spread the second driver over both wrecks and it was presumed that the dog got away. Lena Mae had broken the news gently to Anita and interpreted her lack of emotion as grief. Which it was, of a kind. Anita was shackled by guilt. She had wished Milt dead. When he was on top of her and his heart was pounding, hope was a heart attack. Whenever she touched herself by accident or for comfort and felt his hands she wished he was dead. Every time there was blood on the moon and it was hers but some part of it seemed to belong to him she wished he was dead. Now he was and she wished he wasn't because God would surely punish her without confession and for wishing such an evil thought without forgiveness in her heart. Whatever she did now Milt would never let her go.

"Yeah. It's too bad", she agreed. Hoping her heart wouldn't notice but that her conscience would.

"So, you always get in cars with strange men?"

She looked at him out of the corners of her eyes, her face flush, and shook her head with clipped jaunty turns.

"You're not old enough to be a strange man. Strange boy, maybe", she smiled.

"Well that's okay. I only stored up the nerve to stop that damned bus so I could ask bout Montana."

They walked hand in hand from the overlook to the canyon's edge where a bevy of juniper and piñon entwined to screen them from all but their world and Spider Rock.

"What about your family?" Manny asked, leaning on one elbow as he lay at her side.

"Never met my mom's. Saw dad's at Christmas and Easter. Sometimes at St Labre. You know my dad really loved my mom", she insisted defensively. "He just hated himself."

"What was he? No. Shit. We're talkin like he's dead. He aint dead is he?"

Anita shook her head. "He's alcoholic."

"I didn't mean that. I meant what's his heart?"

She shrugged her shoulders.

"His people", Manny explained. "Your people."

"Oh, okay", she nodded. "Northern Cheyenne and my mom's Lakota. Rosebud."

"What d'you know bout your people?"

"Well . . . Some of em killed Custer", she said raising her eyebrows. "And . . . Mr Spock is one of us!"

She bent over as they laughed and her head touched the side of his.

"And that's all you know?"

She nodded and they both stopped laughing.

"We got Kit Carson. At least you killed Custer. Course, we still got Peabody Mining shoving our elderly about and wanting the land they aint ruined yet. Black Mountain is Manifest Destiny", he said, flicking at a piñon nut and knowing she wouldn't understand because nobody had told her.

"Does your mom like it here? She like ol' Sevens okay?"

"She's happy. Bennie treats her good. He's sober. He doesn't beat her. You know, I guess he lets her be a Catholic and she lets him ride bulls."

Manny laughed like a drain. "What's the difference?"

She smiled and remembered to blush.

"So, your mom's a Catholic. I know what Sevens is about. Then what are you?"

Anita stared at the towering siamese twins of rock, one shorter than the other but both casting shadows in signs of peace or victory across the canyon.

"I'm nothin I guess", she said turning to Manny.

He pushed up onto his knees. To her gaze the sun's last light made his hair shine darker and longer, his eyes blacker and sculpted his face softer. She ran a finger over goose pimples on his arms and she wanted to, but didn't, touch the chunks of his legs that were exposed by the rips in his jeans.

"You're not nothin", he whispered to her as he removed her glasses. "Hozho", he purred, stroking her cheek and drawing out the high and angular lines that composed her face. "Hozho", he sighed, outlining her lips and her nose that sloped gently to a timid bump which he covered with half a kiss. Her eyes slanted faintly to the slightest pinch and in shape and in depth and in light they were midnight on a raven's wing where there is beauty unknown and beauty unseen and he looked into them and believed he could fly. He freed her hair from behind her ears and it bowed on her shoulders until the breeze sent it tumbling and black. Manny raised one hand open palmed and Anita placed hers upon his but it barely covered half and their fingers folded together and wouldn't let go. He put his lips to hers and though full they were tense and then they softened and jade shapes filled the canyon and sheared away to retreating orange on rocks from rim to river.

"Beautiful", he told her again with the wind tangling their hair. And amidst the strands Anita saw a thin horned moon hovering in dragonfly blue. For the first time she felt what it was to believe.

"This life is short", he murmured. "Whatever happens, I'll meet you here. I'll wait here for you. I wouldn't go north without you. I'd risk Skinwalkers for you. Will you catch me if I fall? Will you be here?" he asked, sliding a smooth pebble from his hand to hers. Anita held on to him and pressed herself so hard against him she wished that if her eyes should ever open again their bodies might be one.

V

GUSTS WHIPPED THROUGH their hair as Manny shot hell-bent-for-leather along the devil's highway with windows and consequence rolled down and youthful immortality wound up in the jangling guitar chords of some lonesome heart's serenade. He usually spoke of Gallup, New Mexico and happiness in the same breath, as if one were the other or close when he had to pretend because in truth they were miles apart and miles from anywhere near but as close as they might get. I love you! he howled to Anita, the words stretched out on the desert plain until they meant nothing to clumps of tamarisk and

cholla-cactus huddled at the base of a would-be mesa. She giggled and shoved a lump of Hershey bar into his mouth and laid her head on his shoulder. It had been a good day. Bennie had lasted more than seven seconds at the Navajo Nation Fair Rodeo and had a shot at becoming All Around Champion.

"Ol' Bennie might make it like one of them Holyans. Man, they say they could ride. Might be sayin that bout Bennie. Never know", Manny beamed. "I couldn't have guessed it when we watched him last year. How bout you?"

A thin smile twitched on her lips that agreed without disloyalty to Bennie. She had forgotten last year's performance and only cared to remember the days and months in between that began and ended with Manny.

"That's what I figured. Now let's get that supper he's buyin us."

Resigned to offering but not quite inviting, the diner stood in the pocket of neon it shared with a gas station, ravelled in interstate and tarmac and drivers or passengers from somewhere else who were eager to leave or return, the night shift chefs wearing expressions to go but restrained by a counter, a breakfast bar and next month's rent. The food was never good but familiar. 'What can I get for you folks tonight?' asked the waitress with the painted fiftieth-order-since-dinner smile and they ordered without reading the menus that threatened to intrude upon their reciprocal stares.

"Ignore em", Manny said, turning his back on a gang of kids who were high and loud on whatever makes teenagers who wear baggy shorts and jeans, tight T-shirts and outsize Air Jordans indestructible.

"Hey man. How bout lettin us party with yo' bitch", the biggest mouth shouted across the restaurant to Manny.

Anita shifted from side to side, peeling her legs from the vinyl seat.

"Hey you mutha, y'all deaf or dumb?"

Manny turned and glowered at the kid with the tattoos, light glinting on the cutlery he was beating like drum sticks, percussion to a leer and a gold tooth.

"Skin, listen up. You look chicken shit so you don't need to be jumped in or nuthin. Just yo' bitch. My boys here'll sex her in real good. Don't worry none bout that Skin."

His audience yapped and yammered. A pack from the verge of hunger. Some looked Indian, some Hispanic. Manny banged his knees on the table and sent the plastic tumbler of water and ice clip-clopping in pony tracks on to the floor as he snapped from his chair.

"Well let's do it", sneered the kid with the gold tooth and dilating eyes that suggested the lights were on but there was nobody home. He vaulted a table and licked Anita across the cheek and then stood face to face with Manny, his head bobbing to a rhythm only he could hear. Anita snatched at Manny's wrist.

"Leave it. Leave it", she pleaded. "I want to go."

"Can you read this chief? Says 'Deepers'", said the kid with the gold tooth pointing at his tattoo. "I want you to remember that. We be back on the rez soon man. We'll meet again. Keep her right for us man", he winked.

Anita pulled Manny away and apologized to the waitress who was serving an elderly couple iced tea and reassurance.

"It's not worth it Manny. It's not worth it", she insisted, leading him out of the door and exhaling relief.

'Police!' was all they caught in a volley of dust that lashed the forecourt and glittered gold in the glow of the diner's windows. Four officers hustled toward them barking orders, apparitions emerging to the blind with a countdown of boots, the chink of steel and squeaking leather. Manny raised a hand to shield his eyes and squinted into the white lights but there was only the muddle of shouting and dazzled paralysis until his head hit the concrete and the thud made Anita scream. A policeman grabbed at her like a fisherman fumbling to hold a catch, steering her away with both arms behind her back in a wide arc that had the finesse of a tractor on a fallow field. Manny was flying. A man to each arm. Christ with the feathers on the cross at the mission. "You goddamned gang-bangers", bawled one of his wings and Manny slid down the side of their car in red and blue strobes.

He wasn't flying but dancing. Fancy dancing. Eagles, so many eagles, Anita recalled as Manny's dance stuttered in strange animation, missing drawings or frames or picture book pages that would have given his movements grace.

"THEM GUYS SAY as you aint gotten nothin to worry bout", Bennie assured her as she bent into the security of his truck and the police department was gradually absorbed by the street lamps and motel signs flashing coffee and free continental breakfasts in the rear view mirror.

"Where they got Manny at?"

Anita shook her head between sobs. "Never saw him", she snivelled. "Never saw him. Not after they . . ." She broke down and Bennie stroked her head and passed her his can of Dr Pepper.

"Juvenile detention place maybes. He's pretty tough you know. Reckon it best not to worry, it'll be okay. Aint nothin to be done now. We'll come back in the mornin. Best try to sleep some."

Her breathing jumped and spluttered and her words kept catching behind her tongue.

"You were great today", she whimpered.

"Oh shit, was about time I reckon", he snorted. "Had lots of practice fallin on my butt after a couple of seconds. Least this time I fell on my ass after a couple more!"

Anita sniffed and raised a smile.

There was nowhere to hide in the morning. The threatening heat set out its glare and exposed the lack of consent and the lack of accord between the motels and tourist traps and concrete tipi units numbered one to whatever that housed the children of families on their way to Las Vegas, each with red and yellow and blue and green chicken feathers stuck on their heads while grotesque caricatures of chiefs with folded arms and open palms

towered stoic above signs for Indian jewellery, moccasins and Route 66 T-shirts. A ball of tumbleweed skittered across the highway and stuck in a doorway that opened at nine, watched by a skinny tabby coloured cat that pushed its front legs forward and fanned its claws. Stretching its back into the blade of a sickle, the cat shuddered before padding away with a swagger to patrol its territory along the near deserted Gallup street. Anita sprang from the truck and ran into the police department as Bennie cut the ignition and Lena Mae shuffled over the seat.

"Manny Yazzie. I need to know where Manny Yazzie is", Anita demanded.

The officer looked vacant.

"You know, right?"

He shuffled some papers, turned from the desk and poked his head into an office.

"Miss, would you be a close family member? A sister or . . ."

"No. I love him!" she blurted.

"I'm sorry miss. He's still going through the process and as yet we have no formal identification."

Lena Mae rested her head against the cool sterile wall. Bennie put his arm around Anita.

"Go sit with your momma Nita", he said, wiping a tear from her face with his thumb.

"I aint tryin to be smart or nothin but how is it you recognize that name if you aint got no ID?" Bennie asked.

"Would you be a close family member sir?"

"Yeah. Uncle. Clan uncle. That there is my daughter, you know. This is a picture of em together. His folks live a ways out. Aint no phone or nothin. Here's your ID. And he got a burn right here", Bennie informed the officer, tapping his left forearm. "He got it messin with a car engine. Chidí bijéí."

"Thank you", the officer nodded. "Your name sir?"

Bennie offered his details and turned and smiled at Anita, the girl slumped half on

a chair and half in Lena Mae's arms. He tapped his keys on the counter and read a fading poster about crack cocaine and marijuana, awaiting the officer's return.

"Mr Tso, the Deputy Field Medical Investigator says he will be with you in approximately ten minutes."

"Time is it now?" Bennie asked.

"Coming up on 5.50 am."

The man was early and he called Bennie forward and shook his hand. Bennie stood hunched with his head bowed and his hat clasped in his hands, revolving the brim through one then the other as the man spoke. The colour drained from his face and he blew and shook his head but declined a seat. Anita dived off her chair and slid on the polished floor and banged into Bennie as the man reaffirmed that there had been nothing they could do.

"He was discovered hanging in a cell at the Juvenile Detention Centre and he was dead when they found him, I'm so sorry."

Bennie caught Anita's arms. She was a new born foal and he had afterbirth glistening up to his elbows. Or a fawn he had watched stagger on thin ice and fail to reach the shore. Bennie held onto her and she dangled like a puppet with her head hanging forward and her hair flopping to her knees, suspended above the floor but pulling to kneel. Pulling to pray. A shape in worship. Fetal. Still born. They killed him! They killed him! she screeched. They killed him! she moaned, throttled by grief and shock and tears. Bennie yanked her up and cradled her in his arms, carrying her weight and her pain and Manny's baby.

There was no healing, only time and pain. Hours and days. Always another following. Another morning. Another one of their favourite songs. Another one of his phrases. Another blow to her midriff where now she had nothing, just emptiness below and inside her rib cage from what was once and what was left after her guts had been ripped apart and scattered. Scattered to the wastes or what skulked about those lifeless expanses and snickered and whistled so low as to be there, so faint as to be inaudible. Cruelty that spat and where it pooled in froth was memory. She doubled over and screamed until she had no

voice, no words to damn the sun for rising again. Stranded on one more sorry and reminders, her belly beginning to swell with his child.

"You said you'd be here! You said you'd be here!" Her cry tearing hysterically at the elongated shadow that hitched her to the juniper on the canyon's edge and the fragments drifting royal blue to douse the pyre fallen and jagged behind peaks in the west. She waited again and stars bickered for elbowroom above her before Orion rolled up with the promise. Anita threw Manny's pebble as hard as she could and sank to her knees as it dropped through the bowl of the Big Dipper down to the garden of who knows what or where on the canyon floor. Streamers of lightning silent and distant rippled so sandstone nuns and priests and Skinwalkers holding their book or its kind slid from the canyon walls in mute admonition. Spider Rock looked down impassive. Hell was a dozen fractures without the relief of broken bones.

"It's okay baby", Lena Mae whispered, wiping Anita's nose and eyes. A tiny lizard blinked at them through goggle eyes and then scuttled for the nearest crack in the paving. Hung in the throat of the canyon, a buzzard swam in violet streaks weeping from the rage clawing between earth and sky to the east, circling the sheer curtains of stone drawn over centuries of life and death and baptisms of fear and persecution. "He'll be here someplace. Someday", she said, with her arms around her leading her to Bennie's truck. "Someday", Lena Mae repeated over the drumming of the engine.

VI

Tiggers had stopped being wonderful things. Anita was still sat on the freezing pavement, ducking back and forth with her legs plopped over the curb and her knees rubbing a window in the grit that had collected on the patrol car's passenger side hub cap. She twiddled her fingers awkwardly, the cold having sapped their colour to a jaundiced yellow. The young police officer crouched on his haunches and began speaking to her slowly and the exaggerated big rounded words bounced off her ears in chalk drawn letters rubbed from a blackboard.

"I need the bathroom", she snapped. "Or do you expect that I'll pee in my pants?"

He remembered that she had probably only fallen from Pine Ridge or Rosebud which were both closer than Mars and then looked up for his partner, slapping at the bag containing the little black dress she was accused of stealing as it slipped off his lap.

"You dropped somethin", Anita mumbled.

A little boy at the front of the alternating crowd craned his neck to see what had spilled from the bag and then watched Anita's face turn red and amber on counts of one, two, three and four. She looked at him and smiled inside. His cheeks dimpled under a green knit cap pulled so tight over his ears that a frill of black hair bunched over the collar of a plaid red fleece he might grow into one day, like the jeans stacked in rolls with the toes of his boots peeping out. She guessed that he was about the age her son would be and for a second she saw Manny around the child's eyes. She wondered without conviction and then the boy had gone and she was waving to a forest of legs. And then her hands were pressed up against a partition and the vapour from breath and tears condensed on the glass to obscure the sight of her own baby laying still in a plastic box. He had arrived prematurely and already looked tired of life in his tight little brown suit that was taut and straining to cover a bundle of bones. A nurse strode up and whisked her back to bed, telling her how lucky she was because a federal judge had given an Indian girl four years hard time in Kentucky for doing 'something like her'. "I only want to hold Manny's baby. Our baby", Anita appealed. The nurse paused and her scowl chided, 'You should have thought about that when you were drinking and partying and that poor baby was inside you.'

Anita buried her head in the starchy pillow. She lapsed once but it wasn't a party. She had called Manny a liar for not showing and denounced their love as a lie and walked to the crossroads behind the gas station come convenience store and swopped Spider Rock for a six-pack. Sit here! One of the regulars had instructed, banging the tail-gate of the truck that doubled as a singles bar, and the border town liquor dribbled down her chin as she swallowed deep and fast to bury the bitter taste of alcohol and desolation. Three cans and more tears were all she could remember when she woke and found Lena Mae and Bennie

ashen faced at her bedside in Chinle Comprehensive Hospital.

"Why didn't you tell us?" Lena Mae asked.

"You got a baby comin now", Bennie reminded her and then wished he hadn't.

"It's all I have of him", Anita sobbed. "All I have. They took him. I can't let them take the baby. Baby is our secret. All that's left. I'm sorry."

She discharged herself from the hospital by leaving with an empty bag brim full of guilt, twenty-two dollars she had saved and an open road alive with footsteps. Austin called after her 'How's my morning star?' Milt lumbered along. Manny gurgled blood in his sweetest kiss. Lena Mae groaned, 'Help me Nita'. Bennie wrung the brim of his hat in the Blessed Virgin's light. The priest mouthed 'whore' as he offered the blood of Christ and the wine slipped over her protruding belly and as fast as she swabbed the drips from her navel there were more. The FAS counsellor spelled out 'fetal alcohol syndrome' to her again. The dog danced on the corner and she told herself that she had reaped what she had sewn. She felt dirty. Unworthy. More shameful than ever before. Each was a day in forty and the nights were hers alone. She spent one in Albuquerque when a man from Acoma scooped her up off the sidewalk and drove her to the IHS hospital. According to the doctors he saved her life and they gave her the forms and somehow in a moment seen as consciousness she signed. She never held their baby but she could still feel him jolt inside, before her child's body grew tired of trying and there was only agony wet and black. The B.I.A. Child Protection Services Officer assured her that it was all for the best and she cried at the bus station holding a ticket to Denver, a leaflet from the welfare office with the adoption agency's phone number and the stigma 'incompetent mother'. The doors called for hush and Anita stepped on board with no fixed address, no employment record, a caesarean scar, stretch marks and tied tubes.

"I REALLY NEED the bathroom", Anita repeated to nobody in particular, the young police officer having found his partner in discussion with the store manager. "It's too damned cold to stay down here", she muttered, bracing herself with one arm on the car and

pushing with the other. Barely tall enough to see over the car, she dipped to look through the windshield. Jimmy was in the back seat of the other police vehicle. His face was squashed up against the window and his mouth open.

"Hey! Hey! Wake your ass up", she grumbled and then suddenly started to laugh. She knew when this was over that Jimmy would have some smart comment about the most comfortable hotel he'd had in months. Anita thought that Jimmy could be a warrior. He wasn't her lover, he just happened to be there and he made her laugh. And most days laughter was beyond dares or dreams. They met in detox at Sioux San shortly after her arrival in Rapid City.

"Why in hell would anybody wanna come all the ways from Arizona to go to Torrington, Wyomin", Jimmy asked, as he turned the pages of a tatty copy of *Time* magazine.

"My mom met my dad there in some diner. Thought it might mean somethin. That I might find somethin."

"Shit! What's there? A turn to Scottsbluff? Hell if you went north you could make Alliance. That's a joke. Don't go. Aint much of a welcome for Indians there."

Anita looked down and crossed one foot over the other and back again.

"I know what your sayin, you know. Really", he said.

He saw her eyes welling and she turned her head and cuffed at her nose. Jimmy's chair squealed as he slid across the room. 'Hey', he said softly, patting her knee. She explained the whys and he already wore the T-shirt and had sent the postcard listing the reasons.

"Sons of bitches. All of em", he said drawing on a cigarette. "Want one? Only got two left. Anyways, that's the thing but they don't get it. Shit." He stubbed the cigarette out and put it in his pocket. "Smoke free. Forgot. Anyways, I ask em what the hell their ideas is got to do with me. What they call success. Shit, we never voted em in or nothin, they just decided. Well screw that. That crap is their dream. I aint one of em. Never gonna be. Don't wanna be. Aint gonna pretend to believe in their bullshit. Live to die in debt for some shit

I don't want. Excuse me, I'm not white. Excuse me again but I don't give a shit what you think."

Anita looked at him.

"Yeah, I know. I'm just another bum. A goddamned drunk, how original. I might make Oprah, right? But I aint that, see. This is my fight. My battle. My damned war. They got it all. Everything. But they can't get this. I escape in that bottle, go places they don't own, can't get. Shit, I fly. Sometimes I'm a goddamned eagle. And they can't get me then, hell no. It aint gonna make the news that I'm killin myself. I know it. But that's it right there. I'm killin myself, I decide", he insisted, jabbing himself in the chest.

"I don't need to fly, just forget", Anita said. "I wouldn't wanna pass my shit to an eagle. Eagle don't deserve that." She rolled the cigarette between her palms. "I'd like to go to Rosebud if I could fly. The beginning, you know. I guess it aint many miles but it's a long way."

"It's always a long goddamned way. Hell it's even further to forget. It's easier to fly."

Jimmy rubbed at his forehead and left eye.

"I was sittin under the bridge there one night and a fella asks if I knew what a good friend was? I guess, I said. He nodded and said a good friend is somebody you don't have to call back but when you do they'll still be there."

Jimmy smiled.

"Then we about fell in the creek laughing cos neither of us ever lived anywheres with a damned phone anyway!"

Anita took down the directions to the Rescue Mission and Jimmy said, 'No thanks. I'll take the creek. I'll see you.' She scribbled her signature and printed her name carefully on the register beneath a wet blanket of body odour and fried food that crept to the entrance with the taint of sour groceries sliding past their sell by dates. An old man bundled up in a jumble of clothes and clutching a Safeway sack with a torn handle as if it were the

winning lottery ticket was adamant that he hadn't been drinking. 'I fought for you white people in the war', he mumbled, as he shuffled away, 'I'm a veteran'. Anita sat in the service. She didn't want to listen but she wanted to eat and her eyes ran around the ragged congregation. Our people she thought, so many of our people. Then she forgot how many and they said Amen. Two beds down in the dormitory a middle-aged woman was dancing or singing or being beaten or vowing 'I Do' in an inner language often ignored that sits in places and fills holes that are solitary confinement. Truth without escape. Flesh listening for blood. This is me, she was saying in her sleep, this is me. Anita heard her. She spoke the language and the woman was right, it wasn't okay. Feet scuffed down the corridors and a man coughed up what little he owned in rasps and heaves and a grandmother hummed *Amazing Grace* to the good of the do'ers who came to balance their slates top heavy from Sunday to Sunday.

Volunteers worked the weekends. Are you okay? Have you been drinking? They asked and Anita slouched shaking in a wooden chair. One of them said he could help her. He promised her a drink for the DTs. He said the janitor was his buddy and that he had the keys to rooms where nobody would find out. In the Christian Program Room Anita balked and took the first kick in the stomach and swallowed the craving in her throat and waited for the eagle's wings. Maybe this is flying? But she changed her mind and thought as she had from the first time that, with the exception of one, for all their alleged differences men were just men, the same. As much as they talked about the chase it was all about the hunt and in their anxiety to take blood or make it, they forgot the words to their prayers and were reduced to grunts and groans. A tongue they think only the hunted understand.

Sons of bitches, Jimmy had said. Anita looked across at him again and smiled because by now she knew that the back of the car would be reverberating under his snores. In the chill of the parking lot she tried to convince herself that she couldn't remember the physical pain of that evening in the Christian Program Room, only the memory of its happening. She remembered his smell. That he reeked like a dead horse she had seen with

Manny, bloating by the side of the road to Tuba City. She remembered trying not to gasp for air beneath his weight and the size of his pallid gut pouring over the pieces of her body. She remembered how sore his beard scratched her skin and that when he tried to kiss her he bit her lip. She wasn't flying but she could see him writhing as if taken by disease but how quickly the convulsions left him. A miracle, as if God Himself had touched and cured him. She saw herself broken again. Salvation to the afflicted. Sons of bitches, Jimmy had said. 'Sons of bitches', Anita repeated out loud, flicking her hair and restraining her trembling bottom lip as she straightened her back.

The young police officer trotted toward her. The onlookers had lost interest and submitted to the warmth of the store and the promise of a bargain. Anita presented her wrists and the lattice work of scars were mostly healed but still bled 'He loved me. She loves me not. I hate me. He loved me not.' Each slit a day, a place, a name, colours that she had never seen. Beauty without recognition, a reflection she couldn't believe, but she was. She looked up at a lamp post where a bird chirped and twittered in a half burst of song, its night day and its day long in the streetlight. 'Do you know the most wonderful thing about Tiggers?' Anita asked the young police officer. The bird flew away.

THE FOLLOWING INFORMATION HAS BEEN COMPILED AND/OR VERIFIED FROM SOURCES SUPPLIED BY THE *National Indian Child Welfare, the Native American Rights Fund, the American Indian Special Interest Group and the National Native American Prisoners Advocate Coalition.*

———————

One in seven Native Americans live on less than $2,500 per year. It is estimated that 25% of all Native Americans live below the poverty line, rising to over 40% on reservations. Available BIA statistics indicate a national unemployment rate of 48% among Native Americans. Rates of 50-80% are not uncommon among some Native communities. There are reservations with unemployment rates between 85 and 93% – where 90% of the unemployed <u>are</u> seeking employment. There is a chronic shortage of adequate housing on reservations. General statistics regarding existing reservation housing indicate that 21% have no indoor toilets, 56% have no telephone and 16% have no electricity.

Eight BIA boarding schools are in operation. Boarding schools controlled by various denominations are still in existence in some locations but conjecture surrounds their numbers and mission.

There are still schools on Indian reservations that are operated under a denominational influence.

Even after the passage of the Indian Child Welfare Act (ICWA), more than 50,000 Indian children live away from their cultural roots, as adoptees in non-Indian families.

It is estimated that 6,500 Indian children who live on or near their tribal lands will be placed in care outside of their own homes during the fiscal year.

Indian children are placed in out-of-home care at a rate that is 3.6 times greater than that of the general population.

Of the 28,000 American Indian children thought to be at risk of abuse in 1998, 95% of those cases are alcohol/substance abuse related.

95-99% of all crimes involving Native Americans are alcohol/substance related, including charges, arrests and convictions for child molestation and sexual abuse, which have increased since the mid-1980s.

No national statistics were available regarding the number of Native American detainees who die in custody or awaiting trial. A significant amount of anecdotal evidence can be found.

Nationwide studies indicate that the number of gangs in Indian communities has doubled since 1994. The rise in gang activity correlates with a sharp increase in violent crime on reservations, the homicide rate having reached 87% in the past five years, despite a national decrease of 22%. The Navajo Nation reports having 55 gangs with approximately 900 members.

Reports from the late 1970s and early 1980s estimated that over one quarter of Native American women of child bearing age had been sterilized and that those procedures were done without assurances that those sterilized had consented to the operations. It is commonly accepted that one of the easiest ways to obtain involuntary consent is to present the argument for sterilization in the moments immediately following child birth.

A US Congress General Accounting Office report on sterilizations at IHS hospitals released in late 1976 found that of 3,406 sterilizations performed in four areas (including Albuquerque as cited in the story) over a three year period, 3,001 were on women under forty years of age, and that consent forms provided prior to the operations failed to meet federal requirements. Although official sources state that sterilizations are not as prevalent as they once were, many Native women contradict that statement.

On July 22, 1996, a former Community Care Center maintenance man who worked directly in the Cornerstone Rescue Mission facility in Rapid City, South Dakota, pleaded guilty to third-degree rape in a plea bargain. A former Cornerstone Mission volunteer worker, discovered to be a registered sex offender, was also implicated. One of the rapes occurred at the mission in the Christian Program Room. The victim and her family were residents at the mission. At the time, no screening process or system for background checks existed for volunteer workers. The Alliance of Native Americans protested numerous complaints against the mission. *Indian Country Today* newspaper carried detailed reports (*Northern Plains* section: June 18-25, August 5-12 and September 2-9, 1996).

A common grievance in many reservation border towns and close proximity city areas concerns the perceived harassment of Native Americans on suspicion of shoplifting by employees of large stores.

A Life in an Hour of Anita Half Moon – Epilogue
Sara's Story

by Sara Crazy Thunder

It was 1966 when, at fifteen years of age, I became pregnant. All of my four girlfriends whose ages were around mine, from fourteen to sixteen years old, also became pregnant that year. We were not promiscuous as the priests and local white community believed and judged us to be, we were children having children because we knew little or nothing about being women, our growing bodies, our developing anatomies, birth control or family planning. The federally operated Indian hospital was the only place where free prenatal care was provided but I hid my pregnancy for five months because I did not want to go there, the medical staff talked and whispered about us being poor, unwed and dumb. Although I felt ashamed, I still trusted the white doctors to provide good health care but at no time during those monthly check-ups was I provided with even the most basic natal education. I was scared and didn't know what to expect during delivery.

The day my son was born I was in labor for eight hours without being given any medication to ease the pain. Just before giving birth, I was moved into the delivery room and the doctor approached me and asked whether I wanted a 'tubal' performed straight after giving birth. The doctor explained that a 'tubal' would prevent me from having any other children until I was ready and that the procedure could be undone, but he needed my decision there and then. I thought about saying yes, it sounded like a good idea and if the doctor said it was the right thing to do, then it must be. But Oglala Lakota beliefs teach us that life is sacred and that may have been the reason why I answered no. When I said no I could tell that the doctor was very upset with me. During the delivery I was cut to open the birth passage, and I believe that was my punishment for not saying yes.

Three years later, one girlfriend lost her child in a tragic accident. She went to the Indian hospital and was told that the 'tubal' was permanent. She had been sterilized. It was then that we all got together and began to compare notes. Out of us all, I was the only one who had not agreed to the procedure. We wept openly after learning that they could never have children. Adoption was not an option because it wasn't within their social and economic reach.

How could this happen? Who would believe us? Who would believe that the federal government was medically sterilizing American Indian children with and without their consent? Acknowledging it would be admitting to child abuse. Would any of you want your children aged between thirteen and twenty-one sterilized? Even after thirty-one years I remember and feel a deep sense of loss and sadness – and guilt – because I chose to have only one child.

SARA CRAZY THUNDER, OGLALA LAKOTA, PINE RIDGE RESERVATION, SOUTH DAKOTA.

A Sacred Place

H IS HAND WAS hot and his grip tight. He held on as if the ground was about to disappear beneath him and render his footsteps useless, and then his legs would be useless, and soon the only place he could run to would be the slope where he'd fall. But his left hand retained its composure and it wrapped softly around the tension that held his other hand and mine. He was in a hurry to explain and he hardly blinked as sweat slid from his brow into his eyes. I understood his message if not all of his words. It sounded like poetry. It was poetry. Phrases from a meadowlark's song. In Lakota he told me that he had come from 'Sitting Bull's people', Hunkpapas from Standing Rock, and that he had read about my words in the newspaper.

My words?

He wanted to share the words with his family and friends and although my name was on them I never thought of them as mine, they were already as much his as they were mine.

I looked at him as he continued to talk. His hair seemed to be long but I am sure it was cropped and tufts that had sprouted onto his face before the heat of the day and dash were now stuck to his forehead. He was tall, or at least I think he was, and he carried a certain elegance. Even sweaty and dishevelled with his shirt bunched and flapping out of his pants I knew he was elegant, this tall slim man who stood holding my hand surrounded by pieces of art that to some would mock but to others honoured his people. I didn't get any further. A horse dance stick whirled above his head, the price tag spinning from the sweet-nothings breathed by the air conditioning. He hadn't noticed it but I'd seen it before. It was beautifully crafted and undoubtedly somebody would meet the blur that asked for seven hundred dollars to own a piece of Lakota.

"... mazaska. I have no money", he said, as others who hadn't travelled as far bought the words he had come for and left the store.

I didn't get any further because I was lost in his song but I held onto his hand so he could keep me from falling if I tripped on the way to the place I was running to. It was a different day. A day that had passed with an elder who had since made the journey, but on that day I recognised the dance even though the songs were not exactly the same.

As A BREEZE tapped at the screen door to remind us that the afternoon was passing with a world outside, I held on to the old man's hand. A toddler giggled and wobbled precariously between our legs and a jumble of toys and the old man's chuckle rattled in echo to the child's laughter. We watched the baby and he talked about how tired he was and how he thought it might be time to retire. A girl stepped out of the kitchen and swept the child into her arms and then went back to the business of preparing supper. Chief Ted Thin Elk peered after them and I glanced at the photographs of him sat on top of the TV set.

"A fourteen hour drive back here through the night is getting too much I think", he shrugged wearily, still standing hunched over the toys that were lifeless without their mentor.

The door groaned and creaked and clapped with regular bursts of applause for our unremarkable conversation, neither open or closed, neither dark or light.

"So you're Chapman", he announced suddenly, without need of confirmation or the book in his hand.

I looked into his eyes that from somewhere now beckoned and age and sleep and a watery glaze were all wiped clear. The country rolled away and the years were grass on a high plain where wild flowers had been coaxed out of the ground to run as far as the eye could behold, with antelope darting without thrill or chase, their legs painted with splashes of pink and yellow and blue petals, each frail on the edge of the horizon but content to be

laying anywhere between time and day. The wheezy rattle of his laugh brought me back but wittingly or not he had taken me to a place that I could have never found alone. I had already written some words about a boy and an old man but I didn't understand the story until I fell into his eyes.

I still don't know the boy and I still don't know the old man but I know this story.

MORNING CLUNG TO the blunt shells of trailers and the crude outlines of sterile white wooden houses. Softened only by fading pastel lines of taupe or light blue or yellow, every wall of every box looked as likely to snap as endure these days without number. The day like the faces waiting appeared indistinct. Tomorrow never comes but it does, it's just yesterday that never arrived. Wrecks that were once cars wilted in the heat without hope of former glory, abandoned to ditches and rust and fistfuls of dirt whipping from unpaved streets. For each and the would be drivers little else but the weather ever happened.

An old man sat down on his porch step. The shade had robbed his hair of its familiar silver sheen, reducing it to a pair of dowdy grey curtains draped around his face. He heard the one he called 'his boy' approaching, the skip and thud of feet and ball and the occasional gasp of the crowd's imaginary roar. He raised his hand to wave but remained adrift in isolation, staring at the floor. About twenty feet in front of him lay a dead bull snake. Its head had been crushed by somebody who had taken great pains to reverse back and forth over it, conscientiously ensuring that the world would be a safer place for ridding its scourge. The hunter probably departed the scene content, justified that they had killed for a worthy cause and to brag over a beer with the boys about the one that didn't get away. The harmless old snake had often sought refuge under the old man's porch step, the cool shade and dry earth providing protection from the intense summer heat. But not this morning. Today it lay exposed.

Lifting its head and barking out of obligation the neighbour's dog watched the boy as he bounced his ball past the yard it pretended to guard. Stretching its weary bones with

a certain amount of disdain, the dog kept an eye on a pack of snapping mongrels that were bounding around in a state of high excitement. The scraggy bundle stopped briefly to sniff and cock their legs on a blown-out truck tyre before charging away with tongues lolling from their mouths, taunting and jostling each other with, 'I'll find her first. I'll find her first'. As the temperature continued its climb a few flies became temporarily diverted by the matted bloody crust that until recently had been the smooth contours of the bull snake's head, now indistinct from the rattlesnake's diamond crown.

"Grandpa. Are you sad about the snake?"

"Oh, not really", he sighed.

The old man straightened his back and pushed the unruly hair from around his face to behind his ears, noting the unanswered question on the boy's face as he leant gingerly on the porch rail clutching his ball.

"Well, I reckon it's Sunday. Supposed to be a holy day. Or at least that's what they told us", the old man explained.

The boy remained perplexed.

"Sina sapa. The Black Robes", he continued, pausing to spit and rub the heel of his boot in the dirt. "They came to our people down there on Beaver Creek", he said, pointing south in the direction of north western Nebraska. "In the old days many of our leaders made camp there, including our Great Man. Some named it for him, 'The Chosen Land of Tashunka Witko'."

"Of course," he continued, coughing to clear his throat, "the wasicus came. Then their Black Robes came. They called it Whetstone and then Spotted Tail Agency after Sinte Gleska. The Black Robes built their chapel there and our people called them beavers because they too built cabins of logs and mud."

The old man smiled but it was short lived. He looked over at the snake.

"I remember them well", he said gravely. "When I was a little younger than you are now I was taken from our family and sent east to school. At first my parents refused to send

me but in the end they had to. They would have starved. The Agent cut their rations and the police came and took me away on a morning like this."

The old man's voice was unwavering, belying the emotion and rarely spoken agony of his generation.

"They cut off our hair. They gave us uniforms and made us parade like the army. One time I missed parade and they made me clean bathrooms with my toothbrush. If we spoke our language they sat us in front of the class and made us bite on a rubber band. Then they would pull it back as far as it would go and whack!" The old man slapped himself across the mouth in demonstration.

"I had a friend who ran away. When they caught him they whipped him good. His hip bone was kicked out of place. After that they called him Limps Slow because he couldn't walk properly. We still called him Whirlwind Horse. His name. He was the fastest runner I ever saw."

The boy had started to bounce the ball gently as was his habit, the dull beat drumming on the wooden boards.

"Many years later I learned that they made a movie about it all. *Wards of a Nation*!", he exclaimed, blowing down his nose in mock irony. "I read that the Ford Foundation paid for it."

"The wasicus", he continued, shaking his head gently to emphasise his bewilderment. "They made us cut off our hair and told us not to drink. Then they took us to church and showed us a picture of Jesus who had long hair and held a ceremony that ended with drinking wine."

The old man looked down at his feet. He tapped his right foot on the bottom step and flicked at a loose splinter.

"I don't know. I just don't know", he admitted, staring across the street. "Is this life, liberty and the pursuit of happiness?" He leant in front of the boy and grabbed hold of the railing to brace himself before climbing steadily to his feet. Placing his hands on his hips he tilted backwards to stretch his spine.

The boy looked at his grandfather and put the basketball down.

"But do you know where Chicago is, Grandpa?" he asked, smoothing out a wrinkle in his 'Chicago Bulls' top.

"Well, that's also a ways east of here."

"Where?"

The old man patted the boy's hand and then tapped him gently on the head.

"It's in here", he said.

"If it's in there how will I know when I've found it?"

"When you come back", the old man nodded. "When you come back." He tucked his shirt into his pants and looked at the boy.

"You see", he explained. "What happened to that old snake is only part of how the West was won. Whirlwind Horse is still the fastest runner I ever saw."

I SAW THE horse still running on air above the man's head and felt the warmth of his hand and realised that I was back. Flute music swirled around the store and a middle aged lady from Pennsylvania on her way to Mount Rushmore insisted that she had seen the light and promised to share Jehovah's secrets if we would only open our eyes.

"Don't forget about us", said the man from Standing Rock before letting go of my hand.

I handed him a book and told him that I would not.

"And don't say goodbye", he said in English before starting down the stairs. "Remember we don't have no word for it. Toksa, we'll see you."

A Word About Ethnic Cleansing

"I watched my mother die there", she said, as handfuls of candy pitter-pattered around her feet, thrown by children from the passing float. Pushing at the bridge of her glasses, she leant forward in the canvas chair to duck beneath the alley cat strains of the local school band blaring *Colonel Bogey* as they marched to a fashion, stomping past the second clarinetist who had lost whatever time they had. She smiled at the flustered boy and a tubby little bundle of energy tottered out to his place in the parade and handed him a piece of the clear candy. He waddled back to a smattering of family applause and the elder ruffled the toddlers mop of hair.

"There", she continued dispassionately, "I can't have been much older than him", the child now sitting by her legs occupying his mother in a whorl of pointing fingers and questions. "But I remember. I remember her coughin all the while. Tuberculosis. It took her. It took a lot there."

"Grandma! Grandma!"

She stopped and sat back. The lines on her face melted in smiles and her cheeks dimpled at the sight of the Tiny-Tot Princess.

"Her mom was up all night botherin about if she might fall off that pony." She paused and turned to see who was next in the parade, as if she already knew who would be riding up the street. "Oh my", she beamed. "But would you look at Shayni!"

Shayni rode by, all shiny black hair, poise, stetson and sequins, calmly ignoring the 'Rodeo Queen' sash slipping beneath her arm. She waved and the family whistled and cheered. Unassuming yet secure in the beauty that teased the minds and hormones of the adolescent boys who nudged each other and laughed as she passed.

"You know", she sighed, her attention and voice detached, "some say it was a long time ago. That maybe we should forget. But I don't. I was a Prisoner Of War. Just a baby there but a Prisoner Of War. My aunt told me they had it worse before . . ."

"Wasn't she pretty grandma, wasn't she pretty!"

The old lady nodded, stroked the girl on the cheek and continued.

"They had em in Castillo de San Marcos first. Like a dungeon in Florida. You know where that is? Well, near on five hundred of our Apache people were kept there. One oven. Salty water. Two outhouses and only two tin tubs for bathing. A lot died. It was too wet and humid, like Alabama when they shipped em there. They had our Apache people in army barracks in a swamp there. My aunt said my mother got sick there. She said they had no sunlight because of big trees and a high wall. Malaria took a lot."

Dance! Dance! Dance!

The sun hit them and there was nothing. No children dizzy in chatter and circles. No old men slumped in beach chairs shouting Dance! No drooping horses or the glare off windshields. No Whiteriver Parade. No today. Only showers of jingles and voices unknown thumping deep inside. Blunt but stinging and pure. Drums and voices deep inside. Songs for figures who appear somewhere between recognition and fear where blood runs back and pools thick and warm from a place that few come to know but they see it, these figures, they touch it, they cure. Their voices unknown, their bodies unknown, each closer to God, so close He sees. *'There is One God. The Giver of Life. Upon this earth on which we live Ussen has the Power . . .'* Open arms, open hearts. Feet slapping the ground, bowing their heads to butt and challenge with rough hewn crowns of horns or antlers splayed as fingers on an open palm, perched above masks and identity. Twirling and bouncing, sweat dribbling down four black vestments painted true on flesh and bone, streaking lightning bolts and crosses to the four winds, storms of finger paint hail. Each drop discharged on the lips of time, salt on a tongue that is dry.

She watched the Crown Dancers, the Gah'e, until the sound could not be seen.

"Old Nantan Lupan", she continued, flapping an arm half-heartedly in the direction of Fort Apache where fence posts leaning like drunken soldiers display a sign announcing 'General Crook's Quarters' in front of a ramshackled arrangement of rotting timber. "Crook came to see em. The one who took his place when Geronimo agreed to go, he said our Chiricahua people, the Tchihéné, Tchok'anen, Bedonkohe and Nde-nda-i, would only be gone a couple of years. He lied. Do you know how you can tell when a White man is lying? His lips are movin!"

She chuckled and cleared her throat with a dry cough.

"He put out somethin like five thousand soldiers to hunt down thirty-seven of our Chiricahua Apache people. Naiche's people and Goyahkla, Geronimo. Over half, about nineteen of em, were women and children. Can you imagine that? Popa used to say that the Mexicans had another three thousand soldiers chasing em too. Well, I guess they got em. My aunt told me that when we got to Oklahoma we couldn't talk with the other Indians there cos nobody could speak each other's language. And we were from the mountains and they liked the plains so signs weren't no good. I think they got us then cos it took the children they had taken and sent to Carlisle boarding school to come back before we could talk to each other. The Apache and Kiowa and Comanche children could all talk English from that school so that's how it went. Indians talkin English to understand each other. My aunt would walk thirty miles to see my sister who got sent to school not far from Fort Sill. That changed when the missionaries came. A lot changed. A lot took the Jesus road. Our Apache people became good cowboys. My aunt had a hog but we didn't ever care for hogs much."

The old lady's family loaded themselves into the back of a truck and she eased out of the chair and supported herself with its frame.

"I watched my mother die there", she repeated. "But I know it was worse. They had worse at other places. In the old times at San Carlos the White-eyes gave Apaches tags, called em by numbers so they would forget who they were in with all those scorpions and disease. They kept Apaches corralled like the cattle there on starvation rations."

She tapped the side of the chair and waved at the grinning faces flicking candy at each other as they waited.

"My aunt came back close to Arizona when she got the chance, to Mescalero, she didn't stay at Fort Sill. Our relatives who did have done pretty good though, they've kind of got a little town. But I've been back there you know, to Fort Sill. They've got a big fence around em now, the ones they sent all the soldiers after. They've got em all inside it there, lots of our Chiricahua Apache people, all in rows. Regiments. I remember that all but Geronimo had the same white grave stones. All the same. They think they got us."

A young woman walked around the truck, smiled and held her arm out.

"They think they got us", she said again, taking the woman's elbow before speaking to her in Apache. They stopped and the elder looked over her shoulder. "They think that. But oh, did you see Shayni", she smiled.

Mitakuye Oyasin

VISIONS FROM NATIVE AMERICA
Photography by Serle Chapman

Trickster COYOTE

In 1890 our language and ceremonies were outlawed, in fact everything relating to our identity as Lakotas was outlawed by acts of Congress, so we could no longer practice our way of life wholly and so everything was taken underground. The pain of that time never really lifted from our people, it just kept passing from one generation to the next. It went on for seven generations, about 110 years, until we realized that we needed to cure ourselves; we needed to heal and let this pain go. In 1986 we were given direction and told to seek healing for the people and for our relatives who were massacred at Wounded Knee in 1890 because that killing was so horrendous we had never pulled out of mourning. With that guidance we undertook the Big Foot Memorial Ride in 1990, following the 175-mile trail Big Foot's people had taken from Cheyenne River to Wounded Knee, so we could wipe the tears of seven generations.

In 1986, before we received that direction, our language was nearly lost and we were almost assimilated but now our spirituality is stronger and the Sun Dance has come back across this reservation. One of the best parts of this resurgence is the return of the Horse Nation. The horse is back here with us today and we offer the horse all the pride and respect that he deserves. We're also raising buffalo and we want to bring the Buffalo Nation back in their massive numbers – up to sixty or seventy million – but presently there are only about 250,000 buffalo in the entire world and in the United States 250,000 beef cows are consumed for supper every day, so if we ate the buffaloes they'd be gone in one day! Someday, when the buffalo are numerous again, we will return to a buffalo economy and we will be whole again.

ALEX WHITE PLUME
Oglala Sioux.
Historian/Horse Rancher/Hemp Advocate.

Bull BUFFALO

T'sou'a'e

T'sou'a'e ALOFT ON A ROCK
Gaigwu KIOWA

Na Kovea

Na Kovea BEAR'S LODGE
Tsistsistas CHEYENNE

Daxicke Asow

Dax-bih-chay Ah-sua BEAR'S HOUSE
Apsálooké CROW

Woox-niii-non

Woox-niii-non BEAR'S TIPI
Kananavich ARAPAHO

Mato Tipi

Mato Tipi BEAR LODGE
Lakota SIOUX

Regardless of what Indians have said concerning their origins, their migrations, their experiences with birds, animals, lands, waters, mountains and other peoples, the scientists have maintained a stranglehold on the definitions of what respectable and reliable human experiences are. The Indian explanation is always cast aside as a superstition, precluding Indians from having an acceptable status as human beings, and reducing them in the eyes of educated people to a prehuman level of ignorance. Indians must simply take whatever status they have been granted by scientists at that point at which they have become acceptable to science . . .

The stereotypical image of American Indians as childlike, superstitious creatures still remains in the popular American mind – a subhuman species that really has no feelings, values, or inherent worth. This attitude permeates American society because Americans have been taught that 'scientists' are always right, that they have no personal biases, and that they do not lie, three fictions that are impossible to defeat.

VINE DELORIA, JR.
Standing Rock Sioux. *Professor and Author.*

Devil's Tower? BEAR'S LODGE

Grizzly BEAR

Who Am I in All This?

As a young child my roles and responsibilities included listening, behaving and learning. My responsibilities as a child included taking in as much knowledge about simple duties and responsibilities of daily living. This included simple things such as rising early, at dawn, learning how to weave, and feeding and caring for the family livestock.

As a young adult, my role progressed as I received more knowledge and direction from my family and my environment. My responsibility increased. I gained respect for myself as well as for others. One of my important roles as a young adult was centered on the responsibilities of school. I learned to integrate my home and family responsibilities with expectations from school.

As an adult, I left the comfort and support of home. I was forced into maturity when I suddenly found myself in an off-reservation boarding school. I had to accept my new environment and learn to adjust to new responsibilities and expectations I was faced with. Being away from home, I had time to learn about myself and focus on my individual needs. This was a time of great individual growth and expansion of my maturity. The next role I encountered was a role as a wife. This role required flexibility and adaptability. No longer was I able to focus on myself; I had to consider my spouse in every choice I made. I gained many new responsibilities as a wife and skills in the area of sharing, negotiation, and sacrifice.

The role of wife soon evolved into the role of mother. Once again my responsibility increased to include the needs of my new daughter. Both my spouse and I had to learn as a unit to meet our responsibility as parents.

My lifelong experiences have created an individual capable of fulfilling many roles. I am now in the role of grandmother. I am finding that all of my previous roles are creating a new role which combines my past experiences and integrates them into my current role as a grandmother. With my grandson, I see myself as a teacher. I am able to recognize and appreciate the joy he has brought to our lives. I recognize his talents and abilities and try to integrate my childhood experience into his growth and development.

ELSIE KAHN
Navajo. *Healer and Counselor.*

'I am Eagle Woman.
I am Totsohnii (Big Water Clan) and born for Tsenjikini (Honey Combed Rock People Clan).
Fifteen years ago I received a gift from the Almighty through the Spirit of the Eagle to be a healer and counselor.'

MY LIFE IS PLEASANT
My life is pleasant, calm through my eyes.
As I reached my adulthood I struggled with illness.
Through my illness I gained spiritual strength and wisdom.
A gift was given to me from the Creator to help my relatives.
With this knowledge I go through a mental, physical and
spiritual journey for healing throughout the seasons.
When problems are resolved, life is back in balance,
and harmony is restored.

Mountain LION

There is a record in the Library of Congress that the buffalo were deliberately slaughtered as a military tactic. Our total economy was destroyed with the killing of the buffalo.

There is a comparison between those buffalo hunts and the US policy of deliberately bombing factories and production centres in Germany and Japan in order to end the Second World War. Afterward, the US sent foreign aid to rebuild those economies. At $100 per buffalo, we should be paid $20 billion. We are owed $50 billion if you figure it by today's standards of what a buffalo is worth.

We had a beautiful way of life. Now we are eating miserable commodities and living in their little square houses. They can keep their welfare and commodities and just give us back the land and $50 billion for the buffalo.

Lakota

GREGG BOURLAND
Cheyenne River Sioux. *Tribal Chairman.*

Bull BUFFALO
in the shadow of the Black Hills

63

Humming BIRD

Reverence for our sacred land has always been at the heart and soul of us Apaches. From the time of our creation, we have recognised our sacred obligation to respect the forces that sustain our lives and to ensure that they are kept in proper balance. It is no accident that we are known throughout the world as White Mountain Apaches. Our name directly ties us to our sacred land.

Whenever we take any part of nature's bounty, whether plant or animal, we perform a ceremony. If we do not do this or if we take more than we need, then nature is thrown out of balance.

We Apaches, through the practice of our traditional religion, have been excellent managers of our ecosystems. Unfortunately, with the establishment of our reservation in 1871, non-Apache interests, primarily through the mismanagement of the Bureau of Indian Affairs, have thrown these ecosystems out of balance. Vast areas of our land, which were carefully nurtured by our ancestors, were wrongly taken from us. Severe damage was inflicted on our timber stands, rivers and grazing lands, and our water rights were thrown into jeopardy.

Without doubt, there is a strong relationship between the damage to our ecosystems and the tremendous social problems our tribe has experienced. When an Apache sees his sacred land damaged, the Apache suffers as well. And that suffering will continue until a healing process is set in motion. Our younger generations, who have witnessed this destruction, will now be able to learn the true value of our land. They will be able to establish the same relationship with our sacred land as our ancestors.

We now have the opportunity to bring forth a healing process of our land and our people. Let's go forward with this sacred obligation.

RONNIE LUPE
White Mountain Apache. *Tribal Chairman.*

HOPE
from the album Mirabal

Verse
I drove down Manitou Road
Seminoles shaking shell on Creek dance grounds
It was a manifestation of an ancient episode
Tell you why
Skirts swaying, sweat flaying
And I was spellbound
Chorus
Take me where there's hope
Where women dance like Antelope
Take me where there's hope
Where men dance in a kaleidoscope
Take me where there's hope
ah-hoi-ah (*she took me*)
Verse
Here we go Here we go
Thunder clouds and the electrolyte Hopi

Pronghorn ANTELOPE

66

Corn dancers kachinas bring rain
They were celebrating an ancient prophecy
Mantas swaying, sweat flaying
And their domain remains
Chorus
Boo-yah tribe – *the crazy tribe*
Black top 25 across the Rio Grande
I saw Pueblo Runner stretch his Indian heart
Understand my homeland
Loin cloth swaying, sweat flaying
And never to depart
Chorus
Take me where there's hope
Where we dance like Antelope
Take me where there's hope
Where we dance in a kaleidoscope
Take me where there's hope

Tua·Tuh

ROBERT MIRABAL
Taos Pueblo. *Singer/Songwriter/Musician.*

Coyote

67

East of my grandmother's house the sun rises out of the plain. Once in his life a man ought to concentrate his mind upon the remembered earth, I believe. He ought to give himself up to a particular landscape in his experience, to look at it from as many angles as he can, to wonder about it, to dwell upon it. He ought to imagine that he touches it with his hands at every season and listens to the sounds that are made upon it. He ought to imagine the creatures there and all the faintest motions of the wind. He ought to recollect the glare of noon and all the colors of the dawn and dusk.

N. Scott Momaday
Kiowa. *Professor, Author and Artist.*

Bobcat

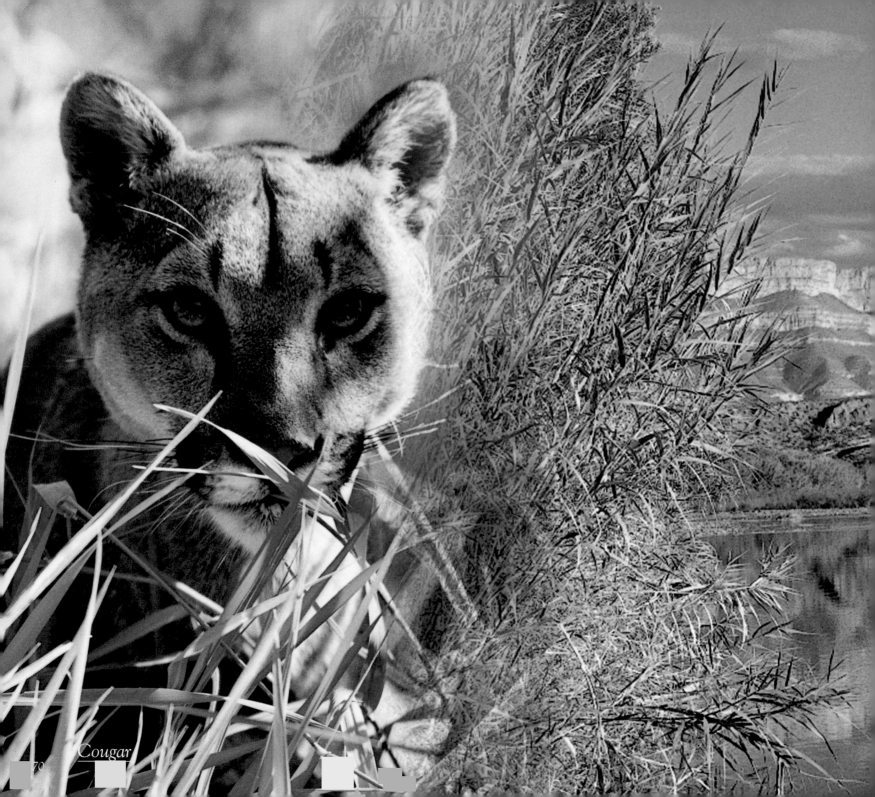

Cougar

Asa-habi
TRAIL OF THE STARS • COMANCHE
nemene

COMANCHERÍA
Big Bend of the RIO GRANDE

Bobcat

A Postcolonial Tale

Every day is a reenactment of the creation story. We emerge from dense unspeakable material, through the shimmering power of dreaming stuff.

This is the first world, and the last.

Once we abandoned ourselves for television, the box that separates the dreamer from the dreaming. It was as if we were stolen, put into a bag carried on the back of a whiteman who pretends to own the earth and sky. In the sack were all the people of the world. We fought until there was a hole in the bag.

When we fell we were not aware of falling. We were driving to work, or to the mall. The children were in school learning subtraction with guns, although they appeared to be in classes.

We found ourselves somewhere near the diminishing point of civilization, not far from the trickster's bag of tricks.

Everything was as we imagined it. The earth and stars, every creature and leaf imagined with us.

The imagining needs praise as does any living thing. Stories and songs are evidence of this praise.

The imagination conversely illumines us, speaks with us, sings with us.

Stories and songs are like humans who when they laugh are indestructible.

No story or song will translate the full impact of falling, or the inverse power of rising up.

Of rising up.

Muscogee

JOY HARJO
Creek. *Poet and Musician.*

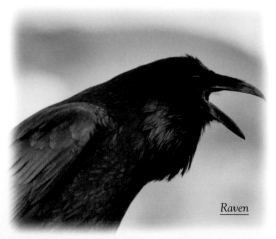

Raven

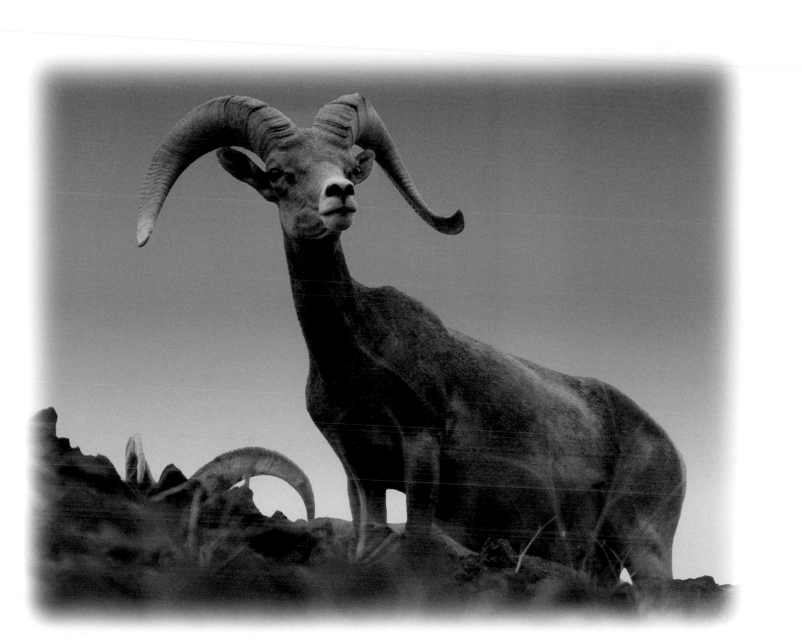

Desert BIGHORN

When is one man's national monument another man's national disgrace? Many members of the Lakota Nation say the hoopla surrounding the 50th anniversary celebration at the Crazy Horse Monument lends to the exploitation of Indian people and doesn't carry the blessing of many tribal members.

It alludes me why professional media people continue to perpetuate the idea that desecrating a mountain in the sacred Black Hills can be twisted and portrayed as a 'humanitarian' effort to return pride to the North American Indian. We have news . . . we do have pride, we always did have pride and always will have pride.

The American public is being duped into thinking that the foundation is providing great educational and humanitarian services to Indian country. Not so.

What is their definition of humanitarianism? It is never openly defined. No money is given to the tribes, no money goes to the American Indian Higher

Bull BISON
in Paha Sapa

74

Education Consortium or the tribal colleges across the nation that are really dedicated to promoting higher education for tribal members.

Respected Hunkpapa Lakota anthropologist Bea Medicine said she has 'always thought it was a sacrilege to mar the beauty of the sacred Black Hills. We never hear anything about the scholarships and the medical university they are supposed to be building up there and they never give money to our tribal colleges such as Sinte Gleska University or Oglala Lakota College.'

Dr Medicine doesn't envisage completion of the monument either.

What's wrong with this picture? Look at the face of the monstrosity called 'Crazy Horse' surrounded by the pristine beauty of the Black Hills and you will surely see what is wrong.

AVIS LITTLE EAGLE
Hunkpapa Sioux. *Editor/Journalist*.

One thing I notice now is that some people get disenfranchised from the so called structural religions so what ever answers they might be looking for they just don't find. Then they look at the Native American cultures. They want to have a bit of what the tribal religions offer but they don't understand that it's not something we choose or do for personal gain, it's a way of life. And it's not tribal people's way to say 'It's ours not yours and we don't want you to be a part of it'. You're always free to practice what you believe but one of the things that is asked of tribal peoples is that we must believe with one heart, and a lot of times that is something that others don't recognise. You can't have wavering thoughts, you have to believe with your heart, not your mind. You have to put your faith in the Creator, totally.

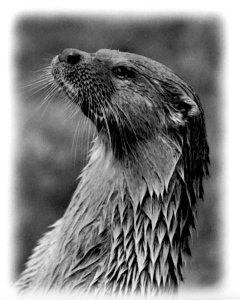

Mountain GOAT
Otter

76

A lot of those people want instant gratification without giving the sacrifice and a lot of times that is the problem Native peoples have with that 'New Age' or 'Mystic' side where they just try to cash in on the beauty of our religions without giving the pure sacrifice. It's not a matter of us saying 'No, you can't have it or be a part of it', it's more a matter of saying 'If you want to have it and want to be a part of it you must believe with one heart'. They forget that it is a hell of a tough way to live. It is hard to live like a Navajo or a Lakota or a Kootenai or whomever, because you have to give so much of yourself. Sometimes the elders will say 'I don't believe in your faith'. And sometimes a person will go for years and years before the Creator will look at them and say 'I believe in your faith and I will help you now'. Where as these New Age people now say 'We can go to the mountains and sweat. Then you will have your sacred name, or you will become a Medicine Man . . . but it will cost between $150 and $3,000 for that ceremony'.

In our way the individual is always the last in line – we live for the benefit of the people.

Ktunaxa

LESLIE CAYE
Ksunka band: Kootenai.
Host – Confederated Salish & Kootenai
People's Center.

Canadian LYNX

Joshua TREE

The message I carry speaks of hope, of our connectedness, of human dignity and of great need.

California Indians have survived through periods when we were taken from our lands – and when our lands were taken from us. We have survived the times when the state paid bounties for Indian skin and Indian body parts were displayed at California State Fairs.

We survived all that. And now we face a truly critical time in our history.

This past year Indian tribes received the most severe congressional funding cuts in history, and yet Native Americans still suffer from the worst human conditions and poverty statistics of any group in America.

At a time when Americans are dying to protect small, foreign nations and provide defence against economic rape and ethnic cleansing, should we not also ensure the protection of basic human rights for Indian nations within our own boundaries?

What we are now engaged in is a struggle to convince our leaders to develop new attitudes toward Indian sovereignty. Toward tribal gaming rights. And toward our ability to self-govern and determine our own future.

MARYANN ANDREAS
Morongo Band of Mission Indians. *Tribal Chairwoman.*

Rattlesnake • Desert Bighorn
Jack Rabbit • Chuckwalla

79

We were there before the oil fields came, and they tell us we have no right over it. We are the people of the land. We are here and our ancestors were here.

Inupiat

BERNICE KAIGELAK

Eskimo. *Nuiqsut Village Spokeswoman.*

Bull ELK

We survive as a people by identifying ourselves with the Porcupine Caribou Herd. Our creation account speaks of the time when the Gwich'in and the caribou were one and today we still carry a piece of the caribou's heart and the caribou carries a piece of our's. We have been Caribou People since time immemorial, the caribou are our life, they are our songs and stories. When we hunt the caribou, we give thanks to the caribou for sacrificing their lives so we may live, and we offer prayers to the Creator. We use every part of the caribou and not just for food; the caribou give us their bones for tools and skins for clothing. Before Western society entered Gwich'in country, we followed the caribou but now we live in villages where the caribou pass. Our diet is still close to that of our ancestors but our culture is now threatened.

The area of the Alaska Coastal Plain known as the Arctic National Wildlife Refuge is our sacred land. In Gwich'in we call it *Vadzaii googii vi dehk'it gwanlii*, 'The Sacred Place Where Life Begins'. This is where the 129,000 strong Porcupine Caribou Herd calve, right in the heart of this fragile ecosystem, and this is the place where the US government and the major oil companies want to start drilling. This is the last 5 per cent of the Alaska Coastal Plain that is not open for oil exploration, so why drill here when Prudhoe Bay is estimated to contain another forty years of oil? If they do, they will destroy this land, they will decimate the Porcupine Caribou Herd and they will devastate the Gwich'in and our way of life. They say there wouldn't be much impact on the Refuge if they drilled but what about the gravel roads, the flares, the pipelines? This tundra is rich wetland and one spill will seep and spread out. Since 1996, the Prudhoe Bay oil fields and the Trans-Alaska Pipeline have been responsible for over four hundred oil spills annually, amounting to around 1.3 million gallons.

What happened to the Central Arctic Caribou Herd near Prudhoe Bay will happen to the Porcupine Herd, they will become sick and starve. If the Porcupine Herd relocate their calving ground the calves will die because of the environment and climate in the other areas. If the caribou die our way of life dies too. The US Geological Survey estimated that, at the present rate of oil consumption in the US, the oil they could extract from the Refuge would only sustain the US for 180 days.

Whatever befalls the caribou will befall the Gwich'in. Are we to die for a six-month supply of oil?

Gwich'in

SARAH JAMES
Netsi Gwich'in. *Chairperson, Gwich'in Steering Committee.*

Sonoran WHITE-TAILED FAWN
Cochise Head, CHIRICAHUA NM

Sometimes I feel I should put on a war bonnet and paint my face just because that is what people expect! It's the stereotypical 'this is how the Indian looks'. People still look at the Indian head nickel the government minted and use it to identify Native Americans. If there is one thing people should try and understand it is our diversity. We don't all look like the Indian head nickel – some of us wear ties and suits for work, some of us go casual, some of us wear construction outfits, some of us have police uniforms on – Native American people contribute to society, it's just that we are put apart.

in-deh

JOE CAMARILLO
Mescalero Apache.
Marketing Director.

Humming BIRD
Black BEAR

85

'Why can't American Indians forget being American Indians and join the mainstream of society like everybody else?'

This reminds me of those who believe that American Indians, as a general rule, are on welfare.

I often point out to those who would believe this that many American Indian tribes signed treaties on a government-to-government relationship with the United States.

Clearly written within most of these treaties was a deal for an exchange of land for certain rights. American Indian nations gave up millions of acres of land for perpetual funds to educate their children, for health care and other rights, and for the right to run their own governments.

This is known as a treaty right, not a welfare right.

The American Indian gave up more to the United States than any other people. Why not respect our remaining right to sovereignty and the right to retain our language, spirituality, culture and traditions?

We are Lakota, Navajo, Hopi, Tohono O'Odham, Cherokce, Creek, Chickasaw, Ojibwa, Cree and on and on. We were sovereign people long before the first settlers landed at Plymouth Rock.

TIM GIAGO
Oglala Sioux. *Editor/Publisher.*

Mission SAN JOSÉ California
Atlantic Coast Line – THE FRONTIER

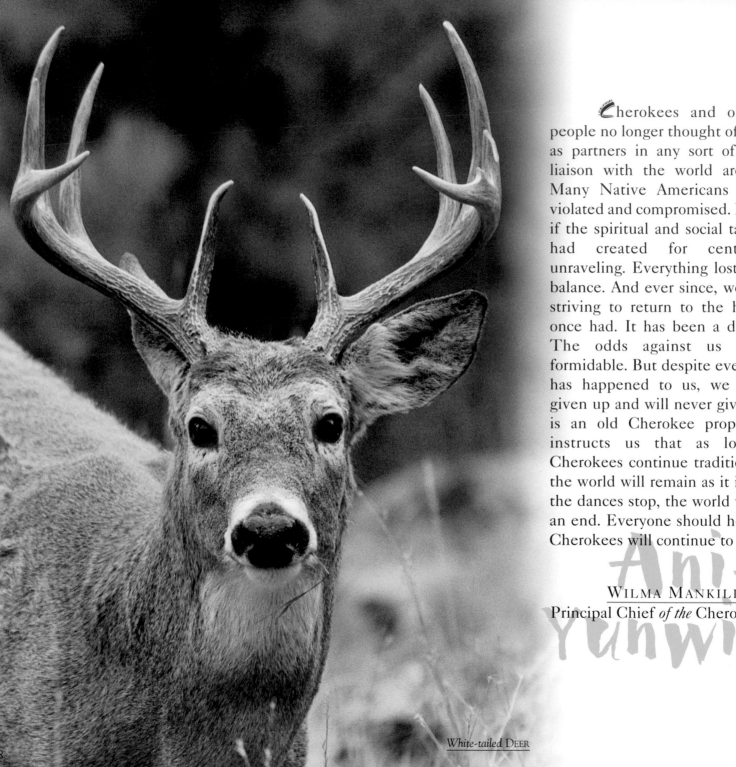

Cherokees and other native people no longer thought of themselves as partners in any sort of compatible liaison with the world around them. Many Native Americans felt utterly violated and compromised. It seemed as if the spiritual and social tapestry they had created for centuries was unraveling. Everything lost that sacred balance. And ever since, we have been striving to return to the harmony we once had. It has been a difficult task. The odds against us have been formidable. But despite everything that has happened to us, we have never given up and will never give up. There is an old Cherokee prophecy which instructs us that as long as the Cherokees continue traditional dances, the world will remain as it is, but when the dances stop, the world will come to an end. Everyone should hope that the Cherokees will continue to dance.

WILMA MANKILLER
Principal Chief *of the* Cherokee Nation.

Ani-
Yunwiya

White-tailed DEER

Coyote

Red FOX

I am Ah-Goo-Gah-Nah-Gidz, 'Between Here and

The morning began with a long look into the mirror as I tried to find a trace of Hidatsa and/or Mandan DNA somehow borne out in the morphology of my facial features. I am Indian, I thought. It was a sober reminder that once again a mindset, perhaps more than anything else, was my saving grace in the awareness of who I am. No Caitlin sketch present in the reflection. No Karl Bodmer painting of the proud Mandan warrior frozen in a posed stance came into view. Only a thousand reproductions caused by facing mirrors, passing on into infinity behind immobile walls. Is the cup half empty or half full I wonder? Have I finally become part of the 'Indian Solution' rather than the 'Indian Problem' by succumbing and becoming part of the melting pot of immigrant America? Really, who am I, I wonder?

I have thoughts of a young woman sitting at the bank of an easy flowing river sometime in the early 'fifties. Perhaps earlier that morning she'd paid a notion to visit a neighbor, help celebrate their child's birthday. Maybe instead she thought for a while about the coal supply going low once again. Time to gather more from the exposed vein a few feet above the river's edge.

Then again, maybe she supposed it impossible that this innocuous river called the Missouri could soon flow freely over her well-cared-for wooden floors. Maybe it was there and then that she made the decision to accept the inevitable and thus shifted her thoughts to the moving of her family to a place she'd only heard about. Los Angeles, California.

How her decision was made I'll never know.

To think that the Indian wars were over by the end of the 19th century is a fallacious thought, I now believe.

The Three Affiliated Tribes of North Dakota have suffered from the worst deprivations to speak of, socially and psychologically. From the smallpox epidemics of the 1800s to the most unsettling of all, the displacement of an entire people in the name of economic and technological progress. What was once a socially and economically healthy community became in a matter of a few years a federally subsidised experiment in social failure. The once-thriving town of Elbowoods, the birthplace and home to several generations of my own family now lies a few hundred feet below the waters of Lake Sakagawea – an ironic name-sake to the woman who is by and large credited for the success of Lewis and Clark's exploration campaign

My mother, an uncle and myself are readying ourselves to hike a shallow hill in south Phoenix, before sun-up. Less than 50 years have now passed between Elizabeth Grinnell's departure from Fort Berthold, North Dakota, to today's climb as we honor the one-year anniversary of her death. Back in North Dakota, what is now considered riverfront property was once shallow hills that she would climb. She made these pilgrimages to greet

continued . . .

here', a Hidatsa and Mandan human being

Rocky Mountain Bighorn RAM

the rising sun, make offerings and pray for her family, her clan, her tribe, pray for balance in our world, even. It was and remained a way to make the smallest of personal sacrifices by hiking these hills early before sun-up to speak to the creative forces of the universe. Today we three are making our own humble trip to pay our respects to our mother, my grandmother, Elizabeth Grinnell, who was without question the binding force behind our family. Though her hill in North Dakota was long-gone, this very hill in Phoenix became her adopted temple.

When we reach the summit, the sun is just rising over the horizon. It is beautiful, radiant, it is she – the giver of life to all humanity. This hill is also a metaphorical and philosophical journey into one's own awareness of who they are as a human being. Who am I, I ask the sun? I am *Ah-Goo-Gah-Nah-Gidz,* 'Between Here and There', a Hidatsa and Mandan human being.

J. CARLOS PEINADO
Hidatsa/Mandan.
Web Manager/Actor.

Grizzly BEAR

93

The *Wasicus* come to us when they've got no place to go. They were given the Ten Commandments, we have the Pipe.

CHIEF OLIVER RED CLOUD
Oglala Lakota *Oyate*.

94

Bugling ELK

For many years I have advocated that people know their culture and live it. Not just live it in their personal lives but institutionalize it through every aspect of tribal government. I believe that every structure on the reservation needs to be rooted in the teachings of our people so that we don't have a poor imitation of a 'white' institution within our reservation. We have to meet the standard that must be met for governmental purposes, but it has to be uniquely Lakota and it has to belong to us. In order for it to belong to us, it has to come from us, and our culture has many teachings from within our ceremonies that can easily be replicated into our institutions. This doesn't necessarily have to isolate us from the outside world, because we've always had the tradition that we adapted what was useful to us from other cultures and we made it ours, so I think that we have to continue to do that. When the horse came to our people we made a place for the horse and brought him into our culture; when steel knives came to us we brought those into our culture – but we never gave up being Lakota. I think education has to be the vehicle that allows us to take our own culture and bring it into everyday life in modern American society.

CHARLOTTE A. BLACK ELK
Oglala Sioux. *Attorney at Law.*

American BADGER

Black BEAR

Taawpwaataakan

That Which Brings Dreams

Bull MOOSE

Ke/na noowan

CREE

Lakota and Tsistsistas religious practitioners ask only that their religious sites and ceremonies be protected to the same degree that mainstream religious sites and ceremonies are protected. If an establishment clause problem exists, it is the failure of the federal courts to provide American Indian worshippers the same protection in conducting ceremonies at sacred sites as provided to worshippers at churches and synagogues. This failure to protect American Indian worshippers effectively establishes mainstream religions over American Indian religions in the United States.

Lakota

MARIO GONZALEZ
Oglala Sioux. *Attorney at Law.*

Racoon

Rocky Mountain Bighorn SHEEP

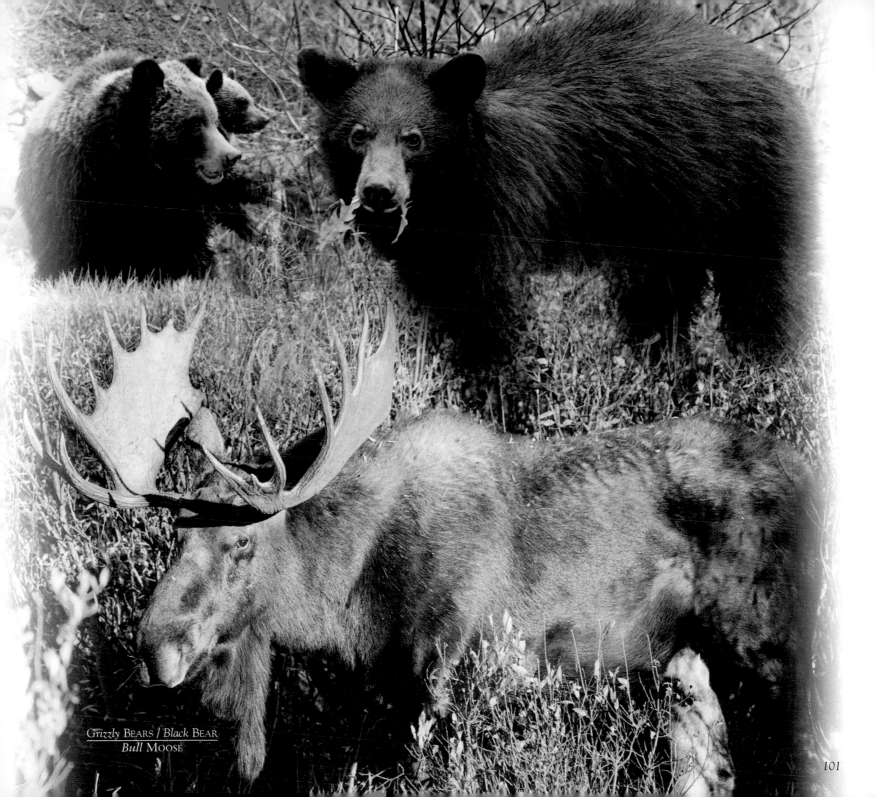

Grizzly Bears / Black Bear
Bull Moose

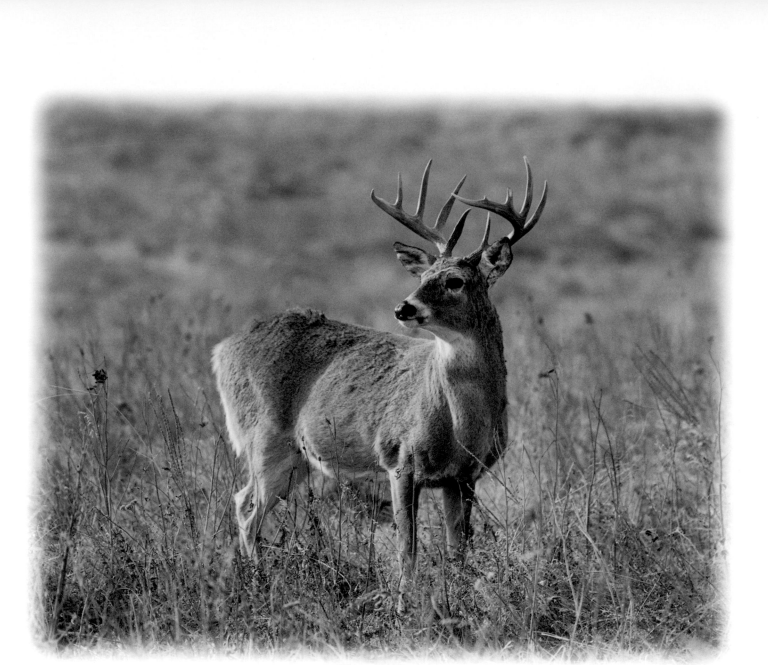

White-tailed DEER

łahn Dádzaaʼ

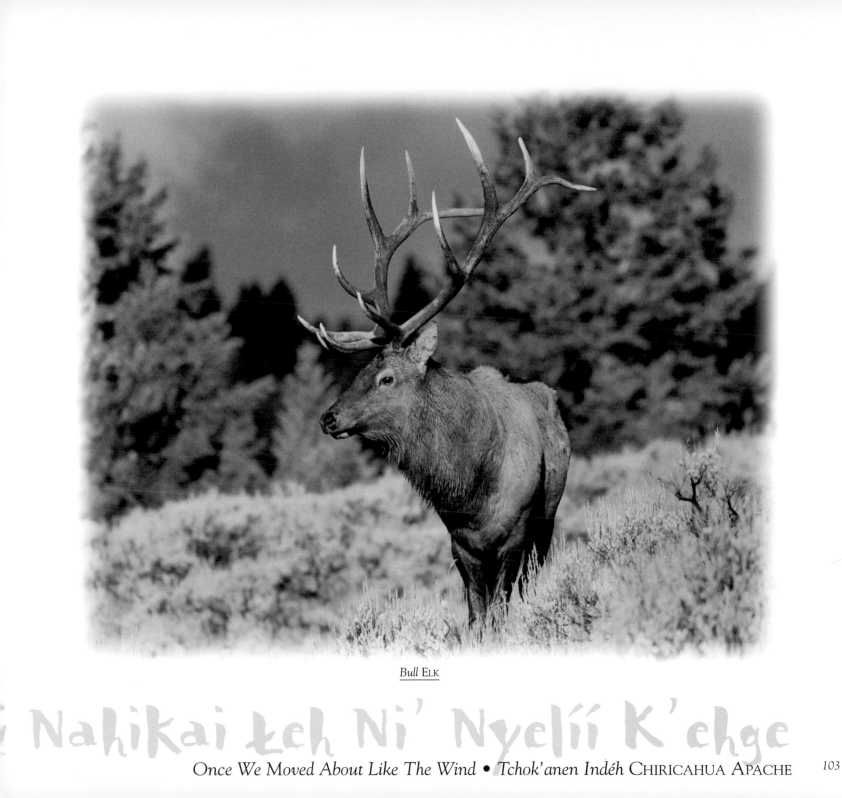

Bull ELK

Nahikai łeh Ni' Nyełíí K'ehge

Once We Moved About Like The Wind • *Tchok'anen Indéh* CHIRICAHUA APACHE

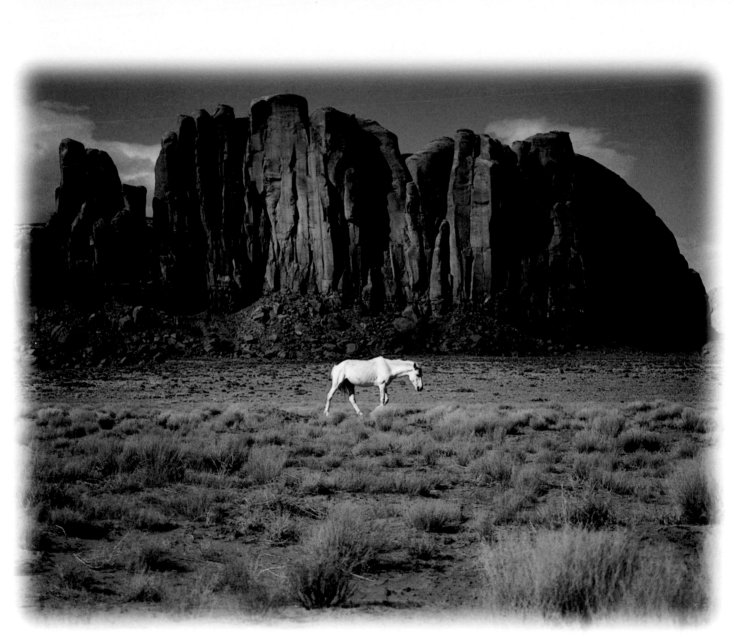

Monument Valley • NAVAJO NATION

The United States involvement in the Navajo-Hopi land dispute is either denied outright by federal officials or brushed aside, but the US presence has always been visible, especially in the beginning. A Federal Indian Agent's need to have federal legal control over some pesky non-Hopi supporters created the rectangular reservation that the Hopi and other Indian nations were federally mandated to share. That included the Navajo Nation. The non-Hopi supporters came from back east after hearing that federal troops were literally dragging Hopi children from their homes to transport them over hundreds, and even thousands, of miles to federal boarding schools. That was in the early 1880s.

These early friends of the Hopi also learned that if Hopi parents or Hopi leaders tried to stop this federal abuse of Hopi children – and of course many did – they were promptly arrested and sent to federal prisons. Some were jailed at Alcatraz and died there. And so these hardy eastern souls began educating the Hopi people about their rights under the constitution and they contacted the media about the federal abuse of children and their parents. The reaction to the news accounts of federal educational activities was predictable, people were outraged and so was the Federal Indian Agent, but for different reasons. Those reasons remain the same today.

The federal government doesn't want anyone to know how they abused the First People of this land but when the Federal Indian Agent tried to take federal control of this little group of non-Indian activists, he discovered that because there were no actual reservation boundaries, he had no legal federal jurisdiction over these individuals. He immediately contacted Washington DC and asked to have a federally recognised reservation. As soon as the lines were drawn he had the non-Indians thrown off his reservation. The US then sent a geological survey team out and they located coal on and around Black Mesa. Corporations representing international coal interests began their multi-million dollar song and dance with these federally recognised governments of the Hopi tribe and the Navajo Nation. This coal grab between the Navajo and Hopi politicians was the beginning of the Navajo-Hopi-US land dispute.

The traditionalists from both tribes immediately said no but their elected leaders said yes. The young people from both tribes backed up their elders. The federal government with the flag of these financial interests of coal lobbyists waving in front of them pushed the Navajo and Hopi politicians. That was in the early 1980s.

Navajo elders, male and female, and their children, marched on the Navajo Nation capital to save Black Mesa, an area where one of the country's richest coal deposits lay. The Navajo people opposed the strip-mining of coal, or the liver, of Black Mesa, a sacred female deity that blessed the land with rain. The Black Mesa coal, like the human liver, naturally distilled the water before it gathered into a giant aquifer under Black Mesa. This water has been identified as the purest of its kind but now it's being used to slurry the coal thousands of miles to Navajo coal fire generating stations in California.

But the Navajo elders and their young supporters, many of whom were arrested and jailed by the Navajo police, could not stop their politicians with the giant land-eating machines of Peabody Western Coal Company and the US.

New lines were drawn by the US. Navajos found themselves on Hopi partition lands and branded as illegal squatters. The fight between the governments of the Navajo Nation and the Hopi tribe over the multi-million dollar coal royalties escalated – and so did the resistance of the Navajo elders and their young supporters.

Today many of the Navajo elders have gone to live with the Creator and the young supporters are becoming elders. Of the hundreds of Navajo families that stood against the multi-million dollar coal corporation, the tribal governments of two Indian Nations and the United States government – only eight families are left to stand alone. But their number grows daily. Many Navajo families that signed a 75-year renewable lease with the Hopi Tribe that the US helped to create and some elected Navajo officials supported, are taking their names off the lease. The Navajo families who had signed the leases wanted to believe the promises of their leaders and those of the Hopi and US governments – that their signatures would bring an end to the land dispute; that they could legally mend broken windows, leaky roofs and patched walls of their homes; that they might even get a new house and more livestock – but the federal government and the Hopi Tribe recently announced through their federal arm, the Bureau of Indian Affairs, that Navajo families on Hopi partition land must reduce their livestock.

The land dispute continues.

MARLEY SHEBALA
Navajo/Zuni. *Journalist.*

WUKOKI – BIG HOUSE
A Wupatki Village

Site of Hopi migrations from Homolovi and Palatkwapi

Sonoran DESERT

MOTHER EARTH SPEAKS

from the album Once In A Red Moon

Verse

I shake I shout...from time to time...
But no attention...is paid to mind...
I fear for you...not just for me...
My heart beats on...why can't you see...

Chorus

Don't steal my thunder...Don't break my heart...
I'm your mother...hear my beating heart...
Hear my beating heart...

Verse

Rape the land...you rape your mother...
Take the poison...from all my water...
Cut the trees...down to my soul...
Strip my body...of all its oil...

Chorus

Don't steal my thunder...Don't break my heart...
I'm your mother...hear my beating heart...
Hear my beating heart...
Don't steal my thunder...Don't break my heart...
I'm your mother...hear my beating heart...
Hear my beating heart...

Haudenosaunee

JOANNE SHENANDOAH
Iroquois Confederacy: Oneida Nation.
Singer/Songwriter/Musician.

Moose CALF

108

Mule Deer FAWN

'. . . the sacred path to womanhood that recreates the story of Changing Woman and Apache creation . . .'

The *Naiiees*, the Sunrise Dance, is an Apache tradition that is passed down from generation to generation. The ceremony represents the initiation of an Apache girl from childhood into womanhood. The *Naiiees* is a four-day event that commences at dusk on the first day when the girl's Godmother dresses her; *Bi keh ihl ze*, 'She is dressed'.

To help her live until her hair turns gray, an eagle feather was pinned in Apryl's hair and on her forehead was placed an abalone shell pendant – the sign of Changing Woman, the mother of all the Apache people, whose spirit would empower Apryl during the Sunrise Ceremony.

Like all of those who have experienced the *Naiiees* before her, the sacred cane will help Apryl walk when she gets old and the feathers and ribbons that adorn it will give her a good disposition; the feathers to protect her from illness, the ribbons symbolizing the four cardinal directions, night and day, the earth and the sun.

APRYL & MEL CHATO
Western Apache/Navajo.

Changing Woman APRYL CHATO

Bitil tih – THE NIGHT BEFORE DANCE

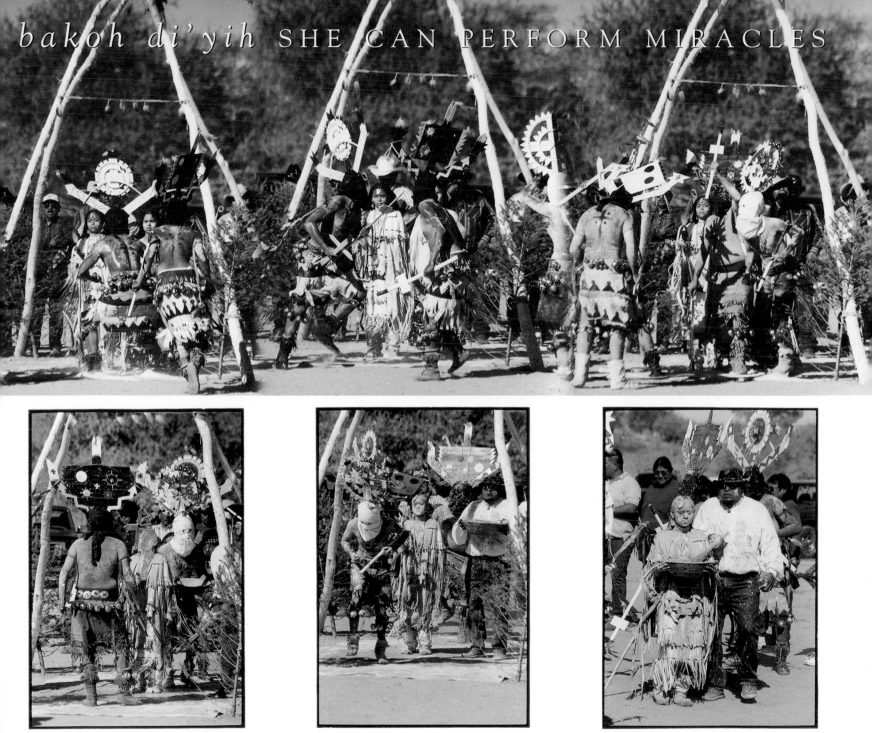

'As on the previous days, the third was guided by the di'yih, the medicine man. Just as it has always been for those who undertake the Sunrise Dance, on this day Apryl received the power of Changing Woman, bakoh di'yih, when she was painted from head to foot by the Crown Dancers and her Godfather with a mixture of pollen, corn meal and stones ground from four colors. With her Godfather and the Crown Dancers she blessed the people and they in turn blessed her.'

Lynx

Newe ehgish nemith
My People Live!

Desert BIGHORN

SHOSHONE

113

Bobcat KITTEN

We need to unite and stand strong to let the United States government know they must respect and adhere to the treaties. Treaties are the supreme law of the land. We've been imposed on by the introduction of the IRA government [Indian Reorganization Act]. The US implemented the IRA government as a means to conquer and divide the people. We are encouraging individuals to go back to traditional government. Let us revive a constitution of what our ancestors strove for. Let us find what it really means – As long as the grass grows and the water flows – These are not gifts from the US government. These are rights from the treaties.

We need to liberate ourselves. The time has come. Nelson Mandela freed his people in South Africa. Palestinians are redeeming their way of life. Russia is no longer the Soviet Union, and the Berlin Wall came down. Across the world there is evidence that the people's desire to be free can be accomplished. Our desire as Indigenous people in America is no less than any other nation's desire.

TIM LAME WOMAN
Northern Cheyenne. *Spokesman.*

Mule DEER

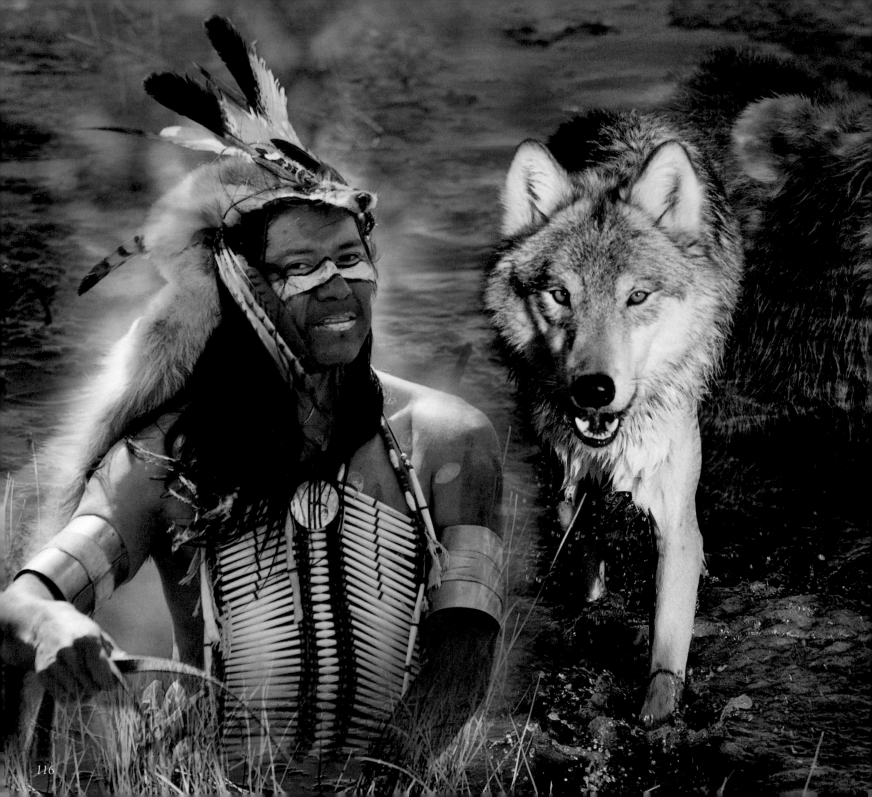

Ĭṣ ṣa wowonnĭẓĭ

Hotamitaniu

No Surrender

Dog Soldiers, Cheyenne.

Tsistsistas

All of our families should know the star knowledge and the seven sacred rites and the ceremonies, but lack of communication has brought our people a lack of identity and that causes these ceremonies and sacred sites to be abused. We need to do our sacred ceremonies to get back to values and respect and honor for sacred places. If we don't do this, there is already so much confusion and chaos we will see more of this where families shed tears and disasters happen.

The birth of the white buffalo calf let us know that we are at a crossroads – either return to balance or face global disaster. It is our duty to return to the sacred places and pray for world peace. If we don't do this, our children will suffer.

CHIEF ARVOL LOOKING HORSE
Mnikowoju Sioux. *Keeper of the Sacred White Buffalo Calf Pipe.*

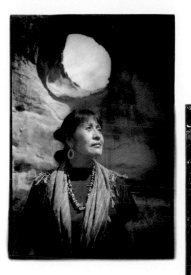
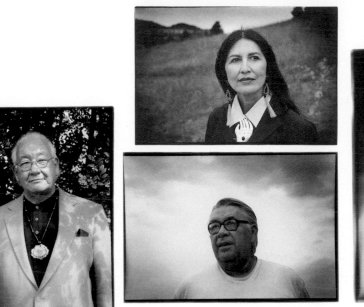
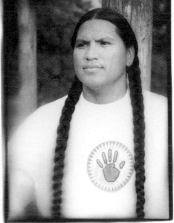

VISIONS FROM NATIVE AMERICA
Contributors

Top: *Marley Shebala Scott Momaday Charlotte Black Elk Vine Deloria, Jr Leslie Caye*
Bottom: *Alex White Plume Joanne Shenandoah Joy Harjo Arvol Looking Horse*

MARYANN ANDREAS was elected Tribal Chairwoman of the Morongo Band of Mission Indians in 1996. The extracts featured are taken from the speech she delivered to the General Assembly of the California Democratic Party in 1996, originally published in *Indian Country Today* (volume 15, issue 47) and reproduced by permission. She works tirelessly to ensure the sovereignty of her people and their gaming interests. The Morongo Band take their name from her great-grandfather, Captain John Morongo, who acted as the tribe's chief interpreter.

CHARLOTTE BLACK ELK is the great-granddaughter of revered Lakota Holy Man, Black Elk, whose life story was recorded by John G. Neihardt in *Black Elk Speaks*. An attorney at law by profession, she has both featured on, and contributed to, numerous documentaries and TV shows, the latter including the *Oprah Winfrey Show* and the former *Paha Sapa: The Struggle for the Black Hills*. She has engaged with the United Nations and in 1994 presented the Declaration of Vision to the general assembly of the World Parliament.

GREGG BOURLAND is Tribal Chairman of the Mnikowoju, Sihasapa, Oohenumpa and Itazipco Lakota people of the Cheyenne River Sioux Reservation located in South Dakota. An adept politician, he speaks passionately for the return of the Black Hills and for treaty rights to be honored. He was a regular contributor to *Indian Country Today* and the quote highlighted was originally published by the newspaper (volume 17, issue 27) and is reproduced by permission.

JOE CAMARILLO is the Marketing Director of the Gila Monsters ice hockey team in Tucson, Arizona. He has worked extensively in the hospitality industry throughout the southwestern states, attempting to balance the need for tourism with the preservation of Native traditions.

LESLIE CAYE has served as a host at the Confederated Salish and Kootenai tribes' excellent museum and cultural facility, The People's Center, located in Pablo, Montana. An accomplished scholar and historian, Leslie is a fine orator with the ability to explain complex historic events and contemporary issues involving not only the Salish, Kootenai and Pend d'Oreille peoples, but other Nations of the Northwest.

VINE DELORIA, JR is quite simply a living legend who has been in the vanguard of American Indian writers and scholars for some thirty years. He has held the position of Executive Director of the National Congress of American Indians and his presence is sought on countless advisory boards. He served as a professor at the University of Colorado, and is a practicing lawyer. The list of essential and highly influential books he has authored includes *Custer Died For Your Sins, God Is Red, Behind the Trail of Broken Treaties* and *Red Earth, White Lies*. *Spirit & Reason*, a collection of his writings, was published in 1999. The passage presented is reprinted with permission from *Red Earth, White Lies* by Vine Deloria, Jr. © 1997 Fulcrum Publishing, Inc., Colorado USA. All rights reserved.

AVIS LITTLE EAGLE is a Hunkpapa Lakota journalist from the Standing Rock Reservation. She is an active voice within the National Indian Media Association and was formerly the editor of *Indian Country Today* newspaper. The extracts featured are taken from her article 'Crazy Horse Mountain: A monument to exploitation', originally published in *Indian Country Today* (volume 17, issue 51).

TIM GIAGO is the president and publisher of *The Lakota Nation Journal* newspaper. Giago founded the *Lakota Times* in 1981 which subsequently developed into the broadsheet weekly *Indian Country Today*. Tim Giago's own column from the paper, 'Notes From Indian Country', became a mainstay in Native journalism and the popularity of the feature led to it being reproduced in numerous other non-Native journals. A compilation of Tim Giago's columns is available in a book of the same title. The extracts included here are from 'Notes From Indian Country', originally published in *Indian Country Today* (volume 17, issue 51) and reproduced by permission.

MARIO GONZALEZ is a notable figure in the legal battle for the return of the Black Hills and the Sioux Nation's land claims, filed as dockets 74-A and 74-B, the former being a 48-million acre claim to Aboriginal title land east and west of the Missouri river, the latter being a compensatory award for the illegal seizure of the Black Hills that has been rejected as the fight continues. On behalf of the Oglala Lakotas, he filed for an injunction at a critical point that prevented what could be described as a 'sell-out' the tribes neither sanctioned or condoned. The paragraph featured is from 'Why The Black Hills Are Sacred', originally published in *Indian Country Today* (volume 15, issue 36) and reproduced by permission.

JOY HARJO authored the best-selling volume of poetry, *The Woman Who Fell From The Sky* and, amongst other titles, her mesmerizing words grace the pages of *In Mad Love and War*, *She Had Some Horses* and *Secrets from the Center of the World*. She fronts and plays saxophone in the eclectic musical experience known as 'Joy Harjo and Poetic Justice', and in 1998 the band received the First Americans in the Arts Award for outstanding musical achievement. Her moving book of 'poetry and tales', *A Map to the Next World* was published in 2000. 'A Postcolonial Tale' is from *The Woman Who Fell From The Sky*. © 1994 by Joy Harjo. Reprinted by permission of W. W. Norton & Company, Inc.

SARAH JAMES is one of the most respected Gwich'in traditionalists and Native activists in the Western Hemisphere. A recipient of an American Land Conservation Award and an Emerging Leaders in a Changing World fellowship, Sarah was a founder of the Gwich'in Steering Committee and remains on the front line in the struggle to protect the Gwich'in, the Porcupine Caribou Herd and the Arctic National Wildlife Refuge from the ravages of oil exploration and drilling. www.alaska.net/-gwichin

ELSIE KAHN is a spiritual advisor and ceremonial leader from the Navajo Nation. Elsie dedicates her time to, and shares her gifts with, the Diné people. In addition to her commitments within the community, Elsie provides guidance to Native inmates and travels to penitentiaries to perform ceremonies.

BERNICE KAIGELAK is Inupiat from Nuiqsut village, Alaska. The people of Nuiqsut are fighting to preserve their subsistence hunting and fishing rights in the wake of oil company development and expansion. Bernice Kaigelak was quoted in *Indian Country Today* (July 21-28, '97) and her statement is reproduced by permission.

TIM LAME WOMAN is from the Northern Cheyenne reservation, located around Lame Deer, Montana. This powerful address was delivered during the Four Directions Walk for Unity in support of treaty rights. The gathering was also in remembrance of the Wounded Knee massacre, and for those who gave all in the occupation of 1973. Originally published in *Indian Country Today* (March 7, '96) it is reproduced by permission.

ARVOL LOOKING HORSE is the nineteenth generation Keeper of the sacred White Buffalo Calf Pipe, originally brought to the people of the Lakota, Dakota and Nakota Nations by the sacred White Buffalo Calf Woman, *Pte San Win*; with the pipe, *Pte San Win* brought the knowledge and inspiration for the Seven Sacred Rites. Arvol Looking Horse has led prayer ceremonies around the world, including in the Persian Gulf during the Gulf War and at the United Nations. Following the advice of the late Pete Catches and Chauncey Dupris, he promotes World Peace and Prayer Day, held annually on June 21.

RONNIE LUPE was Tribal Chairman of the White Mountain Apaches for over twenty years. One of the most respected figures in Indian Country, he was born and raised in Cibecue and played a major role in the preservation of Western Apache language and traditions during his tenure as Chairman. The observations he shares here are taken from 'Chairman's Corner', originally published in *Indian Country Today* (volume 16, issue 1) and reproduced by permission.

CHIEF WILMA MANKILLER became Principal Chief of the Cherokee Nation in 1985. The first woman to hold the office, in 1991 she won her third term with 82 per cent of the vote before standing down in 1995 due to ill health. Chief Mankiller was selected by President Clinton to represent Native American nations at a national economic summit in 1992 and her autobiography, *Mankiller, A Chief and Her People*, was published in 1993. A leader of exceptional ability and courage, the piece featured is © 1993 by Wilma Mankiller, from *Mankiller, A Chief and Her People*, reprinted by permission of St Martin's Press Incorporated.

ROBERT MIRABAL is a unique musical talent whose bold, innovative compositions are without category or restriction. 'Alter Native' is his own description of his latest work, *Music From a Painted Cave*, following on from the excellent *Mirabal*, *Taos Tales*, *Land*, *The Song Carrier* and *Warrior-Magician*. *Hope* is © Little Big Town Music/Yellow Aspen Cloud Music BMI/Sounds Like Music ASCAP, and is reproduced by permission. www.mirabal.com

N. SCOTT MOMADAY won the Pulitzer Prize for his novel, *House Made of Dawn*. A painter, poet, professor of English and playwright, his work continues to be an inspiration and few possess the gifts he shares in the pages of *House Made of Dawn*, *The Names*, *The Way to Rainy Mountain*. and the collection of passages, essays and stories appropriately entitled *The Man Made of Words*. The extract featured is from *The Way to Rainy Mountain* © 1969 by the University of New Mexico Press. Reprinted by permission. All rights reserved. Scott Momaday is the founder of the Buffalo Trust: www.sidecanyon.com/buffalotrust.htm

J. CARLOS PEINADO (J.C. White Shirt) played a leading role in the movie *The Broken Chain* opposite Eric Schweig, Pierce Brosnan and Wes Studi. Off camera he is the graphics/web-site manager for *Native Peoples Magazine*, a publication dedicated to the sensitive portrayal of the arts and lifeways of Native peoples of the Americas.

CHIEF OLIVER RED CLOUD is the grandson of the legendary Oglala Lakota chief, Red Cloud. A leader of the Oglala Lakota Oyate, Oliver Red Cloud fights to protect and preserve the traditional ways of his people and in doing so is a staunch opponent of those who seek to make profit by marketing sacred ceremonies to non-Natives. In the quote highlighted he was speaking against the 'Selling of the Sun Dance', originally published in *Indian Country Today* (Aug.4 – 11, '97) and reproduced by permission.

MARLEY SHEBALA is one of the longest serving and most respected Native news journalists. A features writer for the *Navajo Times*, Marley is the recipient of various awards, including honors from the Native American Journalists Association (NAJA). She has reported extensively upon the Big Mountain crisis and her powerful accounts provide invaluable documentation and insight into a continuing struggle that inexplicably evades the newsrooms of the national and international media.

JOANNE SHENANDOAH has been described as '. . . the most critically acclaimed Native American singer of her time' by the Associated Press. A Grammy nominee in 2001, she has received numerous awards, including several Native American Music Awards (NAMMYs), a 1997 Native American Women of Hope Award, and a Native American Woman's Recognition Award in 1996. A Wolf Clan member of the Oneida Nation, her natural name, TEK-YA-WHA-WHA, means 'She Sings', and her exquisite compositions blend time-honored Iroquois melodies with traditional and contemporary instrumentation around which her incredible voice is prayer. *Mother Earth Speaks* is © Joanne Shenandoah from the album *Once in a Red Moon*, reprinted by permission. www.joanneshenandoah.com

ALEX WHITE PLUME was born and raised around Wounded Knee Creek on the Oglala Lakota Nation. Guided by his parents and grandparents, Alex is a fluent speaker of the Lakota language and is dedicated to the preservation of traditional Lakota culture. He has successfully developed a breeding program for paint horses on the Pine Ridge Indian Reservation and has brought the buffalo back to the Wounded Knee/Manderson area of the reservation. A respected historian and storyteller, Alex's struggle with federal authorities over his OST (Oglala Sioux Tribal government) mandated initiative to harvest industrial grade hemp made international headlines in 2000 and 2001.

VOICES

A Collection of Interviews with

FLOYD RED CROW WESTERMAN
Dakota

APESANAHKWAT
Menominee

STEVE REEVIS
Blackfeet

FERN EASTMAN MATHIAS
Dakota

SONNY SKYHAWK
Lakota

ARIGON STARR
Kickapoo/Creek

LARRY SELLERS
Cherokee/Osage/Lakota

FLOYD RED CROW WESTERMAN

Born on the Sisseton-Wahpeton Dakota Nation in 1936, Floyd Red Crow Westerman has articulated through both his art and activism the reality of the Native struggle that for him began during infancy. As a child he was sent to the Wahpeton Indian Boarding School and it was there that he befriended Dennis Banks, an association that has continued to the present day. Through his no-frills approach and at times satirical but undiluted lyrics, Red Crow expressed day-to-day reservation living and the Indian experience as he performed his brand of country/folk around Denver in the late 1960s, while Banks carried the message into the political arena with the formation of the American Indian Movement (AIM). Red Crow's first album, *Custer Died For Your Sins*, effectively became the soundtrack to AIM's Resistance, a cause to which he has actively contributed since the *Mayflower II* protest on Thanksgiving, 1970. During the 1994 Edgewood Tribunal – something of a watershed within AIM – Red Crow supported Clyde and Vernon Bellecourt and the Banks-aligned AIM Grand Governing Council over the Russ Means oriented 'Autonomous AIM'. Since the release of *Custer Died For Your Sins*, Red Crow has written and performed with a host of prominent artists, including Joni Mitchell, Willie Nelson, Kris Kristofferson, Jackson Brown, Don Henley and Buffy Sainte-Marie. Even though he has made concert appearances throughout Europe, Central and South America, the US and Canada, he is still probably best known for his portrayal of 'Ten Bears' in *Dances With Wolves*, the highlight of an acting career that spans *Renegades*, Oliver Stone's *The Doors*, *Lakota Woman*, *Son of The Morning Star*, *Buffalo Girls*, *Broken Chain*, Sir Richard Attenborough's *Grey Owl*, and the TV shows *Dharma & Greg*, *The X-Files*, *Profiler*, *Walker–Texas Ranger*, *LA Law* and *Roseanne*. In the early 1990s Red Crow undertook a world tour with Sting and Raoni, Chief of the Kayapo Indian Nation on the Xingu River in the Amazon, to raise awareness and support for the Amazon Rain Forest Foundation Project. At the 1992 World Uranium Hearings in Salzburg, Austria, he gave a powerful address in which he called for the foundation of a United Indigenous Nations Council and for the denunciation of the Doctrine of Discovery and the 1823 *Johnson v. McIntosh* US Supreme Court ruling that legitimized it under US jurisprudence. With the foundation of the multi-media production company, Red Crow Productions, sister organization to his Eyapaha Institute, Red Crow continues to use his art and profile to raise awareness for 'Human Rights for Indigenous People'. In conjunction with Eyapaha and UCLA, he announced The Hoop of Life project in 2001, the first annual LA-based American Indian Film, Television and New Media Festival. *Exterminate Them! America's War On Indian Nations: The California Story*, an 82-minute documentary developed from the *Immaculate Deception* series, should showcase at a future festival. Red Crow serves as chairman of the board for the National Coalition on Racism in Sports & Media and as a goodwill ambassador for the International Indian Treaty Council (IITC), AIM's diplomatic affiliate and NGO with consultative status at the UN.

Visions and Voices from Native America

"I am a descendant of those who were hung in the greatest mass execution in American history at Mankato, Minnesota."

I am a Dakota and my people have been living in the lower Minnesota area for centuries. Before that we lived throughout all of northern Minnesota and into Wisconsin. We were the 'woodland' Dakotas and when the westward migration was forced upon the Ojibwas that forced us to move into southern Minnesota. The area of our land is still woodland in lower Minnesota. We live near what is known as the Sacred Pipestone Land Area and that is the only place in the world where you can find that pipestone. Oddly and strangely enough, at the site of Pipestone, Minnesota, there is a vortex that goes through the earth and comes out at Belfast, Ireland, so I have always felt a spiritual connection with the Irish people and the issues surrounding Northern Ireland. I am a descendant of those who were hung in the greatest mass execution in American history at Mankato, Minnesota.

"But every state had a militia and the Minnesota militia's first order was to find and kill Indians who would not accept confinement on the concentration camp reservations. They would hunt them down and get a thumb print or hand print off them and either kill them right there or confine them to the concentration camps."

The influx of Europeans coming into Minnesota and the advent and creation of statehood in the territory of my people made land the issue. My people were forced to make a decision to accept smaller land parcels with the understanding and treaty that since hunting had become limited and food was less plentiful to harvest the welfare of food and other provisions would be provided by the government as part of that treaty. As is still the case today, corrupt agents within the government would do anything in those days to enhance their own profit and pocket and they withheld those provisions from my people and created businesses right out there and forced the Indians to pay for what they got, contravening the treaty. At one point when the treaty stores were coming in and the people knew the warehouses were full, when they went to get their food supplies one of the traders

Floyd Red Crow Westerman

of the corrupt agent there said, 'If they are hungry let them eat grass or their own dung'. Well, that began the uprising and he was found with grass stuffed in his mouth. It was a very reluctant uprising. Little Crow reluctantly lead his people having at first said no because he thought the people could survive without the conflict. But because of the momentum that had already gathered in other parts of Dakota land he saw that he must. There were Indians who were married to and living with whites who protected whites during the uprising, they were Dakotas on the other side who felt obligated to protect certain families and so they too were reluctant to get involved. But every state had a militia and the Minnesota militia's first order was to find and kill Indians who would not accept confinement on the concentration camp reservations. They would hunt them down and get a thumb print or hand print off them and either kill them right there or confine them to the concentration camps. The uprising continued and went up the Minnesota river and it could have been a victorious situation but for the divisions and so the militia and army came in and suppressed the uprising.

". . . they marched them in freezing temperatures to Mankato and there are accounts of how white women poured boiling water on Dakota women and children as they went by and grabbed hold of babies and smashed them to death against walls."

They confined all the people involved in a stockade at Fort Snelling in the middle of winter and it was very hard, a lot of people died from influenza and the cold. It was at that time that President Lincoln was being pressured to hang all of the people and he ended up signing the order for the largest hanging in American history for the thirty-eight and in that random number there was even a blind man! Before they did it they marched them in freezing temperatures to Mankato and there are accounts of how white women poured boiling water on Dakota women and children as they went by and grabbed hold of babies and smashed them to death against walls. Those who did that were the area's early

day Lutherans. It is interesting to note that it was church people who ordered a lot of this treachery, supposedly people of God. People of the church lead this type of assault on Indian people and that is one of the ironies that has been hidden in history. Today those people claim their righteous place with God when in a sense they were the early day fascists. And of course, concentration camp life has continued for us.

"Today those people claim their righteous place with God when in a sense they were the early day fascists. And of course, concentration camp life has continued for us."

When Little Crow was killed out there in a field by some farmer his body was taken to town and dragged through the streets. Then they hung his remains in a doctor's office for many years as a skeletal exhibit and then his remains were claimed as an 'anthropological specimen' before the people fought to get them back. The whole issue of taking Indian remains as trophies is so morbid and to Indians the spirit world is so sacred that it's a complete violation of our rights when it's done and it continues to be an issue today. The reclamation of the remains of our ancestors is a battle that we need to win because there are millions of our people's remains in archaeology departments' drawers, cupboards and boxes in universities.

"Refusal over the sale of the Black Hills is the important thing although for some taking the money is already in the works."

The organization of the Dakotas, The Allies, is that the Dakotas were the parent group for the Lakotas and the *Oceti Sakowin* was created as a sacred unit of friendship and the Sacred Pipestone was at the center of it all. Ever since the story of the White Buffalo Calf Woman who brought the pipe it has been the cohesive structure for the Mdewakanton, the Santee, the Wahpetons and so on. We all have a commitment toward each other, we are considered the *Oyate*. Refusal over the sale of the Black Hills is the important thing although for some taking the money is already in the works. It doesn't make any difference

how much money they might get, or if we would get anything, or if we would ever get the land back, we should refuse it and that should be our position for all time. That way the land remains forever ours by broken treaty.

". . . we have a moral obligation over the United States of America and America will always live with this dark side to it. But if my people accept that, if other Indians who have signed treaties accept and sign their lands away, it will be the final steps toward the termination of Indian nations . . ."

In the Christian ethic, if you steal land – including by broken treaty – you have to pay for it, give it back or both! So that will always be the moral obligation. It is the moral obligation to the words of honor written in the treaty, 'as long as the grass will grow . . .'. Whatever the phrasing, we have a moral obligation over the United States of America and America will always live with this dark side to it. But if my people accept that, if other Indians who have signed treaties accept and sign their lands away, it will be the final steps toward the termination of Indian nations if we relinquish our right s to that land. By treaty, or by broken treaty, we still own the land and that's my contention and that of the American Indian Movement. The treaties were never honored so the contract is broken and any treaty signed at that level is above the Constitution, it is the law of the land, and to those among my people who say, 'I don't think we will ever get the land back', it doesn't make any difference – the land is still there, we should refuse any kind of offer and never sign, it was never agreed upon by the majority of people.

". . . if they signed they would get a few head of cattle each so that their families would survive but in signing you would also be coerced into becoming Christian . . . remembering that you couldn't even have a garden or be given a hoe without first submitting to Christianity. So that's how coercion and starvation became part of the illegality . . ."

There were just a few families who they were able to cajole into signing by use of

coercion and starvation. I'm producing a movie called *The Death of a Holy Man – Sitting Bull's Last Days* and we are going to show that. How when they would bring beef rations to the people at Standing Rock he would go down to the corrals where they were all lining up and the offer they were made was that if they signed they would get a few head of cattle each so that their families would survive but in signing you would also be coerced into becoming Christian – the Christian involvement through the church and missionaries was very strong there – and slowly people signed to become part of it, remembering that you couldn't even have a garden or be given a hoe without first submitting to Christianity. So that's how coercion and starvation became part of the illegality in the taking of our lands.

". . . a land swap deal for the parts of Spearfish Canyon that were in the last scenes of *Dances With Wolves*. That's the land that Costner had and made the swap for. He didn't say anything and he hasn't said anything about it since, he has not spoken of it or to the issue . . ."

First of all we helped Kevin [Costner] produce a great movie. It wasn't perfect but it was a great movie. And then, under the table, his family – his brother, mainly – were making a land deal for a land swap over land that is still in dispute at the federal level between the government and the Lakota people and the whole Sioux Nation. So he was violating the Lakotas by first of all making this deal with the state of South Dakota and the state was also violating the federal position the treaty dispute is in and the rights of all of the Sioux nations that lay claim to the Black Hills. Ours is a spiritual connection with the Black Hills and our contention is that even the federal government can't take that bond away from us and yet here was the state making a land swap deal for the parts of Spearfish Canyon that were in the last scenes of *Dances With Wolves*. That's the land that Costner had

and made the swap for. He didn't say anything and he hasn't said anything about it since, he has not spoken of it or to the issue. I once heard a spiritual leader talking about Kevin and he said that it seemed that his life had degenerated from the high fine places that he once used to hold. I think he was saying that, from the Indian point of view, it's the karma that Kevin doesn't speak to this issue that has set upon him and you know he could speak to it, he could say something about it, and I think that's my regret about where he stands with it all. There is a certain thing that is taking place here that is still playing itself out. It's not over yet, so you never know what Kevin might do with that.

"It's just another condition that is now re-emerging since Wounded Knee. These changes happen, just as they did in South Africa when the Bantu stance started to organize and the ANC developed and then the struggle began . . ."

To Indians, South Dakota is what Selma, Alabama is to blacks. Sometimes the racism is hidden and sometimes it is overt – we would rather have it in the open so we know where the governor is – but you will find throughout the western part of the state that they are the descendants of Custer's 7th cavalry and Governor Janklow is typical of those descendants. We know that it's just in those people to legislate the way they do and to have that attitude but we are learning to get involved in the local politics of South Dakota because the Indian vote will be sizable enough to block most anything in the state once we get organized. But so many Indian people are negative about that form of organization it restricts that possibility right now. It's just another condition that is now re-emerging since Wounded Knee. These changes happen, just as they did in South Africa when the Bantu stance started to organize and the ANC developed and then the struggle began against apartheid and white South Africa and it's the same here.

". . . it's just a matter of a small voice against a huge Goliath but our spark of life is stronger than America's longevity. But the indigenous voice in the world is coming together.'

It's a worldwide indigenous struggle that's going on and we all have a common voice and so we speak together in an international way and through the International Indian Treaty Council we make our declarations to the Human Rights Commission. We've been doing that for twenty years and it's just a matter of a small voice against a huge Goliath but our spark of life is stronger than America's longevity. But the indigenous voice in the world is coming together. The Indian voice from Central and South America, from Chile and Peru, the Maya, we are working together with the Sandinistas in trade pacts. We are trying to ignore the small voice of racism and listen to the larger voice of sovereignty and ever since we stole bingo from the Catholics we've been able to assert ourselves in different ways! Even though bingo and casinos are something of a negative force in and unto themselves. I think it remains a matter of asserting sovereignty in certain ways and making sure the foundations are in place for when the wind changes with the trend in casinos. And remember that it's only a handful of tribes who have casinos.

"My fear is that this whole right wing movement within the American government will seek to terminate Indians and take away sovereignty so we are at odds, we are in a pitched battle . . ."

We have to assert sovereignty. When you look at Clinton he says he is Indian – his mother is Indian – yet he is white in his actions. It is strange how corrupted a leader can be and yet still be supported. And Clinton definitely had to try and restore his own image all of the time. My fear is that this whole right wing movement within the American government will seek to terminate Indians and take away sovereignty so we are at odds, we are in a pitched battle to maintain our sovereignty. I think that while casinos helped to assert the word sovereignty the right wing are using Indian gaming as a popular term to convince white America that Indians don't need reservation lands anymore because they are

making so much money from casinos that they have become successful business entities and in reality that's not representative and it is just a way to justify termination. The important thing for them is to try and pull the land out from under us and their subtle move is to use the casinos as a smoke screen to get at the land.

"In 1973 we asserted the word sovereignty when we were about to be trampled over as road kill cultures of Manifest Destiny. But we asserted sovereignty at that time and condemned the churches as well as the government and we are going to re-establish that."

Indians are not well off! Very few make anything out of gaming. In 1973 we asserted the word sovereignty when we were about to be trampled over as road kill cultures of Manifest Destiny. But we asserted sovereignty at that time and condemned the churches as well as the government and we are going to re-establish that. We are going to condemn the churches for violation of their Ten Commandments. We are going to assert our sovereignty of our lands for all time, no matter how misled some of our leadership might be – some of our own leaders have become so Christianised they have been bought off – so we have some of our own people, the Christian Indians, who are a big stumbling block in our assertion of sovereignty. But there is a movement growing directed toward sovereignty and right now when the people at the grass roots level on reservations find out about corruption in their tribal governments they call upon AIM again. We are attending reservations where this occurs to arbitrate for the ordinary people – we are the arbitrators, not those wishing to spark confrontation. We went onto a reservation in Michigan where a tribal chairman had created his own little dynasty by controlling the millions of dollars that passed through their casino, he even had his own 'goons', but the people were left out of the benefits so they called AIM and we told him that he either had to come clean or he'd be spending time in prison . . . and he's in prison now.

"The Indian tradition of 'All My Relations', of prayer, of spiritual direction, that we exist for all of our relatives not for ourselves, that whole concept can be washed away when money is placed in front of some people . . ."

Money has started to corrupt some Indian people and that's the dark side of casinos. The Indian tradition of 'All My Relations', of prayer, of spiritual direction, that we exist for all of our relatives not for ourselves, that whole concept can be washed away when money is placed in front of some people and that's when it becomes corrupted. They start closing out their own families and hoarding whatever they can and limiting how far this could go to help the people when it should be the opposite. In all of the places where there are profitable casinos they should mass their millions and start investing, there is enough legality to keep track of how much anybody invests so turn it around and start investing by buying back the stolen lands. The Oniedas buy back several farms a month from casino profits and their land base is spreading now. That's what we need to do before it starts blowing in the wind because it's not going to last forever.

"Our spirituality is related to the land and that is why they have never acknowledged our spirituality because they have never wanted to give a full definition on that relationship because if they do then we lay claim to all of the land."

Sovereignty is part of our spirituality and nobody can take that away. Our spirituality is related to the land and that is why they have never acknowledged our spirituality because they have never wanted to give a full definition on that relationship because if they do then we lay claim to all of the land. That's a real hang-up for them, like the Peyote issue, where they call it a drug and we call it a power, and they don't know how to legally define that. At the same time we have spiritual connections to sacred areas, sacred sites, and our connections to those cannot be denied. If they made that law to acknowledge our spirituality as related to the land our reclamation would move so much faster but America doesn't want that because it would be such a positive thing for us. But we are moving in

Floyd Red Crow Westerman

that direction because we can go onto Federal Forest lands and hold our ceremonies in the old places where we used to. Every Indian nation in those areas should back their titles to those forest lands because they belong to them. In the seventies Senator Bradley introduced a bill stating that all of the land in the Black Hills should go back to the Lakota Nation as the only honorable way America could settle that issue. So all the unsettled National Forest lands would go back to their title and in a sense he was saying that we could run our own parks and then all of the other Indian nations could follow suit so eventually we would own all the National Park areas again in title because nobody is on them. We could run those parks and train our own park service people – that is an honorable way that America could come out of this with the many claims that we have that are all related spiritually to the land.

"Our issues stem from the spiritual strength of who we are, our spirituality, nothing else matters because we see in the long run that America is destined not to be a country for very long."

The issues brought up in the book *Custer Died For Your Sins* as well as the songs on my album of the same title are still the same, nothing has changed. Our problem with what has happened during the time between Vine's [Deloria Jnr] book and my album is that there has been a generation gap, there are a lot of young people who don't know those same issues. They are learning about sovereignty through casinos but they are not learning the sovereignty of land as related through spiritual rights because so many Indians have been Christianised that they have not gone back to their own ceremonies and their languages enough yet, although it's coming back and it is growing, but that's the center of the people – that's the center of who we are – the issue all stemmed from our spiritual right to the land. Our issues stem from the spiritual strength of who we are, our spirituality, nothing else matters because we see in the long run that America is destined not to be a country for very long. We are always observing America and we see from the words of a great prophet

and leader, Chief Seattle, when he wrote 'America your time of decay may be distant but it will surely come. Continue to contaminate your bed and you will one night suffocate in your own waste.' Now there is where America will decay. It's decay is within its cancer. America is dying. You cannot strip from the land, the Mother Earth. If they had lived to the Indian values of how to walk on the earth when Columbus came you could drink out of rivers today and that's the whole problem, that the white man has lost his instructions of how to live on the earth and we keep them.

"When the water of the earth, the life blood of all things, is polluted it will be as Chief Seattle said and that time is near. Our prophecies see the self-destruction of America so it's just a matter of time."

We have been oppressed and subjected to follow these ways and we are still in these economic concentration camps called reservations, so we are still in the belly of the beast, still talking to him. I read a statistic twenty years ago that said two in ten people have some form of cancer, and now it's three in nine people, a third of America has some form of cancer and it's heading towards being half very soon. Half of America will be dying of cancer. And cancer is not a disease, cancer is a pollution of the body and that's because of the pollution of the water. When the water of the earth, the life blood of all things, is polluted it will be as Chief Seattle said and that time is near. Our prophecies see the self-destruction of America so it's just a matter of time. I think within the next twenty years we will see a real tragic situation here in America and around the world because Europe and Britain are in the same boat and the *Titanic* is going down and it doesn't pay to shift the deck chairs on the *Titanic*.

"The more computers run and the faster they run and the greater the volume they handle the faster the resources of Mother Earth are chewed up and it all stems from water. Everything needs water to survive and so do corporations but they are polluting as they go along and it gets worse and worse."

Whatever they do now is unlikely to make any sense because they are heading in the wrong direction when corporate power is the only way that they can survive. This country as well as all the other industrial world countries live on a fine line of power called electricity and when that's out everything else is out. People will be dying and looking for food because all of that power isn't going to be there forever. However people might read that and however people might understand that America is in its own corrupted state, not only morally but physically, and that's where a lot people in this world are now, but America being the biggest country uses 60 per cent of the gross national product of the world so you can see who is eating it up. This high technological world looks resilient and successful but it's not, it's like Pac-man chewing it all up. The more computers run and the faster they run and the greater the volume they handle the faster the resources of Mother Earth are chewed up and it all stems from water. Everything needs water to survive and so do corporations but they are polluting as they go along and it gets worse and worse.

"America is a very young country, it has only been a country for a little over two hundred winters, but we've been here for fifty thousand winters so we know."

You can watch the issue of water. Watch the issue of air and how it's changing the world's atmosphere and the ozone layer, and it's all an environmental issue as far as Indians are concerned. We see the direction in this time we live in. America is a very young country, it has only been a country for a little over two hundred winters, but we've been here for fifty thousand winters so we know. We know what we have to hang on to and we know why. We have our instructions and they are what we live by.

APESANAHKWAT

One of the most telling statements Apesanahkwat made during his eight terms as Menominee Tribal Chairman came while testifying to the Senate Committee on Indian Affairs in May 1998. Responding to former Senator Slade Gorton's (R-WA) 'American Indian Equal Justice Act', proposed legislation that would have virtually abrogated tribal sovereign immunity, Apesanahkwat related Gorton's bill to House Concurrent Resolution 108, which facilitated the 1954 Menominee Termination Act. He demonstrated how Gorton's ideology was rooted in that of then termination proponent Senator Arthur Watkins, quoting Gorton's belief that 'no wrongs' had been 'committed against the Indian people who are living here now' and that Indians should 'get over' grievances of their 'great-great-grandfathers'. Apesanahkwat told the committee, "The reality, however, is that tribal sovereignty was recognized by the government of the Senator's great-great-grandparents, and is no more an anachronism than the sovereignty the United States achieved as a result of its separation from the British Empire". A Vietnam veteran, US Marine Buddy Apesanahkwat Chevalier had returned from combat to find that the ravages of termination had not diminished, despite the 1973 Menominee Restoration Act. "Loss of self government, land, economy and resources – these things were not all restored – leaving us in social, economic and cultural ruin. In 1975, armed with weapons, myself and 49 others seized the Alexian Brothers Novitiate in protest. Our cry was deed or death," he said of the 34-day siege in January 1975 when the Menominee Warrior Society, augmented by AIM, demanded improved social services and accountability of the interim-government. A hereditary Chief of the Eagle Clan, he first served on the Menominee Legislature in 1982, becoming Vice Chairman a year later, then Chairman in 1984. His latter administrations were dominated by the Kenosha Project and the controversy it engendered. In 1998 Apesanahkwat resurrected the off-reservation casino plan, claiming it was "the most important project the Tribe has ever undertaken". The 'Paradise Key Casino' would have become one of the largest Indian gaming operations, but regulator's concerns about investors, the clandestine nature of the compact between the tribe and the state signed by the then Governor of Wisconsin, Tommy Thompson, and revelations that associates of Thompson's who had lobbied for the casino might have shared in a $46.5 million windfall upon its completion, all contributed to the project's downfall. Governor Thompson was appointed US Secretary of Health and Human Services by George W. Bush and his successor, Governor Scott McCallum, rejected the off-reservation land-in-trust proposal and with it the casino. Upon leaving office, Apesanahkwat returned to acting, featuring in Chris Eyre's *Skinwalkers*. International audiences recognize him as the character Lester Haines from the TV series *Northern Exposure*, and he also starred in the Lou Diamond Phillips directed *Sioux City* and the formula western, *Stolen Women*.

Visions and Voices from Native America

"... I deal with everything from people who don't have food on the table and fuel oil for their homes, to multi-million dollar economic development ventures, to managing a four hundred person administration ..."

Traditional tribal government was always done by a unanimous consensus and now it's done by a majority vote of a city manager type structure where all the power is consolidated – whether it's five, nine, thirteen, or in some instances more, council members who make the decisions on behalf of the tribal membership. One of the traditional characteristics we retain is the general council wherein all the tribal membership can come to one major meeting a year and by a majority vote of the people they can mandate things of the elected council. In many respects you could call it another means of breaking up tribal identities, but it's more practical for today because we need our business done on a day-to-day basis as an integral part of a macro economic system, so we require a mechanism whereby we can make decisions and connect things very quickly. These days the tribal chairman is essentially the chief. As Chairman I'm the only full-time employee of the Tribal Council. I am the Chief Executive Officer and Head Administrator, so I deal with everything from people who don't have food on the table and fuel oil for their homes, to multi-million dollar economic development ventures, to managing a four hundred person administration. A chairman holds similar responsibilities to those of a chief, neither having omnipotent authority. He is governed by, and his power tempered by, the limits of a modern constitution as well as by the will of the tribal council. Chiefs similarly are governed by the majority will of the people and by the consensus of the various chiefs of each clan represented. For example, in our tribe we have five clans and each one has a chief and a sub-chief.

"The very nature of our culture would not allow for that.
While in other situations corruption is rampant and it's often in places that have severe poverty."

In some government structures corruption is something that is bred by the very nature of the structure of the administration establishment. In the Menominee's structure we have one of the most accountable administrations not only in Indian Country but in the United States and the world as a whole. There are so many checks and the politicians of the elected council members do not have direct access to money. Because influence cannot be

bought from council members since the majority of the council determines what policy and what ventures and whatever issues get to come before it, theoretically a businessman could come in and try to buy five of the nine council members to move an initiative but he would have to do it independently because each one of those council members when they actually came to table would know that those other council members had been bought off. The very nature of our culture would not allow for that. While in other situations corruption is rampant and it's often in places that have severe poverty. Some council members may have an inadequate understanding of a sophisticated modern system and be unaware of what's taken place so as a result corruption exists. In our administration it is virtually non-existent through vigilance and the integrity of the people who are elected.

"It's something that I hope will come to the attention of the international community – that throughout the world the United States government causes revolutions and creates upheaval in Third World countries under the guise of demanding democracy and yet they don't allow democracy to flourish here in this continent which is inhabited by over five hundred Nations."

Sovereignty is a concept that is inherent only in government and nations. It provides and establishes by its very nature the powers of government; the power to make internal regulations and the power to do commerce with other nations. There are many facets and elements and powers of sovereignty but in the case of Native American sovereigns, we are limited by an incongruous concept that the United States has imposed under the US constitution called 'plenary power'. Basically what it says is that the Congress of the United States has the plenary power to abrogate various attributes of sovereignty through their procedures by enacting laws of Congress but in doing so they are required also under their constitution to compensate the Nations. In that, the fifth amendment has whatever value they assess of that particular attribute of sovereignty they are abrogating. In my view, and I think in the eyes of the international community, this is a flagrant imposition of a colonial concept within a paternalistic mandate which does not recognise or fully acknowledge the sovereign power of indigenous nations as independent nations. We struggle with that because we work within the US government's infrastructure of jurisprudence which is premised on this broad concept of 'plenary power'. It's something that I hope will come to the attention of the international community – that throughout

the world the United States government causes revolutions and creates upheaval in Third World countries under the guise of demanding democracy and yet they don't allow democracy to flourish here in this continent which is inhabited by over five hundred Nations. States are given vested powers of government whereas tribes possess inherent powers that pre-date the constitution. But in the larger scheme of things, as this country sees it, there's the federal government and then there's tribal government, and then there are state governments and then of course colony and municipal governments – in that order! It's a flawed concept because it doesn't meld with the concept of free nations when we have a paternalist policy that says they can – at will – abrogate any attribute of sovereignty we exercise. There are moves to abrogate sovereignty in just about every state that has large populations of Indians who are embarking on gaming as an economic development venture. There are many states who are in essence extorting from tribe's sovereign abilities to regulate environmental issues and other civil regulatory issues and if tribes are foolish or stupid enough to acquiesce to these demands without seeking redress through the court and through legislative process then woe betide them and their leaders for not having the foresight and the tenacity to find other remedies.

"Termination was one of the most harmful policies ever conceived by Congress and fortunately it was repealed by President Nixon. We, the Menominee, were one of the tribes who were terminated."

Eisenhower's tenure of office and the entire 'Termination Policy' period was a very, very, very traumatic and very negative experiment in federal Indian policy. Basically, in essence, it subjugated Indian land and assets to state taxation, control and state regulation. Termination was one of the most harmful policies ever conceived by Congress and fortunately it was repealed by President Nixon. We, the Menominee, were one of the tribes who were terminated. Throughout my five terms as Chairman we have resolved many of the inadequacies of the restoration and termination era policies but we can never totally regain and recover what we've lost. I don't think there's anything that any administration has attempted to do, whether it stems through design, conspiracy or ignorance that could be as devastating as termination has been, although Senator Slade Gorton and others of his mind-set are doing their best to abrogate some of the more fundamental attributes of sovereignty such as sovereign identity and means testing and other things that would erode tribal powers.

Apesanahkwat

"We are trying desperately to develop our economies within Indian Country so that our people don't have to leave their homes because of the pressures imposed by federal policy."

There is a distinction between termination and the so called welfare reforms and programs. The real problem is that in Indian Country there exists no infrastructure for jobs. People with venture capital are not willing to put it into Indian Country because of sovereign immunity and any disputes arising from their ventures with tribes will not give them a venue for redress. We are attempting to devise mechanisms that will alleviate that problem. I think the event of welfare reform and the criteria of the J.O.B.S. program is going to bring some difficult transitions and Indians may be compelled to move into the urban areas to seek employment and that is one of the reasons why we are so aggressive with economic development and finding ways of keeping our people on the reservations. We are trying desperately to develop our economies within Indian Country so that our people don't have to leave their homes because of the pressures imposed by federal policy. What's going to happen is the tribes are going to inherit the responsibility and the liability of providing social programming without having the revenues to do it.

"Because there's so much poverty in Indian Country, some tribes have gone to agreeing to put hazardous and nuclear waste on their reservations unbeknownst to the dangers . . ."

There are so many stringent laws within the various states on regulating hazardous and nuclear waste and it's because of the congressional mandate of the Environmental Protection Agency. That agency has no jurisdiction and no ability to develop environmental control in Indian Country. Now this a very critical area that I am very active in. We are developing programs within the EPA that provide infrastructure and technological assistance and financial assistance to tribes to develop economic initiatives comparable to states that regulate. Because there's so much poverty in Indian Country, some tribes have gone to agreeing to put hazardous and nuclear waste on their reservations unbeknownst to the dangers of that sort of thing. I sat on a national commission that is wholly dedicated to bringing environmental protection to Indian Country and developing the wherewithal to do that.

". . . the treatment of Native Americans in the intercontinental US is one of disgrace . . . Indians try to escape that reality and the conditions they're forced to live in and for many the only route they find that can make that happen is alcohol."

There are people who go to bed hungry and there are people who could potentially freeze to death in the winters – in fact there are those who do freeze to death in the remote areas. The history of the treatment of Native Americans in the intercontinental US is one of disgrace and is one that the American people have a real problem getting to grips with. Indians try to escape that reality and the conditions they're forced to live in and for many the only route they find that can make that happen is alcohol. And while that's temporary and it's more devastating than it is helpful, it does give them a few hours per day of escaping the reality that they are forced to endure. It's incredible to me that there are Indian people who do not know why it is that they find relief and solace in the bottle and they do it almost as if there were no tomorrow or they couldn't care less about today – and that speaks of the condition they're in. Everything from cultural emasculation, to being regarded as useless parents, to being any other thing you could conceive that is compared to the middle-class American white picket fence, two-cars in the garage and comfortable home lifestyle that they would never achieve. It goes right to self-esteem. It goes to self-worth. It goes right into why we have the largest suicide rate of any other race. All of those factors are attributed directly to the social conditions in which we live. We've attempted to counter those problems by maintaining 247,000 acres of virgin forest from which we've been able to harvest timber on a sustained eco principle and not rape the earth but still maintain a workforce for our people. And we've also developed a casino – in fact we were one of the first tribes in the country to develop a casino some twelve years ago – that has provided us with a lot of our dollars for social programming as well as jobs. So we've been fortunate that our leaders looked out for what we were doing and we continue that legacy today.

"Things have changed in that we have become sophisticated enough to tell the Christian missionaries to get the hell out of Indian Country and that we don't believe what they're saying."

There's been much made of the Freedom of Religion Act but in my experience people practiced their spirituality regardless. If a person believes in traditional ways they

Apesanahkwat

don't have to do it publicly. Certainly the days when the cavalry rode in and shot and killed people for practising their beliefs are gone. Things have changed in that we have become sophisticated enough to tell the Christian missionaries to get the hell out of Indian Country and that we don't believe what they're saying. So things have changed by evolution and familiarity and reality itself has changed and Freedom of Religion really has had no impact on anyone other than those who are imprisoned and are still prohibited from practising various forms of Native religion. I always say that if you really believe in the way of the Creator you don't have to have a church, you don't have to have a ceremony – you can talk to Him right here and right now.

". . . I see that the American young men, the 100,000 who died in Vietnam, died because of economic aggression. They died because the powers that be in this country killed them . . . I still respect veterans who are not part of that – who were used and exploited and who thought they were doing an honourable thing. I also respect those young men who had the fortitude to say no and went to Canada. They were probably braver than we were – we who went and took lives and had our lives taken . . ."

I fought for the US in Vietnam which is a paradox, but I can tell you that if today the United States started a war someplace I'd tell them to go to hell! I wouldn't go. I have to say that the propaganda at the time was very, very compelling. It had Native people believe that we were being invaded by communists – though we had no real understanding of what communism was – and we believed we were protecting the freedom and right that we've always had as Indian people within Indian Country, which is one of the reasons why I went. I believed that until I went to Vietnam and our 'Kit Carson's Scout', a captured North Vietnamese regular who turned into our scout, asked me, 'Chief, what are you doing here in Vietnam anyway? You know they took your country and now they're over here raising hell with us'. I was appalled by his question and really angry with it until he said, 'Look around here. Where do you see a national government? Where do you see a local government? Where do you see a presence of any government?' And it was then that I began to ask questions and look at the reality and in retrospect I see that the American young men, the 100,000 who died in Vietnam, died because of economic aggression. They died because the powers that be in this country killed them. They are the ones that sent

them into battle, exploiting their youth and their fortitude, their naivete, their masculinity, and every virtue that young men of eighteen, nineteen, twenty, twenty-one years of age have – including their patriotism and their love for their country. They exploited that for economic reasons. I fully understand that and I still respect veterans who are not part of that – who were used and exploited and who thought they were doing an honourable thing. I also respect those young men who had the fortitude to say no and went to Canada. They were probably braver than we were – we who went and took lives and had our lives taken and threatened. I think we are a nation of Indian people who now fully understand the enemy. We now fully understand the nature of capitalism and its dangers. We fully understand the corruption of national government. We fully understand the legacy of colonialism and what it seeks to do in those underdeveloped countries that don't know any better. So we're better prepared today than we've ever been in terms of repelling propaganda. Propaganda is no longer an effective mode of brain washing – because we've been there.

". . . the fact that this country is dominated by non-Indian people is not because we were defeated in war and not for any other reason than the religious and philosophical belief that the Creator intended us to share this with other living beings . . ."

One of the things that was painfully apparent to me in Vietnam was that it was just a big reservation and we were part of the military police, comparable to the old Indian police that the army caused to sell their people out. Hollywood has so maligned and mischaracterized my people as a culture that the American people are confused and are afraid of Indian people. They don't know who we are. We are the most peaceful people on earth and we love life with all the fervour of any other of our relatives placed here by the Creator, but we have also tasted the violence and the tenacity and the viciousness of a wounded people. Even in the most vicious times, our culture tempered wanton violence and unwarranted cruelty to other living entities but Hollywood disregards that and shows us in another light and it's for that reason that I became an actor. I want the American people, and indeed the international community, to know who we really are as a people and what we really believe. The criteria for my participation in any movie is that it must have a degree of accuracy, or they will at least permit me to advise on accuracy where necessary.

Apesanahkwat

If it can't be that way then I'm not going to do it. The fact that this country is dominated by non-Indian people is not because we were defeated in war and not for any other reason than the religious and philosophical belief that the Creator intended us to share this with other living beings and that's what we did and we were exploited for that and it was taken as a weakness. We were cheated and as the 'progression' moved forward we were cheated by unscrupulous and crooked emissaries of government. We never had this country wrested from us. We shared it with the Europeans who came here in search of freedom from the oppression that the old guard of ancient Europe oppressed upon them. They learned that oppression very well. They imposed it over here and it was too late when we realised what was happening. Today we live in the aftermath of that.

". . . we acknowledge that all races of man are all relatives and that we're all children of one Creator. The lashing out at the whiteman is not intentionally meant to infer a verbatim characteristic of all white people – rather it speaks of the frustration toward a government that has done what it has to the Native American."

I believe the biggest problems facing Native Americans today are probably drugs, alcohol, gang violence and the corruption of the family unit – the corruption of society. The decadence of humanity is as intoxicating and alluring as any other evil that has visited us. Frankly, I don't know what the solution is but I think awareness is the beginning of how to deal with it and you need examples to illustrate why and examples have to happen on both sides. If I had the opportunity to make only one point that is important I'd just want other people to know that Native American people are very holy people – we acknowledge that all races of man are all relatives and that we're all children of one Creator. The lashing out at the whiteman is not intentionally meant to infer a verbatim characteristic of all white people – rather it speaks of the frustration toward a government that has done what it has to the Native American. But because we're resilient and because we're a spiritual people we have the capacity to forgive. I'm encouraged that the Creator has a reason for everything that has occurred and to all those things there will be an end and a time when retribution and reconciliation and responsibility will culminate in a greater understanding; far beyond what we as people could ever give or receive from writings, speeches, films or most anything else, because we live in a society that doesn't hear. So we do the best we can to survive as we can now.

STEVE REEVIS

Hired by Pierre Choteau, Louis Rivet arrived in Blackfeet territory circa 1829 and made his living and reputation as a trapper and interpreter at Fort Benton. The son of a French-Canadian, Rivet was multilingual, an ability that allowed him to negotiate both trade and passage with the Lakota Sioux, Blackfeet, Cree and Gros Ventre. The skill wasn't lost on the territory's indigenous landlords who called him 'Gros Ventre Talker' in the days that followed his marriage to a Gros Ventre woman, and ultimately Rivet boasted as many wives as he did languages. Over time, the Rivet name was adapted to Reevey and then Reevis, resulting in a son of Louis's being known to some as Charlie Reevis and others as Crow Chief, the boy being raised by the Big Nose people of his Blackfeet mother. "You should never forget where you came from", says Steve Reevis of the legacy of his great-great-grandfather, Louis Rivet, and his great-grandfather, Crow Chief. Recognized internationally for his roles in *Dances With Wolves*, *Wild Bill*, *The Doors* and *Fargo*, and his portrayals of Chato in *Geronimo, An American Legend* and Yellow Wolf in *Last of the Dogmen*, few could accuse Steve Reevis of forgetting where he came from or of being a 'Hollywood Indian'. With his siblings, he grew up on the Blackfeet Nation surrounded by poverty and commodity food amidst the social and economic conditions that continue to cripple the reservation today. However, in common with many on the Blackfeet and other reservations, the tenacity of his relatives – particularly the strength of his mother, Lila – pulled the family through. "We were dirt poor", he reflects. "And it is still really a Third World situation for the Blackfeet and many of our Indian people." He attended boarding school in Flandreau, South Dakota before progressing to Haskell where he equated basketball, and not acting, with ambition. It wasn't until the crew for the movie *War Party* set up their pre-production operation around the Blackfeet Nation that a career in Hollywood became a possibility for Steve Reevis. His father, the inimitable Lloyd 'Curly' Reevis, appeared in *War Party*, as did Steve who, after accompanying his brother to an audition, was employed as a stunt double. The experience provided him with the impetus to pursue whatever opportunities might be available in the movie industry, but he still took a piece of the reservation with him to Hollywood, his 1971 Ford Torino becoming his mobile home on Sunset Boulevard. Following *Dances With Wolves* he upgraded to a van in which he and other aspiring Native actors lived until bigger paydays. Between movies he undertook commercial assignments, including the Guess Jeans campaign with the first Native American 'Supermodel', Jackie Old Coyote. In addition to appearing in high-profile movies, Steve played He Dog in the TNT feature *Crazy Horse* and Freddie in the thoughtful Peter Bratt movie, *Follow Me Home*. Despite being perceived as a celebrity and recognized as the indigenous face of 'Census 2000', he has truly never forgotten where he came from and he continues to be a familiar figure in Browning, Montana.

Visions and Voices from Native America

". . . today a large percentage of Indian people are struggling just to make ends meet. Struggling so much that sometimes they can't even recognize hope. Sometimes there aren't even dreams . . ."

As a young boy I grew up on the Blackfeet reservation located around Browning, Montana, where my mother raised us five children. My eldest sister was raised by my grandmother but the conditions were still hard financially. From my own experiences of living on the reservation I can say that there's not a whole lot of financial stability, particularly because of the lack of work and severely limited employment opportunities. On the reservation you have to supplement whatever income you have with commodities but in reality commodities from the government aren't a good source of food but for a lot of families there is no other option. Of course, you have the alcohol that also goes with that and alcohol is a really big problem on the reservations. I don't know exactly when it was introduced to the Indian people but I know that as the reservation system was established on a set foundation and those areas became recognised as 'reservations', then alcohol became much more of a problem for Indian people. Along with alcohol comes spouse and child abuse, many forms of neglect and a lot of other negatives that arise with alcohol and poverty. A lot of times when non-Natives think of Indian people they will think of the 'savage' movie stereotype, and even if they know that's not true through study they will still think of us in the old days when our people lived free and in harmony with Mother Earth. But in reality, today, a large percentage of Indian people are struggling just to make ends meet. Struggling so much that sometimes they can't even recognize hope. Sometimes there aren't even dreams of maybe being a lawyer or a doctor. Sometimes even that kind of thinking is beyond Indian people who live on reservations.

". . . growing up there I watched my uncles, my cousins, my dad and other men drinking and so that's what I did. I just followed suit. When that happens you get stuck in a place where you think that it's the norm and that's what I thought until I was able to break free . . ."

Steve Reevis

Personally, the way I see it, is that alcohol has been within our Indian people for three or four generations, maybe even longer than that among some tribes, and when you get alcohol within the family system, especially among the male gender, then it becomes a major problem. As a boy my role models weren't Indian people. I used to play basketball so they were usually NBA players because growing up there I watched my uncles, my cousins, my dad and other men drinking and so that's what I did. I just followed suit. When that happens you get stuck in a place where you think that it's the norm and that's what I thought until I was able to break free from that mind frame. Because alcohol is in a family structure for some generations it is easy to fall into those habits. Leaving the reservation helped me. I was able to look back and see what I was doing and what a lot of other people were doing there. For me that was a lot of partying and a lot of drinking pretty much every weekend but I had to get off the reservation to see what I would call the outside world and to see the opportunity I had to make something out of my life. From experiencing the outside world I was able to see more clearly how I had been living my life on the reservation. Where I live now there isn't really any problem with alcohol so I'm not around it, where as if I was on the reservation I would probably still be around it. Also, you have a choice. Everybody has a choice and when I go back to the reservation I choose not to party around. I have four children and it's just not a part of my lifestyle anymore.

". . . when I went back to what the Blackfeet people call the 'Pipe Life', which is our spiritual way of life, my eyes started to open up and I realized how for years we had been subjugated and forced to accept different things that were totally against our natural way of thinking."

I wasn't really a part of the era when traditional Indian spirituality was denied us. By the time I was born it was still there and it still hung over our heads but not so much as in the days of my mother and my grandmother. Those years were the times of the missions and as the missions came in they tried to turn everybody into a Christian or a Catholic or

whatever denomination was there and so our people really had a tough time of it. They weren't even allowed to speak their own language. My gram became pretty much a devout Catholic and so did my mother, so of course my brothers and sisters and I were raised in the Catholic Church. Because of that I never really understood or knew about what the government and different churches had done to Indian people by denying us our own spirituality. It wasn't until later, in my early twenties, when I went back to what the Blackfeet people call the 'Pipe Life', which is our spiritual way of life, that my eyes started to open up and I realized how for years we had been subjugated and forced to accept different things that were totally against our natural way of thinking. When I came to that realization it was pretty much the time of religious freedom and so I never had to go through too much of that but I know from being told that it was very hard on all Indian people. Not being able to speak our languages, not being able to follow our traditions and spirituality, basically just not being allowed to be Indian people. From the stories I have heard, they felt that they had to become something totally alien and to follow something that really didn't connect with them as human beings. I really have to say that I have good feelings for, and think a lot in a good way about, my ancestors, who did have to go through that and who sacrificed their lives in many different ways – either by being killed or by alcohol or by being put in missions – and to this day the fact that we still have a lot of our spirituality intact means that I have to feel good about my ancestors and thank the Creator that they were as strong as they were to go through all of that.

> **". . . this is part of the trouble we run into when there are legal battles**
> **over land. In a lot of situations, when Native peoples are involved,**
> **it seems that the federal government can just change something**
> **in the structure of their words within a particular law that will**
> **override the Native people."**

Although there are other mountains around our area that are sacred to us, Chief Mountain is pretty much the most prominent sacred mountain the Blackfeet have. Chief

Mountain is the place where a lot of the people from the Blackfeet Confederacy go to fast and to seek out spiritual visions from the Creator through the Grandfathers and the Grandmothers in the Spirit World. Our people hold that mountain to be sacred and it is a very powerful place for us.

I have heard that there are non-Native and non-Blackfeet people who also go up there to fast.

I could be wrong but I think part of the mountain is on our reservation so within my own family we haven't experienced any problems in getting up there, despite Glacier National Park, but I have heard of other problems from the treaty over Glacier National Park. I'm not sure what's happening with our claim to harvest timber there in the eastern portion of Glacier but at least on the foothills of the Rockies we are able to cut timber because that's on our reservation. I have heard that we should have access to Glacier National Park, or at least part of it, and the legal battle is not just over our right to harvest timber but also our hunting and fishing rights. Of course, this is part of the trouble we run into when there are legal battles over land. In a lot of situations, when Native peoples are involved, it seems that the federal government can change something in the structure of their words within a particular law that will override the Native people. I've heard that time and again, and it's very frustrating for me as an Indian person to hear all of these instances and that these situations are still occurring today. I can see that making it a National Park up there that they now call Glacier may have been enough justification for them to override the treaty but it wasn't justifiable to us. To us that was land that we inhabited and that we feel we have a right to, even today. So for me it's a hard and frustrating thing to hear over and over, and I know for me personally it is time to become more involved to see if I can help in any way on that side of things. A little ways back they were trying to obstruct our rights to the water that runs through the reservation. I heard a story that a lot of the farmers on the eastern side of our reservation were suffering because of that. Again, as I see it, it seems that they want to take all or most of our water rights from us and the way we look at

it is 'Jeez! We've been pushed to just a small part of what was originally our reservation and yet you're still trying to take things from us'.

". . . my relatives stretch from the tip of Chile to the tip of Alaska. All of the Indian people throughout this western continent are my relatives and in Mexico and further south they are still killing the women and children over land."

People need to hear our side because there are so many atrocities still happening today. I speak to Native youth quite a bit, and sometimes to adults, and I always say to them that my relatives stretch from the tip of Chile to the tip of Alaska. All of the Indian people throughout this western continent are my relatives and in Mexico and further south they are still killing the women and children over land. I always have to mention this to my Indian people because there has to be a point where all of this stops. And I know that some of us have to become more aware and sophisticated in our understanding of international and domestic law because that's the only way we are going to be able to contest a lot of the battles that are going on. There are non-Natives who realize what we have gone through, and are still going through, and they are trying to help us. To me that has to be good because in the whole scope of things, in time, when people look back at us as Indian people, they are going to realize that what we were about, and what some of us are still about, will help change this world to a more harmonious place, but right now people just overlook us and think of the movie stereotypes. They don't see a different side – the true side.

"People still think that it's all about the star spangled banner and all of the glory but in reality it isn't and wasn't. There was a lot of destruction and a lot of innocent lives taken."

It's still a struggle over here and it's still difficult for us to be able to truly say what we need to say. It's difficult for us because people are still turning away from the truth and to me the truth has to come out because when a country is based upon lies in its history

Steve Reevis

books then that country is always going to be screwed up. Until the truth fully comes out as to how this country was actually taken then it's always going to be that way. Until that time comes, when people start realizing and listening, then I think a lot of people will start looking inside of themselves instead of looking at the government. Then they will start thinking for themselves and start seeking the truth for themselves. But it hasn't come to that point yet. People still think that it's all about the star spangled banner and all of the glory but in reality it isn't and wasn't. There was a lot of destruction and a lot of innocent lives taken. A lot of times if an Indian person says these things then non-Indians just turn away and say that we are always complaining. But there are some who realize and will listen and it's always encouraging when you find non-Indian people who you can talk openly with about what our people have been through and are going through.

"... it's a hard thing to see how Indian spirituality has been dragged out there and abused like it has been and I really don't agree with it. It's a down trodden thing and those that do it are just pulling us down. Their intentions are all self motivated and that's where ego comes in, and that ego comes into play with a lot of the Wannabes ..."

Of course there are the Wannabes but there are also those who have some Indian blood in them and those particular individuals seem to be very sincere in going to reservations and spending time. You can tell those that aren't sincere because when they go to reservations and they realize what it's all about they turn away because their thoughts are based upon the romanticism of Native people. But there are those who spend time around Native people and try to get the best insight they can for their own personal lives and don't step over any lines of spirituality that might be disrespectful to Native people. As far as actual Wannabes are concerned, they have to appreciate that it's not a good thing and realize how we look at spirituality and that it's not 'convenient'. It's not something that we just do on a weekend or that we do for show amongst the outside world. It's truly one

on one with the Creator and a lot of times out there people don't realize what the Creator is about and they don't sincerely give of themselves and seek the Creator's guidance. I think in time those that are sincere, not the Wannabes, may be able to help open some doors for Native peoples and help us to share our spirituality with the world and help people to understand the harmony of the Creator and how we are supposed to live in harmony with each other. I see a lot of non-Natives drawn to our spirituality who are actually opening up their minds and looking inside themselves but of course their are still a lot who just don't understand and I really don't know how or what they think, it's kind of crazy to me! I'm never one to be confrontational with people and when they come up to me and ask me some crazy things I try to tell them in the kindest possible way about Native people, but it's a hard thing to see how Indian spirituality has been dragged out there and abused like it has been and I really don't agree with it. It's a down trodden thing and those that do it are just pulling us down. Their intentions are all self motivated and that's where ego comes in, and that ego comes into play with a lot of the Wannabes. They have that desire for leadership, 'Look at me, I'm a leader. I'll set up a sweat and you can pay me *x*-amount of dollars and I'll perform a ceremony for you', and in reality they won't know anything about ceremonies and they probably won't even know anything about themselves. They've probably never looked at themselves enough. If you're asking for money in a spiritual situation then you really have to start looking at yourself. You can't buy a prayer. As far as people up there around Browning who I'm around in the 'Pipe Life', you never see them asking for money and most of them don't have high incomes – most just get by – but you will never see them asking for money for the spiritual gift that was given to them by the Creator. People have to realize that these spiritual gifts have been given to Native people by the Creator solely so that we can understand the Creator's plan for us and the earth and it has nothing to do with money.

"If they become so enchanted with Indian people because of a movie, like
***Last Of The Dogmen*, then they should go and find out about Indian people because that**
was just a movie!"

Steve Reevis

I'd like to tell the Wannabes to look inside themselves and at their own history, and find out about their own people. If they become so enchanted with Indian people because of a movie, like *Last Of The Dogmen*, then they should go and find out about Indian people because that was just a movie! It was a good movie, a movie that made you feel good because it was like 'What if? What if those people still lived like that?' And that was beautiful because you saw the harmony that those people had. But now I would tell others that it's not like that. It's not like *Last Of The Dogmen* for Indian people today, so go and find out how Indian people have to live today because there are still atrocities and a lot of hardships that Indian people have to endure. The reality for Indian people is that we have struggled since the coming of the white man, so look at us and realize what has happened to us. It's all good and fine in a movie but that's not the reality of life.

". . . when I'm involved that's the struggle I go through because I'm dealing with people whose bottom line is money but the bottom line for me is my Indian people."

I've been on movie sets where we've had to tell them that 'This isn't the way we dressed' or 'This isn't the way we spoke or how we would speak to each other', there are a lot of difficulties. In Hollywood it's difficult in terms of getting them to do the ground work – in trying to get the right wardrobe, trying to get the right consultants – and even after doing that are they able to let their egos go and listen to Indian people if they are making a movie about Indian people? A lot of times some will listen to a certain extent but won't fully go with the Indian side because they feel they know enough to make a movie. Most of the time I think it's just about the dollar and not so much about the people. The bottom line is always the almighty dollar. So as far as I'm concerned, when I'm involved, that's the struggle I go through because I'm dealing with people whose bottom line is money but the bottom line for me is my Indian people. I've been on movie sets when it's been tough but I've always told them my side of it if there has been something that was wrong. And I've

Steve Reevis

felt that I needed to because it's not only on my head, it's wrong for our people, and those things keep perpetuating the half truths and untruths about our people for the sake of money. There has to come a time when we start making our own films, or somebody who is totally open minded will come in and support us, so that we can have the truth out there. There are a lot of documentaries made but there aren't any feature films that are solely Native at the high end of it, the forty-million-dollar movies. I'd like to see more Native people writing and producing work like the film *Smoke Signals* that won a couple of awards at the Sundance Film Festival. That's a good Native film, based on a story from a book by Sherman Alexie who is a good Native writer. I don't know if it will always be set up the way it is now but the way it feels is that it will always be 'Hollywood' until we, as Native artists, can redress the balance of power. It's difficult to be involved with movies that depict Native people unless they are really sincere about listening to Native people.

"A lot of them don't look into the past and will walk away from the theatre and think that it was only a movie so somehow we have to communicate that this is actually recent history."

The majority of people who go to the movies get so wrapped up in the film that they don't realize that what they are looking at is often portraying something that only happened to us about one hundred or so years back, and although a lot of the beauty and harmony among our Indian people was still there so were the atrocities and often that's forgotten. A lot of them don't look into the past and will walk away from the theatre and think that it was only a movie so somehow we have to communicate that this is actually recent history. I don't know how many Native people are out there writing but just from the Blackfeet perspective, stories like the Baker Massacre and the Starvation Winter of the 1880s need to be told because I think doing so is all a part of education that every one of us needs in order to start moving in a more positive direction in this world. People just don't realize that these atrocities were very recent and in some places are still going on. So many things need to come to light. Like the FBI – how powerful they are and how much power they were able

to obtain because people were just prepared to follow and not see for themselves and being unwilling to investigate for themselves. People are still prepared to rely upon the media which, of course, covers up all kinds of things. A friend of mine who is Indian was going to go into the FBI and I remember teasing him about it, about the way the FBI has treated Indian people. And after I got through teasing him I said, "Well, maybe you're going to be the one who can get in there and start changing some of their minds", but he didn't. In the end he didn't join the FBI.

"I believe that we have to come together as Indian people with one voice. Although we have diversity among us as peoples the problems we face are pretty much the same and we are all confronted by similar issues."

I think the biggest misconceptions come from movies that have either portrayed us as savages or romanticized us. It's easy for non-Indian people to see us that way and put us in the past and keep us there so they don't have to deal with us and realize that we are here today. All the information about us, and all the media, has never really come from our own mouths and because of that we are perceived to be all of these things that we are truly not. We are human beings that are on this earth who have endured terrible times and are still having a hard time. We have major problems with alcoholism and drug abuse. We have a high suicide rate, particularly among our youth, and a low life expectancy generally that is below the average, but people are not aware of these things. The biggest challenge facing us is the government because every time we try to do something positive for ourselves it appears that the government tries to pull us down and stops us from progressing and changing our situation, so the US public are not confronted with the reality of the past or the present. Until that is corrected we will always get the short end of the stick. I believe that we have to come together as Indian people with one voice. Although we have diversity among us as peoples the problems we face are pretty much the same and we are all confronted by similar issues. We have to come together with one voice so we will be heard and not ignored and then we can make changes for our people.

FERN EASTMAN MATHIAS

The qualities of an Elder are not gained easily and the stature requires more than the advancement of years. Although she would have probably countered the claim, few truly deserved the recognition of Elder more than Fern Eastman Mathias. For over sixty years she selflessly dedicated her life to Native rights, constantly challenging injustices and standing up for Indian people. Fern entered the Relocation Program during the dark days of the Eisenhower administration's Draconian 'sell or starve' Indian policy; the era of termination and relocation spawned by Representative William H. Harrison's (R-WY) House Concurrent Resolution 108, the 'sense of Congress' that ultimately provided for bills that terminated 133 tribes. The harsh reality of relocation left some on skid row and others desperate to return to their reservations but Fern was among those who stayed and, having united with other relocatees, when the traditional reinvigoration that began on the Hopi mesas was carried from Hotevilla to the cities, it was Fern and many of her fellow relocatees who gave 'Red Power' its movement. A descendant of Chief Cloud Man, a decisive figure in Dakota history, Fern's great-grandfather, Many Lightnings, was a veteran of the 1862 Dakota resistance in Minnesota and her grandfather, Ohiyesa ('The Winner'), became one of the first Native authors to have his works published. Under the name Charles Alexander Eastman, Ohiyesa authored *The Soul of the Indian, Indian Boyhood,* and ten other books. Ohiyesa was able to recount experiences from his flight to Canada after the 'Minnesota Uprising'; to being the post physician at the Pine Ridge Agency, and as such one of the first to witness the horror of the Wounded Knee Massacre in 1890; to his stint at Carlisle Indian School. Inspired by her ancestors and influenced by the likes of Cesar Chavez and Dr Martin Luther King, the latter of whom she once met, Fern could count the occupation of Alcatraz, the liberation of Wounded Knee in 1973, and the Longest Walk amongst the numerous pivotal events she contributed to. She worked with Anna Mae Pictou-Aquash in Los Angeles to raise funds and awareness for the American Indian Movement, and eventually became Director of AIM's Southern California Chapter. She fought doggedly for federal, state and city recognition and protection of Native American sacred sites and she was in the vanguard of the fight against the use of Native American mascots in sports. Her dedication to the spirit of AIM continued until she faced her greatest battle; in 2001 Fern defied a life-threatening illness and fought her way through many critical days. Anybody who believes that one person alone can never make a difference did not have the privilege of meeting or knowing Fern Eastman Mathias, one of the great American Indian leaders of her generation. When asked what her message was to future generations she would say, "Stand up. Be proud of who you are. Be proud that you are Indian and don't let others put you down." Fern passed away on March 31, 2002. The following interview stands as one small tribute to a mother, grandmother, sister, aunt, friend and mentor who touched many lives.

Fern Mathias

"My father was a farmer and in 1936 he was sent to jail because he dared to go to the Department of the Interior's Bureau of Indian Affairs' agent to ask if he could lease Indian land, just like all of the white farmers leased Indian land. The agent thought that it was not good for an Indian person to ask this because who was he? He was just an Indian, he wasn't white."

I was born on the Sisseton-Wahpeton Dakota Nation in 1930. In our tradition each child is born to a name that relates to their position in the family, be it first born, second born, third, fourth or fifth, so you know where you come in your family. I am the oldest in my family and my name is 'Winona'. A lot of things are expected of Winona, she has to help her parents and help in every aspect of their younger children's development. I was to lead the way for my brothers and sisters so I had a lot of responsibilities. My father was a farmer and in 1936 he was sent to jail because he dared to go to the Department of the Interior's Bureau of Indian Affairs' agent to ask if he could lease Indian land, just like all of the white farmers leased Indian land. The agent thought that it was not good for an Indian person to ask this because who was he? He was just an Indian, he wasn't white. But my father was very friendly with the white farmers around there and they helped him in court and eventually he won his jury case. I was only six years old at the time but ever since then most of our family have been activists because we learned one thing. We learned that one person can make a difference. One person can make a change.

"That's what the American Indian Movement is all about, working for The People. We say AIM for spirituality, AIM for sovereignty, AIM for sobriety, AIM for self-determination and AIM for support. We support anyone who needs our help."

I also learned that to be an activist you have to be in the forefront and expect people to talk about you all of the time. If they get into trouble they may come to you for help, or they might criticize you if you're demonstrating or standing up for your rights, but either way you learn how to deal with it. You learn how to be tough and how to just flick it off your back. Most people are like sheep. Most Indian people will lay down for white men and their

authority but we know that we are proud of who we are, we are proud of our culture and we are proud of our ancestors and so we will continue. In 1953 I was one of the Bureau of Indian Affairs' 'relocatees' to Los Angeles, the relocation program to get Indian people off the reservations having started in November 1952. I came here in March of 1953 and the program ended in the late 'sixties because it didn't work out how they had planned. Those of us who came here because of the relocation program became the American Indian Movement type of thinkers and we learned the system, we learned how the government works, and so we went back to our people to start working with them, to help them, and that's how I became a member of the American Indian Movement in 1969. The following year we formed our own chapter, the San Jose Chapter of the American Indian Movement, and ever since that time I have dedicated my life to working for The People. That's what the American Indian Movement is all about, working for The People. We say AIM for spirituality, AIM for sovereignty, AIM for sobriety, AIM for self-determination and AIM for support. We support anyone who needs our help.

"But Alcatraz to me was like the rebirth and I think it was the rebirth to a lot of people. At the time my mother was a Christian but when she went to Alcatraz she changed, she said that she was going to go back to her own spirituality."

In 1969 I was living in The Bay Area when we heard that the occupation of Alcatraz was happening, so my mother and father, some of my brothers and sisters, and my children, went there. We went there every weekend for several months, I think it was November through June, so that was a lot of weekends! But Alcatraz to me was like the rebirth and I think it was the rebirth to a lot of people. At the time my mother was a Christian but when she went to Alcatraz she changed, she said that she was going to go back to her own spirituality. I wasn't around South Dakota and Nebraska when Raymond Yellow Thunder was murdered and I didn't go to the trial in Custer but Dennis Banks and others were there. I remember the court house burnt down and people went to jail. At the time of the

Fern Mathias

Jumping Bull compound in 1975 I was down in Mexico City representing AIM at a 'Women's Conference', and I saw it on the front page of a newspaper so when I got back I contacted a friend about it. At that time I was also the editor of a magazine called *Indian Voice* and so I decided that we had to get the story, so my friend and I jumped on a plane to Rapid City. When we got there we couldn't find a company that would rent a car to us to go to Pine Ridge so we had to lie. We told them that we were tourists who needed a car to visit Mount Rushmore so of course we got a car!

"The following year I was one of the ones accused of killing those FBI agents! Bruce Ellison showed me the list and my heart sank when I saw it. Even though I was in Mexico City when it happened they still accused me!"

When we got to Pine Ridge there was no activity, all you could see was Feds, Indian people weren't milling around, they were hiding. We were looking for certain people, certain leaders, so she and I went to the Jumping Bull compound. We took pictures of it all but we could easily have been shot at by those FBI agents because they were all over the place, it was crawling with FBI and we were the only Indian people foolish enough to ride around there and go out to the compound! We took photographs of the inside of the house where the Feds had shot-up the pictures of the children of the Jumping Bull family. Their kids had been in the service and in the photos they had their military uniforms on and the Feds had shot holes in them. So when we got back to San Francisco we reported it all. The following year I was one of the ones accused of killing those FBI agents! Bruce Ellison showed me the list and my heart sank when I saw it. Even though I was in Mexico City when it happened they still accused me! At that time they didn't know what had happened.

"When people think of AIM they always think of that time. The average person on the street can't figure AIM out but a good example is the Ward Valley struggle where nuclear waste might leak into the Colorado River . . ."

When people think of AIM they always think of that time. The average person on the street can't figure AIM out but a good example is right here at Ward Valley. We help

wherever we're needed and Ward Valley is where the US government was giving some land to the State of California, and the State of California hired an organization called 'US Ecology' who had already been responsible for unlined nuclear waste dumps that had leaked and failed. But they don't care, they hired the same corporation and what could have happened is that the nuclear waste might have leaked into the Colorado River and the Colorado River is where Los Angeles, San Diego and all of those different communities get their water. So what does that tell you? It tells you that people are not aware because the media is not telling them. The media is owned by the big corporations so the media does not want the truth to be known, so we have to do our own public relations. We've got a coalition of the five tribes who live out there on the Colorado River and Ward Valley is a sacred place where they have ceremonies, but the US government doesn't care about that and often state legislatures, officials and governors don't care either. All they care about is money. It's greed, that's all. So AIM has to be out there because the government knows that AIM stands up for our culture and our sovereignty and because of AIM most tribes are using their sovereign rites. They're doing it with the casinos, they're doing it in every phase.

". . . AIM has to work with our sacred sites, like at Ward Valley and Big Mountain, and right here in Los Angeles where there are sacred sites all over and developers building all over them . . ."

In Ward Valley those five tribes made a stand and others are too. We're now using this high-tech stuff to spread the word. We've got cell phones, faxes, e-mails and websites, so the world will know what goes on because we are going to keep telling them. The US government is going to have a rough time getting them out of there and recently the Bureau of Land Management pulled out and now it's up to the Interior Secretary to negotiate with the five tribes. So AIM has to work with our sacred sites, like at Ward Valley and Big Mountain, and right here in Los Angeles where there are sacred sites all over and developers building all over them, like the Roman Catholic Church. The archdiocese are

Fern Mathias

going to build their Lady of the Angels cathedral down there where City Hall is, where the County Buildings are, and the Federal Buildings. They'll be sitting down there like they are our leaders but Cardinal Mahoney didn't even ask the Indian Catholics or tell them what he planned to do, so a lot of those people are upset at him. In fact, we've had demonstrations there because it's going to be built on land sacred to the Gabrielino and some of those Catholic Indians joined us. At what is now Olvera Street is where the Gabrielino lived, and right there at the corner of Temple and Hill Street is where their burial grounds were and that's where this cathedral is being built. The archaeologists hired by the city and county didn't tell all of those things, they left it all out, they didn't say that this was Indian land first. Maybe they just said that Indians had been here but they didn't tell what was on that property but we have talked to people whose families lived there for hundreds of years and they know what's there.

". . . governments of the United States have never cared about what they do with the bones of our ancestors but if I went to the burial grounds of the caucasians here and started to dig up their bones I would be put in prison."

Sacred sites are places that our people lived around and that's where we hold certain beliefs. We may have held burials there. We may have held sacred ceremonies there. They are places where our ancestors reside. In LA there are sacred sites about every four miles. If you go to any of those places you can almost see where they would be because of the location of the waters. The governments of the United States have never cared about what they do with the bones of our ancestors but if I went to the burial grounds of the caucasians here and started to dig up their bones I would be put in prison. It's just another symptom of racism.

"All of those faces up there on Mount Rushmore are the faces of people who were our enemies. People are like ostriches, they hide from the truth and they create things like Mount Rushmore to stop the truth from being told . . ."

These issues have to be addressed through education. Our teachers have to be educated so they can teach the American children. It has to start with the youth. The youth have to know the truth and then people will know. It's like with my people, the Dakotas. In 1862 my ancestors came under two Presbyterian ministers, Dr Riggs and Dr Williamson, and my grandmother thought they were the greatest people on earth, but little did she know that they were the ones who told Abraham Lincoln about our so called 'renegades'. The renegades were the ones who fought because our people were starving due to the traders and government Office of Indian Affairs being corrupt and, along with the government, not honoring our treaties. They were taken into custody and thirty-eight of them were hung in Mankato, Minnesota in 1862. Their families and all of the women and children were put into compounds around the Minneapolis/St Paul area and they died there. It was the winter time. It was December. It was genocide. People think that Abraham Lincoln was a good person but he was the one who ordered this and I would like the world to know that and to know that all of those Presidents were the same way. George Washington was a no good person who has been put upon a pedestal by the whites at Mount Rushmore. All of those faces up there on Mount Rushmore are the faces of people who were our enemies. People are like ostriches, they hide from the truth and they create things like Mount Rushmore to stop the truth from being told so we as the American Indian Movement are trying to educate people.

". . . dignity, honor, solitude and respect – that's the Indian way. In the Indian way you are reverent every day and every hour of every day."

We are educating our own people to stand up and be proud of who they are. If you are proud of who you are and you practice your spirituality you have a lot of power and so more and more people are practicing their spirituality and that's the foundation. My father was never a Christian and every day he would go out to pray by himself. I saw that power but my mother had become a Christian because all of her uncles and aunts were

Fern Mathias

missionaries and preachers so she took us to church. In the Presbyterian church, our Indian church, we were true Christians. We went by the Ten Commandments and we helped each other and were generous, using more or less the same principles of our traditional spirituality – dignity, honor, solitude and respect – that's the Indian way. In the Indian way you are reverent every day and every hour of every day. If you pass a tree that's beautiful or you see the ocean or something, you have reverence. You have reverence all the time, not just on Sunday for one hour. When I was going to college I joined the Presbyterian church in South Dakota and was that a shock to me to find out what a white Presbyterian church does! I was there for about two or three months and I got out of there because they were not true Christians. All they cared about was money and how they looked. All they cared about was material things and I didn't grow up that way. I grew up with the earth, working with the earth and the animals, with the weather, the sun, the trees, the lightning – I grew up the Indian way and that's how we were with our Indian church so there is a difference but it's all Indian. But I think that today it is corrupt and they have taken on too many non-Indian ways but I grew up in a different time.

"Now they feel proud but who gave them that pride? I think it was the American Indian Movement when they came out in 1968 and said, 'Be proud of who you are. We're Indians'. And we want to stay Indian and continue the Indian race."

Where AIM is at today is trying to teach our youth. We have youth programs teaching traditional songs and how to make traditional outfits, and we are helping kids to decide what nation they want to be. Just like my grandchildren are part Dakota, part Kootenai and part Navajo – and on the other side my daughter married an Oneida so those grandchildren are part Dakota, Kootenai and Oneida – you have to choose what you want to be. You can only be one. My children chose to be Kootenai but they still listen to me, and I think my grandchildren are choosing to be Navajo so they are learning the language

of the *Diné*. We have to be proud of who we are because there are a lot of Indian people who are not, they are ashamed. A lot of them ran away from the areas but now some of them are coming back and asking how they can find out about which nation they belong to. Now they feel proud but who gave them that pride? I think it was the American Indian Movement when they came out in 1968 and said, 'Be proud of who you are. We're Indians'. And we want to stay Indian and continue the Indian race.

"The whole Western Hemisphere is Indian so we have no borders. We are all Indian from the top of the continent to the bottom. It's all red . . ."

America has tried to shut us down but we are going to stay proud and that is what AIM is about, to keep our cultures and to teach our youth and to stay away from alcohol because alcohol and drugs are what the US government uses to keep us down. The whole Western Hemisphere is Indian so we have no borders. We are all Indian from the top of the continent to the bottom. It's all red, so when you see people with dark hair and dark skin from south of the border you know they're Indians, they are not Mexicans or Colombians they are Indians. We've got to join together and support each other. Look what's happening with the Uwa in Colombia; how Occidental Oil tried to take all of their land with the help of the US government. Look at the Zapatistas in Mexico and how the Mexican government is using the US government to help kill those people in Chiapas and take over their lands and resources. In Latin America Indians are still massacred daily. We are all Indians and we are glad for all of the support we get against our common enemy – the corrupt alliance of the Corporate State – multinational corporations buying influence in the US government. CEOs of big corporations are now inter-changable with the office of President and Vice President of the United States. You don't need to win an election you just need the best lawyer and the most money and often it's blood money from the genocide of our people.

FERN EASTMAN MATHIAS
(1930 – 2002)

SONNY SKYHAWK

er name is Katie Roubideaux-Blue Thunder. She's the little girl in the buckskin dress with a doll cradled in her arms as she gazes out with eyes of dawn from a popular sepia postcard. Katie's father, Louis Roubideaux, was an interpreter for the US Government on the Rosebud Agency, once doubling as captain of the Rosebud Indian Police after the force and reservation had been established in 1878. 'Roubideaux,' said Dr Hardin, the agency physician from 1895 to 1902, 'would be interpreter for God or the Great Father at Judgement.' Hardin's assessment may have been fair, for if it happened around the Rosebud, or before that the Spotted Tail and Red Cloud agencies, Roubideaux or one of his family were often there; his relative, Charlie Roubideaux, was an eye-witness to the murder of Crazy Horse. On John A. Anderson's 1894 photograph, 'Chiefs of the Brulé Sioux', Louis is there. Stood next to Whirlwind Soldier, Louis looks a little conspicuous beside him and other Lakota legends like He Dog, Crow Dog, High Hawk, Hollow Horn Bear and Two Strike, his white hat and bristling ginger moustache begging the question, 'Was he a Brulé headman?' Louis Roubideaux walked and talked in two worlds and put himself in the frame and he seemed to recognize the power of the photographic image. "Indians are in every bit of mainstream life but there's a celluloid time warp. We are only seen in loincloths and feathers. Now we're working on taking back the image of our people," said actor/producer Sonny Skyhawk, the great-grandson of the girl on the postcard who shares some of her father, Louis's, attributes. Skyhawk describes his childhood as being reminiscent of *Grapes of Wrath*, traveling with his grandparents in their search for work and picking cotton at the age of five. He recalls being called a 'dirty redskin' in elementary school, after which he realized what poverty and discrimination were and that he was caught within both. Through school theatricals he began to find his place, self-esteem and a role model – the late Eddie Little Sky. Today Sonny is a movie industry veteran, his thirty-year tenure encompassing feature film walk-ons and scripted parts; television roles ranging from *Little House on the Prairie* to *L.A. Law*; and consultancy work on major productions such as *Geronimo, An American Legend* and *Windtalkers*. However, on occasion his methods have not found favor within the industry, the furore he kindled around TNT's *Crazy Horse* being one example. By contrast, American Indians in Film, the advocacy group he founded in the late 1980s, united with the NAACP, the National Hispanic Media Coalition and the Asian Pacific Coalition in 2000 and secured a 'memorandum of understanding' from CBS, NBC, Fox and ABC with regards to their appointing 'vice presidents for diversity' after the networks had continually overlooked 'actors of color'. In June 2001, the Oneida Nation launched Skydancer.tv Inc., a film, TV, and 'new media' production company formed in association with Skyhawk and award-winning filmmaker Dan C. Jones (Ponca). Working with NBC, Skydancer.tv's first project was *The World Championships of American Indian Dance*.

Visions and Voices from Native America

"My mother graduated from St Francis boarding school and she tells me about whippings with electrical cords and how a nun once sprinkled beans on a hardwood floor and made her kneel on the beans for hours at a time until she keeled over from exhaustion . . ."

There was a period of history, starting before the turn of the century and lasting ninety-seven years, when Indian children were forced to attend boarding schools – schools run by the Lutheran, Catholic and Protestant churches. Those people took it upon themselves to come onto the reservations to provide some sort of education. But that was really just the white wash on the wall. The real truth was that with the sanction of the US government, they were trying to de-culturalize the children from being Indian and assimilate them into being white. One of the threats that local Indian agents would make to native parents was that if they did not send their children away to boarding school the food allotments provided by the government which families received fortnightly, sometimes monthly, would be withheld. I am hoping to produce a feature film which deals with an experience in a boarding school so that the atrocities that were perpetrated on young Indian children will finally be exposed. In my research I have heard many stories! When children arrived at the school their hair was cut. They were forced into showers where they were doused with disinfectant for lice, sprayed with DDT and then made to stand naked for a couple of hours while the DDT did what they supposed. They were forced to march everywhere they went. People talked about being thrown in dungeons with bread and water, something you'd imagine happening in a prison not a school. A recent article I read about a boarding school in Canada included testimony detailing an electric chair with an attachment to a car battery which was used to 'zap' children's fingers, hands or toes as punishment. Misdemeanours would include speaking your own language, or not washing your hands; speaking out of turn or touching a friend; making your bed incorrectly – really ridiculous things – but the boarding schools ran with regimentation. Children had to sweep floors, press their clothes a certain way, clean windows, work in laundries, and these were

kids who started at about six-years old. My mother, for one, graduated from St Francis boarding school and she tells me about whippings with electrical cords and how a nun would sprinkle beans on a hardwood floor and make her kneel on the beans for hours at a time until she keeled over from exhaustion. She tells me stories about how she would run away, even in the middle of winter, only to be brought back and punished severely.

". . . these were not just crimes against native children, they were crimes against humanity and it should never have been allowed to happen . . ."

Indian children didn't want to be there. They knew what was going on. They told their parents what was going on and they heard their parents discussing what was going on. But times were so tough, especially during and after the Depression, that many of the families really didn't have any choice. There are some who believe the boarding school system wasn't all that bad but you could compare those schools to prisons, only the children had committed no crime other than to be Indian. Many elders have since passed on and have taken the memories of torture, discrimination and abuse – sexual and violent – to the grave with them because of the embarrassment of having endured that. Many who are alive today still refuse to talk about it some fifty or sixty years after the event. These were not just crimes against native children, they were crimes against humanity and it should never have been allowed to happen. Someone should have said something or done something. May the tortured spirits of those who have passed on rest in peace, for they can no longer be harmed by those zealots.

"Taking the 'Indian' out of the 'Indian' was intended to reduce us to a non-human level. A form of that today is the use of Native American images as mascots."

Taking the Indian out of the Indian was intended to reduce us to a non-human level. A form of that today is the use of Native American images as mascots. Nationally, the Commission for Racism in Sports have been talking to teams like the Atlanta Braves and

the Washington Redskins, trying to ban the use of Native American images as team mascots. In California we have an organisation called the Committee for Native American Rights to do the same thing in the state school systems. American Indians in Film was contacted by the CNAR in regard to mascots being utilised in the LA Unified School District and asked if there was any way that we could help with this issue. A number of Native Americans from the community worked tirelessly on the campaign and I was able to make a presentation to the school board explaining why it is so damaging to the young generation of Indians today to see their images ridiculed and demeaned, emphasising that the school district and schools in general should be in the business of educating our future generations, not in the business of discriminating against one race or another. Six out of the seven board members voted to ban the use of Native American images as mascots in that school district so the end result was that the largest school district in the US banned the use of Native American images in their schools. Taking that momentum, we decided that instead of contacting each individual school district we would have a State Senator from the State of California sponsor legislation that would in essence force the State of California Department of Education to abolish Native American images as mascots. That is presently on going. Although there are laws and legislature presently on the books of the State of California those laws haven't been enforced, so the way that we are making them do that is by advising them that we will file suits in state courts and if need be in federal courts, or in the United States Commission of Federal Rights. Mainly our ammunition is the fact that there are existing laws stating that no-one who utilises federal tax dollars can discriminate against any race, so we can use that specific law saying that we would go further, delaying federal funds that are due to the schools yearly if they don't adhere with that existing law.

"People say the mascots are harmless and not meant to be offensive but we have video tape which shows Indian effigies being hung and burned on football fields in what is described by those same people as just 'the heat of competition'."

Sonny Skyhawk

When we hear the comment, 'Well, we're honoring the Native American by utilizing their images', we as Indian people don't believe that it honors us – it's a form of ridicule – it's institutional racism and we don't think school children should be allowed to discriminate against other children. To those that say the mascots are harmless fun I'd have to say that I think discrimination and racism is a disease that has permeated through schools to generations of people which reduces a race of people to a caricature. It's demeaning. 'Redskins', 'Warriors', 'Braves', are not only words but tools that are being used to discriminate against Native Americans. People say the mascots are harmless and not meant to be offensive but we have video tape which shows Indian effigies being hung and burned on football fields in what is described by those same people as just 'the heat of competition'. Can it be that people are so desensitised that they don't understand how these things affect children? Young Indian children who go to these schools will reply that they are Mexican or something else rather than Indian when asked what nationality they are because they know that saying they are Indian means they'll be held to ridicule. Many years ago there was a chain of restaurants called 'Sambos' but because of African American political weight and complaints those people were sued in federal court. And even though they fought it, it was found to be discriminatory to use that image of a people. A mascot like that, or one that belittled people of the Jewish faith or most any other race or creed in the United States, would not be tolerated and it all comes down to political clout and public perception. We're hoping to change things.

". . . Although there was no census at the time, it's estimated that there was a population of 50,000,000 Native American people before Christopher Columbus landed. By the 1900s there was an estimated population of 250,000. So when you talk about what has happened to any other race of people, there is little comparison to what has happened to the American Indian."

Steven Spielberg's *Schindler's List* showed the atrocities committed against the Jewish people in the Nazi death camps and his more recent *Amistad* showed the enslavement of African Americans – being brought here in chains. My dream is to bring this to rest by doing a feature film about the genocide and atrocities committed against the American Indian. Not only the adults but the children. The massacres that took place which were called battles instead of the massacres they truly were. Although there was no census at the time, it's estimated that there was a population of 50,000,000 Native American people before Christopher Columbus landed. By the 1900s there was an estimated population of 250,000. So when you talk about what has happened to any other race of people, there is little comparison to what has happened to the American Indian. Today's population is a little over 2,000,000 so we have come back but we're a long way from where we were.

"If we fail to speak up those things will continue to happen. To those who say, 'It's just the way it is', I say . . . it is not the way it should be! And shame on America for allowing this to continue."

Images of our people have been used in the film industry since Thomas Edison perfected the kineticscope in 1898. In those days images were used which showed us as uneducated, stoic, bloodthirsty savages subservient to the Anglo race. Nowadays they exploit our images to market products like tobacco, flour, beans and liquor if they can get away with it. Whether it's a Jeep Cherokee or the Atlanta Braves, the exploitation and stereotypical images will continue if we allow them to. If we fail to speak up those things will continue to happen. To those who say, 'It's just the way it is', I say that some of the American people are still in denial of the atrocities, oppression and genocide that has been committed against our people for the last five hundred years. It is not the way it should be and shame on America for allowing this to continue. It is true that this generation of Americans may not have had anything to do with the brutal past of their ancestors, but their government did. Their ancestors may be long gone, but their government is still very much here. In essence, we are all responsible for the actions of our past because that is a part of

who we are today. Each and every one of us has and carries the responsibility to uphold the commitments of our heritage!

". . . if we leave the reservations the government will again say the land is not being used and will move in and try to confiscate those lands . . . We need self-sustaining economies on reservations so that people don't need to leave."

When the US government first mandated that we settle on reservations the lands that were selected by them for us were lands that were not capable of producing crops, or grass for cattle or buffalo to graze, or anything else. Funds that were agreed by treaty are supposed to provide for the American Indian and those annuities are now renamed welfare by some. The government is seeing to it that those funds are cutback and the only way to to provide for yourself is to get off 'welfare' and get a job by moving to the city because the reservations have no manufacturing or industry whatsoever. But if we leave the reservations the government will again say the land is not being used and will move in and try to confiscate those lands. In the sixties the government's Relocation Program sent Native Americans off reservations to learn trades without taking into consideration that those people's cultures were more important to them than becoming a plumber or anything else! This resulted in more people being displaced in the metropolises who became dependent on the welfare system and actually increased the problem. It must be the responsibility of the US government and the tribes to find ways of bringing industry to reservations. There are industries that would work and provide viable solutions to the problems. We need self-sustaining economies on reservations so that people don't need to leave. We don't need somebody who has never experienced life on the reservation coming in and saying, 'I've got a great idea, let's build a moccasin factory'.

". . . although the millennium is upon us, unfortunately we still have elders on some of our reservations who freeze to death when they don't have the money to pay for fuel to be brought into their homes."

Still today, on some reservations there are homes that are not equipped with heating, water or indoor plumbing. When you go onto some reservations you can see the outhouses where people have to go in the middle of winter and often elders don't have heating or the money for gas and need to have water brought to them. Some people only have a wrecked car for shelter. I'm always amazed that our ancestors existed in buckskin and buffalo hide tepees which kept the cold out and the warmth in even when temperatures reached forty below zero. Yet although the millennium is upon us, unfortunately we still have elders on some of our reservations who freeze to death when they don't have the money to pay for fuel to be brought into their homes. That some of those things are still allowed to exist is shameful to the American people and to the US government.

". . . education is the weapon that we have to counter today's
society with . . ."

Today the fight goes on but the 'weapons' are different. Our ancestors fought with anything that they could, going against a Springfield rifle with a bow and arrow was not something that we could help and if we could have had it differently, I'm sure we would. But the weapon, if you will, that we have to counter the society of today with is education. We are reaching toward a position where we will be able to convey the history, show our accomplishments and the contributions that we have made to what is now called America. There are thirty American Indian Colleges that are supported by the American Indian College Fund and other institutions. But they are not supported by the United States Government. There's legislation going through the Appropriations Committee which will for the first time apportion monies to help the Indian Colleges but when you know that there are five hundred and fifty eight federally recognised tribes, thirty colleges really don't stretch far enough! Things are not equal by any means in terms of education but the advent of gaming has improved ten-fold the possibility of an American Indian child getting an education.

Sonny Skyhawk

"Our neighbors on Pine Ridge still face Third World country conditions – people raising families out of cars – and their casino barely sustains itself. Donald Trump and Steve Wynn haven't much to worry about . . ."

Monies derived from gaming go to the infrastructure of the tribe to build roads, sidewalks, health clinics, water and sewage treatment plants, the basic necessities that everyone takes for granted and enjoys today. And there are funds set aside to guarantee a full four-year scholarship to young Indian people who want to go to college. Indian people *per se* wish that it wasn't gaming and casinos that have brought us to this point but if it wasn't for gaming many would still be dependent on the US government. The impression is that all Native American tribes now have gaming and casinos and that's a misconception because out of the tribes that do have gaming only 5% are actually successful, often because of geographical location and the lack of access to main public thoroughfares, and out of that 5% only 2% make big money. Our neighbors on Pine Ridge still face Third World country conditions – people raising families out of cars – and their casino barely sustains itself. Donald Trump and Steve Wynn haven't much to worry about, but they have contributed millions of dollars towards lobbying against Indian gaming.

ARIGON STARR

One of Arigon's grandmothers spoke only Kickapoo and Spanish and did what she could to stave-off assimilation, moving south of home with other Kickapoo families who tried to avoid the melting pot. Years later, her granddaughter jumped right into it with tunes from a place called the 1960s playing as she took the plunge in Los Angeles. As a young man, Arigon's father, Ken Wahpecome, had left the poverty and prejudice that was allotted in larger parcels than the Oklahoma land-holdings in tribal hands, and joined the US Navy. "I was raised in a totally urban environment", said Arigon, moving from state to state, city to city, with her father's station. "My dad said that for a long time he did not want to be Indian and my sister and I picked up on that, so I guess we didn't actually acknowledge that we were Indians for a long time", she explained. Her perception altered when she arrived in Los Angeles – the tunes were there, her musical aspirations were there, and so were Native people. Lots of them. More in fact than in any other city in the United States. Initially working as an artist and animator for Disney, and later for Viacom and Showtime as an entertainment publicist, when she discovered the American Indian Registry her priorities changed. She networked with the artists whom were signed to it and both professionally and socially Arigon made her way in the community, making the rounds from stage to powwows to acoustic performances in coffee shops and back again. In addition to hinting at some of her musical influences, among them The Beatles, Queen and The Rolling Stones, her debut CD, *Meet The Diva*, gave notice that she was now proud to be Kickapoo and Muscogee, the lyrics to many of her songs being Native oriented and issue based. "So many Indians are like me", she said, relating to her song *Native* from *Meet The Diva* and the soundtrack to the movie *Naturally Native*, "we can't speak our tribal languages. We blend with the modern world, yet so often the old ways are the best." *Meet The Diva* won her the first of two NAMMYs (Native American Music Awards) for what she describes as her 'Native American Alterna-Pop', the second being awarded for her single, *Junior Frybread*, from her follow-up album, *Wind-Up*. Augmenting her songwriting and performing, Arigon has a keen sense and understanding of the value of marketing and promotion from her prior nine-to-five days, essential qualities for any artist who seeks crossover recognition. After attending the Native Grammy Showcase in 2002 she commented, "There was a whole lot of drumming going on. Lots of flutes, too. We hope that next year we'll see some genuine rock n' roll on that stage!" You see, Arigon doesn't do ambient Native flute recitals. Arigon doesn't do traditional voice and drums. Arigon is like Ziggy, she plays guitar. Her third CD, *Backflip*, was released in Spring 2002 and features collaborations with Nashville-based 'alt-country rockers' BR549.

Visions and Voices from Native America

"In all the time that I grew up around the United States it is the only place where I've ever had somebody look at me like 'Oh look at that Indian! Oh no!' I've never experienced that anywhere else."

I am a Kickapoo/Creek Indian and I grew up all over the United States, primarily because my father was in the navy. Both of my parents were from Oklahoma and they bring that to me but I was raised totally in an urban environment. Neither of my tribes have reservations which comes as a shock to some people, 'What! Don't all Indians have reservations?' Well, no! My father still has a land allotment but he only has mineral rights, and the same with my mother, and I think they get a check for about five cents every year for those mineral rights! Basically, as far as a reservation goes, that's what we have. My father grew up in dire economic situations. He was raised on the land and his family farmed but there was no money. My father was pretty ambitious and he wanted to do things. At school he had been very athletic and he just wanted to get out because there was nothing happening there. Even today in Oklahoma there is extreme prejudice. In all the time that I grew up around the United States it is the only place where I've ever had somebody look at me like 'Oh look at that Indian! Oh no!' I've never experienced that anywhere else. Mainly people from cities are just curious and they want to know, so you try to tell them, and then they are surprised but in Oklahoma, and I'm sure in places like South Dakota . . . well, I don't want to say what they say to us! My father got out because he knew there was nothing for him there and we were lucky, I feel fortunate to have been raised around the country and to have seen another side to it rather than having just stayed in Oklahoma and been treated as second class. We were never taught to be second class, we were taught to be proud.

". . . my father's parents told him that he had to learn to live in the white world. They told him that it was unfortunate but that's how it was going to be and that he was to learn how to live with it and be successful but still be Indian . . ."

My grandmother only spoke Kickapoo and Spanish because part of our tribe moved down south because they didn't want to be around white people but my father's parents told him that he had to learn to live in the white world. They told him that it was unfortunate but that's how it was going to be and that he was to learn how to live with it and be successful but still be Indian and that's what my parents taught us. I didn't know about this for a long time and it has only come out recently when my dad has been telling me stories from way back when because he said that for a long time he did not want to be Indian and my sister and I picked up on that so I guess we didn't actually acknowledge that we were Indians for a long time. It was only when I moved to Los Angeles for my career in the music industry that I realized that there were other Indians here and I had no idea that this city was such a hub for Indian people, so I networked and started meeting people, I started going to powwows and got into the community. I found out that there was a group called 'The American Indian Registry' where they signed up performers, singers and actors, and that's where people would go to meet and I got in with that crowd.

". . . at the end of every movie about Native people it's '. . . and they all died at the end of the movie. Isn't that sad, boo hoo hoo hoo', so nobody thinks that there are any Indians anymore . . ."

I think that one of the major misconceptions is that there aren't any more Indians because we all died and it seems like at the end of every movie about Native People it's '. . . and they all died at the end of the movie. Isn't that sad, boo hoo hoo hoo', so nobody thinks that there are any Indians anymore and it's a shock and a surprise when they find out and it's like, 'What! There are still Indians? I didn't know!' And nobody has ever heard of our tribe! How many know about Kenekuk the Kickapoo prophet and what he taught our people from way back? With regard to the whites he said, 'Work with them but don't be one', and that's how we were raised. There has never been a movie about the Kickapoos and I think the only reason that there is any recognition of our tribe is because there used to be comic strip called *Lil' Abner* and in it they had a thing called 'Kickapoo Joy Juice' and

people are like, 'Oh, Kickapoo? Yeah, Kickapoo Joy Juice, I've heard of that!' Then the next question is usually, 'What's the recipe? Or what is it like? Does it taste like Mountain Dew?' Right, yeah, it was a comic strip, okay!

". . . it's usually questions about tipis or sweat lodges or 'Are you spiritual? Can I borrow some? Can you tell me what the secret of the universe is because you Native people are so spiritual? Come on, tell me, tell me, tell me!' And there is nothing to tell. It's not something that you would want to share with a stranger . . ."

Other times it's usually questions about tipis or sweat lodges or 'Are you spiritual? Can I borrow some? Can you tell me what the secret of the universe is because you Native People are so spiritual? Come on, tell me, tell me, tell me!' And there is nothing to tell. It's not something that you would want to share with a stranger, plus you wouldn't have time. All of those stereotypes are so damaging. Because a lot of my friends are actors I know for a fact that when they try to get parts in movies they are either put on horses or in tipis – the leather and feather gigs – and that's about all that they can get. Indians are not seen as contemporary people working in offices or being lawyers or doctors, or even being in the music business. If an Indian kid listened to some of the Indian music that is out there right now it would be rare for them to hear rock and roll or jazz or R&B – any of the different genres – because it seems like the major record labels only want to hear the drum groups and traditional Native vocals, which is good because it's our traditional music and it's great for it to be out there but there are others of us who want to express ourselves in a style that is a little more mainstream. But some of the Indian music that is out there shouldn't be because it's sacred music, sacred songs, and it's often taken out of context.

"I have a song called *Indian Bones* that's all about the Repatriation Act and people go 'What?' And I say, 'Yes. I wrote a song about a Congressional Act and it's about the bones of our ancestors coming back to us'. And that act is so very important . . ."

What I really want to try and do is to convince people that there are contemporary Native people out there who are influenced by the world and hear other music. I'm a big fan of British music. I've always been a big fan of *The Beatles, The Who, Queen* and *The Rolling Stones*. I thought that most of the music that came out of Britain was fabulous. That was the first music I listened to when I was growing up and then I realized that there was a group called *Redbone* who were an Indian band who had a number one song. But that was back in the 'seventies and I thought 'We've got to change that'. Even if it's not me that becomes number one, I'm hoping that when I'm playing to kids, at a school or something, I might inspire some little kid to pick up a guitar or play the piano or some other instrument to express where they're at through music, because that's what I try to do in my music. I have a song called *Indian Bones* that's all about the Repatriation Act and people go 'What?' And I say, 'Yes. I wrote a song about a Congressional Act and it's about the bones of our ancestors coming back to us'. And that act is so very important because there are a lot of our relatives, our ancestors, who are in numbered boxes in the Smithsonian, at universities and in museums all over the United States. Those are strange places for people's remains to be at and it's because they look at us like, 'Oh, these aboriginal people. These non-people', and nobody would think of exhuming bones from Westminister Abbey in London to analyse them as scientific specimens, or in the United States, 'Okay, open that thing up, let's take a look at what we have left of George Washington. Okay, how about Abraham Lincoln? Well no, we already know how he died but maybe we can discover something about his diet'. It's crazy. Our people are just as important – we are people – and it's just another way to dehumanize us. What would others feel like if it was their grandmother or their aunt on some display shelf or in a box in a museum? So I sing about that on stage and people are surprised but at the same time I don't put people on a guilt trip, I hate that, and if there are Indians in the audience I just say, 'You know what I'm talking about', and I never preach to the converted. The song itself is very happy sounding but its got very serious lyrics.

"In all of the conversations I have had with New Agers they have told me how they have been Indians in a past life and how we are sisters because their supposed Cherokee Princess grandmother blah, blah, blah. You know I'm always impressed when somebody says they are part Native and they don't say they are Cherokee!"

Whenever I go out people usually assume that I've got a traditional flute or drummer, they want to know if I sing in our language and I'm like, 'Well, that's something special and private', and I just want to communicate where Native Americans are today and where we are at and what the important issues are that we are dealing with, like the Repatriation Act. Another song I have called *Spirit Guide* is about all the New Age people I have met. In all of the conversations I have had with New Agers they have told me how they have been Indians in a past life and how we are sisters because their supposed Cherokee Princess grandmother blah, blah, blah. You know I'm always impressed when somebody says they are part Native and they don't say they are Cherokee! It's like, 'What a relief', but seriously, it's scary. For them it's a hobby, they don't have to live it everyday and have to be it twenty-four hours so it's 'Okay, all of those poor Indians. Let me help all of those poor Indians because they don't know what they are doing. Let me see if I can help them out', but we are capable! We are very capable and we are learning and trying to pull ourselves out by the bootstraps like, 'Come on! Let's go, we've got things to do', but these New Agers just want to see us in a certain way and I don't like it!

Arigon Starr

NATIVE

All around the world
People are looking inside
The teachings of the past
Are better than what they have tried
Native, Native, Native
Coming Home
Native, Native, Native
Coming Home
I feel I understand
Our elders had inner sight
They saw beyond today
Past the pain and the fright
Native, Native, Native
Coming Home
Native, Native, Native
Coming Home
Let's begin where we began
The power of change is in our hands
In our hands
Never let the dream die
Finish what they began
There's changes being made
And I'm doing all that I can
Native, Native, Native
Coming Home
Native, Native, Native
Coming Home

Lyrics by Arigon Starr from the album *Meet The Diva*. Reproduced by permission – Starrwatcher Publishing (ASCAP)

LARRY SELLERS

His parents traversed an era when Native participation in the dominant society depended upon strictly adhering to its dictates. "To get ahead, my parents were encouraged to be as white as possible", Larry Sellers explained. A Vietnam combat veteran, he was raised in Pawhuska, capital of the Osage Nation in Oklahoma, where he grew up in an ostensibly Catholic household. Nonetheless, ancestrally traditional Native beliefs had held a prominent place within the family, both his grandfather and great-grandfather, Wuh-paska, having been Cherokee medicine men. Although born Wazhazhe (Osage) and Cherokee, and enrolled as Wazhazhe, Larry embraced and practices traditional Lakota spirituality. Through *Hunka*, one of the Seven Sacred Rites of the Lakota, he was adopted into a Sicangu Lakota family from Salt Camp, an area approximately five miles west of the Rosebud Sioux Tribal Headquarters. He has been a Sun Dancer since the late 1970s, becoming a helper and then a Sun Dance leader on the Rosebud in the mid-1980s. "I was offered a contract on *Dances With Wolves* but I turned it down. I knew I had two days during that time that I was going to Sun Dance," he recalled. "And the ceremonies and beliefs always come first in whatever I do." Most people associate Larry with the character Cloud Dancing from *Dr Quinn, Medicine Woman* and, broadcast in ninety-two countries, *Dr Quinn* afforded him international recognition in a quarter-century entertainment industry career that began as a stuntman. He played Honewah in the epic, *Revolution*, and on the small screen he has appeared in *Beverly Hills 90210*, *General Hospital*, *Walker–Texas Ranger*, and the movies *Crazy Horse*, and *Son of the Morning Star*. In 1994 Larry received a First Americans in the Arts Award for Best Actor but when four years later, while presenting an award, he described the event as 'the Native American Special Olympics' the joke, and his point, was missed by many. *Rabbi In Disguise* and *The Adventures of Big Little Man*, two screenplays he has written, exemplify his alternative wit, and he often incorporates humor in his capacity as an educator. Larry serves as a national spokesman for the children's literacy program, Reading is Fundamental (RIF), and in 1997 he was invited to the White House by the then First Lady, Hillary Clinton, to emcee an RIF celebration. One of eight scholars chosen as a Fellow at the Newberry Library Center for the History of the American Indian, he continues to contribute to education programs and presents Parenting and Traditional Values workshops on the Osage Nation where he is a member of the Wazhazhe's Buffalo Bull fireplace. He featured in the Film For Thought documentary, *Way of the Warrior*, with Henry Kingi, Sr (Cherokee), the co-founder of the Black Stuntmen's Association, and Henry's son, Dorian. Film For Thought catalog the piece as 'A father takes his son on a journey to rediscover their Native American roots in the desert southwest, where Lakota shaman Larry Sellers helps him face his fears of a Vision Quest', and in the documentary Larry discusses how, in the Lakota tradition, he became *heyoka*. "One who has become *heyoka* can always recognize another, even in a crowd", he attests.

Visions and Voices from Native America

"A lot of people can lead a sweat and it doesn't make you anything exceptionally special it just gives you responsibility. I think the difference between responsibility and recognition is misunderstood."

Unfortunately today we have a lot of people who are identified as phoney Medicine Men and Medicine Women, and phoney Holy Men and Holy Women, and it's all for economic gain and for self-aggrandisement. I run in to people all the time who tell me 'Hey, I'm a sweat lodge leader'. Yeah, but do you pray while you're in there? Or is the important fact that you're leading a sweat? Particularly in Native beliefs, there is no such thing as just a sweat lodge leader. A lot of people can lead a sweat and it doesn't make you anything exceptionally special it just gives you responsibility. I think the difference between responsibility and recognition is misunderstood. They want to be somebody so they say 'I'm a healer' or 'I'm a sweat lodge leader' and what they are actually saying is 'Look at me. Look at me', which is totally the opposite of what Native beliefs are about. There are people out there who are truly seeking something spiritually that they can identify with and function by to make themselves better human beings. Whether they turn to Native beliefs or some other beliefs the important thing is that those beliefs lead them to being better human beings.

"The spirituality that the spirits have given Native people are gifts from the spirits of the Creator. That's their gift to you. Nobody has the right to sell that."

Particularly here in America, people have found a way to market that spirituality which goes back to the dogma of Christianity. They want to say, 'I have the knowledge of the universe. I have the key to the universe, and if you pay me I will give this to you'. And that's like 'Wait a minute! Why should you sell spirituality? Why not let them experience it for themselves?' If you believe what you say you believe in then you have nothing marketable. The spirituality that the spirits have given Native people are gifts from the spirits of the Creator. That's their gift to you. Nobody has the right to sell that. I don't sell a gift that's been given to me. If it's as sacred as I say it is then I have to give it away and

that's exactly what true traditional people do. That's what true traditional people identified as Medicine Men or Medicine Women or Holy Men or Women do – they give it away. The problem is that society is so used to placing a dollar value on everything that it's not worth anything if it's given away but you'll find the people who actually truly experience the things they are looking for are the ones who have been given this gift. If, for example, somebody wants to do something for me, I can't take it. If somebody wants to pay me money I can not take it because it's not my gift to sell. Give it to people who need it the most. There have been times when I have been wondering 'Where am I going to get the money so I can eat tomorrow?' but I still couldn't take anything.

"It's like in the Sun Dance when the people offer a piece of themselves – the blood, sweat, tears and pain – because that's the only thing we truly have to give of ourselves, the only thing."

I'm not this big guy. I'm not somebody important or that I have this knowledge that everybody is seeking but the responsibility I feel is for The People. Culturally there are times when people will say that you have to offer a gift. The gift could be an animal or a rattle, something that spiritually would be important and is significant to the individual giving it. Tobacco is an important gift because of its use in ceremonies. Tobacco is an offering the spirits like, they can't use a twenty dollar bill. It's like in the Sun Dance when the people offer a piece of themselves – the blood, sweat, tears and pain – because that's the only thing we truly have to give of ourselves, the only thing. That's not to say that people who do not pierce don't get their prayers answered but if you're going to give anything, the Creator doesn't care if you put fifty thousand dollars there, He can't use it. He doesn't care how sincere you are with that fifty thousand dollars but if you offer a piece of yourself – blood, sweat, tears and pain – for the prayers that you're offering, that's what He wants to see. He wants to see how sincere you are. He wants to see what you're willing to give, what you are willing to commit of yourself.

"Some people come to the ceremony and have no idea what the ceremony is about. If I had it to do all over again I would wait until I was eighty, then I think I might know enough to do that ceremony."

There are non-Natives who are very, very sincere. They don't come out and say, 'I am a healer, I want to do this ceremony', or 'I'm a Medicine Woman, I want to do this ceremony', or 'I'm a sweat lodge leader, I want to do this ceremony'. They are the ones who come and put the sweat and the work and the time into whatever is going on. They are the ones who will go the extra distance to help everybody, not just themselves. They don't just show up the day before and want to dance. Some people come to the ceremony and have no idea what the ceremony is about. If I had it to do all over again I would wait until I was eighty, then I think I might know enough to do that ceremony – I still have a lot to learn. But there are people who show up on the spur of the moment who have no idea what the sweat is about, no idea what that pipe is about and no idea what the ceremony is about. They just seem to want that vision for self-aggrandisement. They make things up, 'Oh, I saw this, this and this'. They want to elevate themselves to make others think that they've really had this vision. If you believe in the values of the pipe you can't determine what somebody else's spirituality is. But they know. The spirits know.

". . . you can ask people to leave anger, their racism, their hatred, their prejudice, their ego and anything else that is not good outside the dance ground and they don't."

In South Dakota there are Sun Dances where there are just Lakota people, Sun Dances where you have to be Indian and it doesn't matter which nation, and Sun Dances where it's mixed. All of those are fine. What we need to do with all of those is to ensure that the sanctity of that ceremony is not sacrificed for the egos of the people who are there for it. I have seen it time and time again when non-Indians come and their egos are accommodated by the people leading the ceremony, which is really unfortunate because it hurts that ceremony. The people who are really sincere at those particular ceremonies will

have their prayers answered. Each has an effect upon the ceremony. If people who pray under the shade go back to the camp and gossip or get angry and scream and holler or say things that they shouldn't, they affect that ceremony. You can ask people to leave their anger, their racism, their hatred, their prejudice, their ego and anything else that is not good outside the dance ground but some don't. Leaders of that ceremony cannot say 'You can't dance', but it's getting that way now which may be the only way to preserve the sanctity of the ceremony. At some it's good that non-Indians are not allowed but it's not good to be praying beside somebody one day and then the next day say 'I can't pray with you today because you're not one of us'.

"The first indicator with insincere people will be the first words out of their mouths – 'I studied with' – and in Native beliefs you don't study with anybody, we live it . . ."

The first indicator with insincere people will be the first words out of their mouths – 'I studied with' – and in Native beliefs you don't study with anybody, we live it. We learn from experience. You don't go to a school or read a book and you don't sit and listen to someone pontificate on how spiritual you need to be! For me the best teacher is by example, not how many books you read or how many movies you see or who you've studied with because if you don't live that you can't know. It becomes a way of life, not 'It's not convenient at this point so I'll set it aside but in order to make these people think that I'm really somebody I'll live it for this time period and when I get away from it I'll be somebody else'. Native beliefs teach you to conduct yourself by incorporating true values every second, every minute, every hour, every day, every month, every year, all of the time. It is a way of life. A lot of the New Age people want a metaphysical experience they can have a conversation piece about or be affected so much it may change their lives, 'I'm going to tell people how this changed my life and how spiritual I am now'. You run into people all over the world that do that, 'Well, do you believe what you say you believe in? Then do you

conduct yourself in the way you say?' Many times they don't. But it's interesting because true spiritual people always run into true spiritual people. I have run into people all over this world who are truly spiritual and we have prayed together respecting each other's beliefs. None of us have to be right, my way is not right as compared to somebody who is Buddhist, or someone in Europe who is truly spiritual and considered to be Christian. And they reciprocate because true spiritual people don't have to be right! But the people who do not understand what they say they believe in constantly have to be right. If your ego is in the way and you claim to be what they call 'a pipe carrier' or 'traditional person' and you have anger toward non-Native peoples about a lot of things that have nothing to do with them you don't understand what you believe in. You can dislike the actions and dislike whatever is going on but you can't take that hate into any of the ceremonies.

"The Black Hills, especially being something spiritual, is totally alienated from Christianity. Spirituality has nothing to do with Christianity because the structure and dogma of the church doesn't allow you to be a spiritual person. Christians who are do so on their own and I have great admiration for them because they have to go through just as much as we do . . ."

One of the things for people to understand about the Black Hills issue is the concept of being a part of the land, of being a part of the universe, but if they don't understand that then it's very difficult because they will think that the land is just there to occupy. Throughout history Native tribes have lived within the framework of each landscape, whether it be deserts, mountains and plains or rain forests and they've known that they are part of it – not in control of it – but a part of it. Native peoples have always said, 'We are part of this land, it isn't something we control. These may be our hunting grounds that we fight for in inter-tribal conflicts because we need to feed our people and they need to feed theirs but none of us own it.' The Black Hills, especially being something spiritual, is totally alienated from what is called Christianity. Spirituality has nothing to do with Christianity because the structure and dogma of the church doesn't allow people to be

Larry Sellers

spiritual. Christians who are do so on their own and I have great admiration for them because they have to go through just as much as we do in order to practice our spirituality but they believe within the concept of what Christianity is supposed to be about. Those types of people will understand the relationship with what is considered to be sacred ground, a sacred area, but for people who don't experience that it is really difficult to get them to understand unless you just want to tie it to a land base and economics. A lot of Anglo-Americans will think, 'Well, we can develop this land, we can do this, we can do that', with no consideration towards the land itself. Yet Native people say, 'That's our sacred land, that's what our spirituality is tied to'. When we say we hold those grounds sacred it is rarely understood, especially in the courts. The Blue Lake area up in Taos when they wanted to cut that forest down for sixty some years and finally the court realised that it had spiritual significance to the Taos Pueblo people was one of the first times a court had identified Native spirituality as being important to the earth.

I can't say what would be an acceptable resolution to the Black Hills question because I can't speak for any Lakota people. What I would like to see is the Black Hills returned to the Lakotas. If people living there want to move out that's entirely up to them but when they pass on the land shouldn't be left for their families and future generations because it is Lakota land. The buildings, the rent and the land taxes that are paid now would go to the Lakotas. I don't think the Lakota people will take the Docket 74A money. Most of the people don't want it because the emphasis now, especially upon Pine Ridge, Rosebud and Cheyenne River; the reservation areas up there, is that the Black Hills remains a sacred religious area. Since the seventies the move has been to turn back to Native spirituality.

". . . to me there are no experts on the subject of Native peoples. . . the so called simple societies and simple cultures in reality are so very complex that it takes a lifetime to figure out how they work . . ."

Some people think a lot of the existing interpretations are written in stone. But it's

hard to say that because to me there are no experts on the subject of Native peoples. They might know a little more than another but when it comes to Native beliefs and tribes, the so called simple societies and simple cultures in reality are so very complex that it takes a lifetime to figure out how they work and how they function. I don't agree with everything that AIM does but in the seventies one of the greatest things they ever did was to let Native people know that it's okay to be Indian. A side-effect of that was that a lot of the younger people during that time who were seeking who they were often read anthropological studies and books by people who claimed to be experts and they thought that what they read was how they were supposed to conduct themselves but in the long run what this, that or the other anthropologist wrote was not that way. But they had to start some place. In the seventies if you had a difference of opinion about any of the Native issues and reinforced your identity, spirituality, or the concept of being a sovereign nation, then you were automatically and without question branded a militant.

". . . so why is it not feasible to think that there were peoples who originated here and moved in the opposite direction because all Native peoples here on this continent believe that we came from the earth, not over the Bering Strait land bridge. And if it's all theory and it's all hypothesis, then why not?"

The Bering Strait theory is a hypotheses. Scientists will say, 'Well we have some artifacts to support this', but they also have artifacts to support that the horse and the camel originated here on this continent and migrated in the other direction, so why is it not feasible to think that there were peoples who originated here and also moved in the opposite direction. All Native peoples here on this continent believe that we came from the earth, not over the Bering Strait land bridge. And if it's all theory and it's all hypothesis, then why not? It's just as acceptable as migrating in this direction especially with the horse and the camel migrating in that direction! We don't have to be right but the anthropologists and archeologists – they have to be right. All we care about is that we know that we came from the earth.

Larry Sellers

"I will not do anything that requires me to set aside the values that I function from and those values come from the pipe and my spirituality. I have been fired off shows because I wouldn't do that."

Ever since I started in this business over twenty years ago I have used traditional values to function by which is not, often times, in agreement with how most people succeed in this business. I will not do anything that will bastardise my beliefs or somebody else's beliefs. I won't do anything that is insulting that I feel is degrading toward any Native peoples. I will not do anything that requires me to set aside the values that I function from and those values come from the pipe and my spirituality. The ceremonies and beliefs always come first in whatever I do – always.

". . . we had the opportunity to incorporate Native thought into the writing, which was the first TV show in the history of television to do that . . ."

I think we have to look at increasing people's awareness from two stand points. Because you're non-Indian, if everyday when I saw you I slapped you in the face you might tolerate it at first because you understand the position but at some point you would become tired of being slapped in the face. We could have done that on *Dr Quinn* with the harsh reality of what went on, or for most people who do not know what went on and are unaware of what took place, we can present it in a softer manner because it's too harsh . . . and because CBS were afraid that they might offend the audience. But to present the reality as it was, as harsh as it was, we'd have been slapping people in the face all the time and that wasn't our purpose. Our purpose being that as a TV fiction show we had to entertain but in that process we had the opportunity to incorporate aspects of history to try and educate people and expose them to things that have gone on. If they gain an interest they can seek out other forms of information. At the same time we had the opportunity to incorporate Native thought into the writing, which was the first TV show in the history of television to do that.

"... but the government want their cake and they want to eat it too. They want Indian people off welfare and they don't want to support them anymore but a lot of the things that are given to Native people are not free and clear ... it's cost Native people dearly and that cost has been in a lot of lives."

Casinos are a way in which Native people can get off welfare but the government want their cake and they want to eat it too. They want Indian people off welfare and they don't want to support them anymore but a lot of the things that are given to Native people are not free and clear – it has cost them a tremendous amount of land, mineral rights, natural resources and entire cultures in some aspects – so it's not that Native people are getting something for nothing or just being supported by the government – it's cost Native people dearly and that cost has been in a lot of lives. But I think that the casinos help Native people to become more self-sufficient and in doing that it helps them to increase their land base and increase their reservation size, even though they pay exorbitant amounts for the land because non-Indians know that they want to buy it. But I think the casinos are a way out of the welfare system and a way toward being less reliant on the government, even though there are certain aspects of those benefits that are required by treaty or contract. These are still sovereign nations whether people want to identify them that way or not and the government still has to uphold all of those requirements. There are casinos in the east that make tremendous amounts of money and in other places they might make just enough to support their tribal services. Every time that a tribe tries to develop some kind of industry on a reservation the government has always denied it. I've seen it time and time again, if it's Native people trying to do it themselves the government will always find a way to turn it down and that is to keep them dependent on the government.

"At one time there were eighty-eight different reservations in the state of Oklahoma but because of the Allotment Act a lot of them were abolished. The only reservation that is truly left there is what would be considered as the Osage reservation ..."

Larry Sellers

I'm originally from the state of Oklahoma and I love the area and a lot of the people, both Indian and non-Indian, because they are good people. At one time there were eighty-eight different reservations in the state of Oklahoma but because of the Allotment Act a lot of them were abolished. The only reservation that is truly left there is what would be considered as the Osage Reservation, or Osage County, and that was never signed over and released as a reservation. The state of Oklahoma wants to use Native people, the culture and the people themselves, to attract tourist dollars but they do not want to ensure that any of the treaties, contracts or agreements with the Native people are upheld, they want to abrogate all of those. It's an interesting and complex situation back there. There are a lot of wonderful people in the state of Oklahoma but the politics and the attitude towards Native people hasn't changed in a long, long time.

"The Creator will always provide you with what you need. It may not necessarily be what you want, but what you need. A man who does not try to dig himself out of a hole will not get out. If he doesn't want to get out of there, there is no way . . ."

In Native society today you have to go back to the value base of the family and what the individuals are familiar with to determine how they respond to certain situations. If they come from an alcoholic family then often times that is what they will turn to. If they come from a traditional family who tries to follow the ceremonies and those particular values then that is what they will turn to. The Creator will always provide you with what you need. It may not necessarily be what you want, but what you need. A man who does not try to dig himself out of a hole will not get out. And that value base to me is what is going to get you out of that hole and understanding that the Creator is providing you with what you need and if you want more you have to work your way out. They have to determine for themselves as to how they get involved with those traditions and beliefs. That is going to move them in a direction of doing other things to get out of that hole.

"Maybe those ceremonies do not exist for us anymore here in the physical world but they still exist over there, on the other side . . ."

We can either sit and complain about what has happened to us and blame the white guys for it or we can try to do something about it. I believe that every tribe I know of has lost a considerable amount and they are constantly trying to bring back certain things. If you feed the spirits in whatever way they determine in connection to the sacred items for ceremonies then if the respect for that entity, of that spirit, is brought along and taught to the younger people, at some point that entity will give the gift to one of them which will help bring that ceremony back. It may not be exactly like they practiced it before because there will be a whole process of developing that ceremony but it's a move in that direction. It may take time. It may take generations in order to get certain aspects back. But the songs will come back. Somebody may be given a song and maybe the next generation will be given one or two more songs and that entity will communicate somehow with someone they feel deserves their friendship in order to bring those back. That's how you regain certain things but they are never completely lost. Maybe those ceremonies do not exist for us anymore here in the physical world but they still exist over there, on the other side, in the other dimension.

"If you truly understand what that term sacred means you should feel it, you should hear it, you should see it, you should taste it and you should smell it. It should encompass your entire being every time you use that term."

When people use the term sacred my feeling is that they should understand that term because it's not just a word in the dictionary. If you truly understand what that term sacred means you should feel it, you should hear it, you should see it, you should taste it and you should smell it. It should encompass your entire being every time you use that term. I hear a lot of people say 'It's sacred' yet their is so much anger connected to it. You use that word as it is. You don't use it in an angry way. You don't use it to boost yourself if you truly understand what that term means. If this item is sacred, if it's something that you want to protect, then you treat that as sacred and you treat the entity that is connected to that

physical item with respect. It's an entity that helped the people and that's why the ceremonies return, to help the people – to help human beings be better human beings – not to control their lives. There is no sin, you believe in either right or wrong, and they want to see what decision you're going to make. If you make the decision that they like it moves you closer to that entity giving back what has been lost. And that is how you regain those things.

". . . the same people who called the Sun Dance heathenism and savagery, mutilation of the body, which it's not – they were the ones who abdicated their beliefs – and they know the value now because they've found themselves and they are dancing."

Our Creator is not One of retribution. Our Creator is not One to make you suffer. The spirits don't make you suffer. They move you in directions gently. If you move in this direction and it's the wrong way something may happen and you're like 'Oh, I'm being punished'. And I've done that, I'm guilty of it ,'What did I do wrong now?' But they move you in directions gently and it's just that some people are harder of hearing and they may need a bigger push! Especially if their egos are in the way! But it's interesting because the same people who called the Sun Dance heathenism and savagery, mutilation of the body – which it's not – know the value now because they've found themselves and they are dancing. Our ancestors practiced it and it was a gift from the spirit world to our ancestors to make us better human beings. And in that, that is all we try to do.

COYOTE

and the order of the New World

History, reflected Abraham Lincoln, is the one thing from which there is no escape. It is said that he uttered those words during one of his chronic spasms of anguish, agonizing over how the loss of 620,000 lives to reconstitute Old Glory and the fledgling democracy would be recorded in the annals of the United States. He needn't have worried, emancipation ensured his place as 'Savior of the Union'. "Other than in the minds of some good people who spoke out about slavery being evil, the Civil War had nothing to do with freeing the slaves, it was about the Industrial Revolution", reasoned John Trudell. "The economic reality was that if the US was to be a world empire the use of slaves was going to hold it back in its destiny because the machine had arrived and that was going to be more effective than slave labor. It was the North telling the South that they were going to take this technology."

Is to prevail to bestride history, so war becomes what you say it is and your interpretation remains true so long as there are believers? Sometimes even survivors become believers. They have to. Two hundred and fifty thousand survivors looked over their shoulders in 1900 for the thirty-three million uncles, aunts, mothers, fathers, sisters, brothers, sons, daughters, nieces, nephews and grandparents who had been lost beneath the conquest. Lost in the fall of 1492. Lost in paradise where heaven met earth and became Virginia. Lost in Manifest Destiny. They danced Wovoka's steps but they still couldn't find them. 'Kill The Indian! Save The Man!' was bellowed at these survivors. They called them *una gente in Dios*, before 'a people in God' became 'Sioux' and 'Apache' and hundreds of other mistranslated names that meant 'enemy'. Forever the enemy, never 'the People', 'the True Men', 'the Allies' or 'the Human Beings'.

If they had used the survivors' names there would have been no Indians to kill or souls to save, only truth. 'Kill The People! Take The Land!' The 'New World' wasn't new at all. There was no immunity to the imported diseases of the cross and gun but it didn't end with the slaughter at Wounded Knee in 1890, more it gained momentum with the Indians of All Tribes occupation of Alcatraz in 1969 and the Oglala Sioux Civil Rights Organization's-AIM supported liberation of Wounded Knee in 1973. On March 11, 1973, as the siege at Wounded Knee intensified, the besieged occupants issued a statement declaring Wounded Knee to be The Independent Oglala Nation. 'Let

it be known this day, that the Oglala Sioux people will revive the Treaty of 1868 and that it will be the basis for all negotiations.' For a moment Abe Lincoln, whose image stares out across the Lakota's sacred Black Hills from the so called 'shrine to democracy', Mount Rushmore, was right – there is no escape from history. In 1980 the US Supreme Court described the US Government's contravention of the Fort Laramie Treaty of 1868 and the seizure of the Black Hills from the Lakota Nation as 'rank' and 'dishonorable', two words not readily associated with the principles of democracy. For the survivors the struggle remains.

The buffalo survived too – just – and the media found their way to the boundaries of Yellowstone National Park for the slaughter of winter 1996/97 to see if they could survive again. "We originate from the Buffalo Nation and we are relatives. We have a pact with them for interdependence. The buffalo survived a slaughter just like we did", said Rosalie Little Thunder, a Sicangu Lakota grandmother. "It's like they are killing us and the elders really feel no separation. Other cultures have a hierarchy that puts people above animals but Lakota people don't do that. We are equal with the other living beings. We followed the buffalo and adopted their ways. I think we learned from the buffalo how to live in balance on this earth and how to live with other things without abusing or decimating them."

Buffalo cows, calves and bulls dropped in temporary stockades before being decapitated. Native peoples from across this continent of '500 Nations' gathered to pray for the blood bath to end and mingled within their voices, the bawling of calves and the crack of bullets gave words to tunes that were never songs. 'Brucellosis!' cried the US Government Department of Agriculture. 'Lose our brucellosis free status?' the State of Montana cried back. 'Natural regulation, we can't stop them leaving our boundaries', cried Yellowstone National Park and the US Government Department of the Interior . . . And Native people just cried.

"My father told me the story of the Little Thunder band being massacred in Nebraska in 1855", Rosalie continued. "Some soldiers came and they fed the people. There was a grandmother there who sensed that something was very wrong. She told her little grandson to hide in a burrow that was near her feet, so he crawled into that hole. As he lay there in the burrow the soldiers fired on our people. The grandmother threw her shawl over the hole to hide him. As she was shot she threw her body over the hole to hide him. Later that little boy told how his grandmother's blood dripped through the shawl. He lay very still and quite a while later he emerged from the hole. The soldiers saw him and chased him but he hid and got away. He traveled north, maybe 150-miles or more. A little ten-year-old boy walked that distance to find other relatives to tell them what had happened. That little boy was my great-grandfather and when I was watching the buffalo being slaughtered I recalled those images."

That winter the buffalo were unable to reach a satisfactory compromise with the bullets of official sanction and as the years have passed they still haven't. Montana's livestock owners fear that

the State will lose its brucellosis free status and with it their market if the buffalo wander out of Yellowstone onto 'their land'. 'Kill The Buffalo! Save The Cow!' The Inter-Tribal Bison Cooperative (ITBC), an organization comprised of fifty-one tribes dedicated to restoring the buffalo to Native Nations in a manner which is compatible with traditional cultural lifeways, has continued to remind the bureaucrats that brucellosis is a cattle disease, introduced to the buffalo through the Texas cattle-drives of the 1880s. "It really touched a lot of people", Rosalie concluded. "There is a lot of apprehension and nervousness. People feel like they are being attacked again and I've heard many elders ask, 'What's going to happen next?' Because the buffalo were slaughtered before. And then we were slaughtered. They see it happening again. How can this happen in a supposedly civilized country?"

In 1988, the Gwich'in asked a similar question and in January 2001 they had to start asking again. The caribou provide the Gwich'in with spiritual and physical sustenance, just as the buffalo do for the Lakota. "Our creation story tells of how the Gwich'in came from the caribou. A pact was made between us that still stands today. We are as one", explained Faith Gemmill of the Gwich'in Steering Committee. "We became aware of this threat to our culture and way of life in 1988. Major oil companies, the US Government, and the State of Alaska want to gain access to the coastal plain of the Arctic National Wildlife Refuge for oil development. This is the area known to the Gwich'in as the birthplace of the caribou and in our language we call it *Vadzaii googii vi dehk'it gwanlii* which translates to, 'The Sacred Place Where Life Begins'." The Reagan administration 'recommended development', before George Bush Snr pursued legislation to open the Arctic National Wildlife Refuge (ANWR) for oil extraction, but the *Exxon Valdez* disaster undermined the effort and Bill Clinton opposed it throughout his two terms. Then, having entered the White House with the financial support of multinational energy companies, abandoning Kyoto and opening the Refuge were high on George W. Bush's agenda.

With 95 per cent of Alaska's North Slope already available for oil extraction, the US Geological Survey reporting that only 3.2 billion barrels of oil may be economically recoverable from ANWR – an amount that at the US oil consumption rate in 2001 would only sustain the nation for 180 days – with the peak production year estimated to be 2027, and the best case production scenario of 600,000 barrels per day dwarfed by the 11 million barrels currently imported, the administration persisted regardless, suggesting that ANWR would reduce US dependency on OPEC and ease the energy crisis. Upholding the party line, in October 2001, Secretary of the Interior, Gale Norton, 'misled' the Senate Energy and Natural Resources Committee, choosing to present data from a BP study during her testimony instead of that compiled by one of her department's agencies. In attempting to determine the impact drilling would have on the 129,000 strong Porcupine Caribou Herd, the Senate Committee had requested information from the US Fish and Wildlife Service. "We

tried to present all the facts but she only passed along the ones she liked. And to pass along facts that are false, well, that's obviously inappropriate", a Department of the Interior employee told *The Washington Post*. But nobody really seemed to care; the Gwich'in's sacred land was a long way away, and so what if a high-ranking government official 'misled' a Senate Committee? Who cares about caribou and Indians when you drive an SUV? Even if raising fuel efficency on SUVs to 27.5 miles-per-gallon would save an amount of oil commensurate to that which might be extracted from the Refuge.

With her track record in mind, it would be hard to make the case that Secretary Norton cared about the Gwich'in. A protégée of Ronald Reagan's infamous Secretary of the Interior, James G. Watt, Norton had advocated drilling in ANWR since 1985, having worked with both Reagan-Interior Secretary appointees, Watt and former Christian Coalition head, Don Hodel. James Watt, who at his Senate confirmation hearing explained that his apparent lack of interest in protecting endangered species was born from the belief that Judgment Day was upon us, once compared environmentalists to Nazis and was forced to resign as Secretary after making a comment laced with racist and sexist overtones. Don Hodel was at the center of the appalling Peabody-Navajo Nation lease scandal that left the tribe some $600 million poorer. As founder of the Mountain States Legal Foundation, James Watt recruited Norton to that firm, an organization which has continually opposed Native rights, including sacred sites, sovereignty and subsistence issues. Both under the auspices of the Mountain States Legal Foundation and in her capacity as Colorado Attorney General (1991-99), Gale Norton contributed to eleven significant briefs that attacked tribal sovereignty to profit states' and corporate interests. The Secretary of the Interior presides over the US's principal conservation agency which embodies a third of the nation's land and includes oversight of the National Park Service and the Bureau of Indian Affairs. George W. Bush placed all of that in Gale Norton's hands.

Secretary Norton insisted that only 2,000 acres of ANWR would be impacted, but in the Energy Security Act passed by Congress that 2,000 acres equated to 'surface acreage covered by production and support facilities'. Remarkably, supports for oil rigs and pipelines don't occupy much 'surface acreage' therefore, with the oil in ANWR concentrated in numerous separate pools, Secretary Norton's 2,000 acres of spin could choke the Refuge with steel and flares. Title V-Section 506 (of the Act) states that 'no less than two hundred thousand acres' of ANWR 'shall be offered [for lease]'. "If the Earth is to survive for future generations these policy-makers should emphasize decreasing the demand for fossil fuels rather than increasing the supply. What about energy conservation, alternative energy and improved efficiency? It's time to stop sacrificing Native cultures and sacred land for oil", protested Gwich'in spokesperson Sarah James, holder of an American Land Conservation Award and recipient of an Emerging Leaders in a Changing World fellowship. Article 1 of the UN International Covenant on Civil and Political Rights, and the UN International Covenant on Economic, Social and Cultural Rights, both state, 'In no case may a people be deprived of its own means of subsistence'.

With a population that once numbered around 100,000, the ten bands of the Gwich'in Nation lay across northeastern Alaska and the Yukon. Today's 7,000 survivors are descended from the ancestral Di'haii Gwich'in, arguably the continent's most ancient inhabitants. "We have lived in the Arctic for thousands of years and we understand our environment. We know that if oil development is allowed in the birthplace (ANWR), the caribou will be adversely impacted and our way of life will be devastated", said Faith Gemmill. In essence: terror *n*. 1. great fear, panic or dread. 2. a person or thing that inspires great dread – terrorism *n*. the systematic use of violence and intimidation to achieve some goal. 2. the state of being terrorized – terrorize *vb*. to coerce or control by violence, fear, threats, etc. 2. to inspire with dread. "It [ANWR] is the least hospitable area left in America", Congressman Don Young (R-AK) informed the nation, the tacit promise to make the wilderness bloom with technological society's wonders an echo of Manifest Destiny; that the land beyond this last frontier, like the frontier of 1841, is wild, uninhabited and to be tamed – this is progress, it is manifest, there is divinity to that which God has ordained.

In the week after 9/11, President George W. Bush stated that opening the Arctic National Wildlife Refuge to oil development had now become a 'matter of national security'. Some considered this to be a cynical attempt to achieve a flagging political objective, while others didn't notice or were too afraid to offer dissent for fear of being vilified as either unpatriotic or supporters of the Taliban, or at best, something in-between. That anybody would or could condone the crime against humanity that was committed on September 11, 2001, is almost beyond belief; that people were accused of doing so if they disagreed with the Bush administration's existent agenda or subsequent response to 9/11 continues to beggar belief. As the War on Terror began constructive debate was stifled at the behest of the administration. In the days of 9/11, forgetting that civil liberties do not favor the guilty but protect the innocent became part of the price and contradiction of 'freedom at all cost'. During a speech at Georgetown University on November 7, 2001, former President Bill Clinton intimated that the United States was 'paying a price today' for its past. "This country once looked the other way when a significant number of Native Americans were dispossessed and killed to get their land or their mineral rights or because they were thought of as less than fully human. And we are still paying a price today." The axis of evil wasn't new.

With the Arctic National Wildlife Refuge a cornerstone of George W. Bush's energy policy, it appeared that oil from Central Asia was intended to be the centerpiece. For access to the Caspian's fossil fuels, sooner or later, the tribes of Afghanistan were going to have to make way just as surely as the Gwich'in for oil, the Navajo on Big Mountain and the Northern Cheyenne for coal, the Lakotas and Pueblos for uranium, and on and on. "[Bush's] Assistant Secretary of State, Christina Rocca, in August 2001 in Pakistan, explicitly discussed the oil interest [with the Taliban]", claimed intelligence analyst, Jean-Charles Brisard, who co-authored *Ben Laden: La vérité interdite* (Bin Laden:

The Forbidden Truth) with Guillaume Dasquié. On August 2, Assistant Secretary of State Rocca issued a statement detailing 'US relief assistance for the Afghan people' and we can only speculate whether the régime's brutal human rights abuses were as high on the agenda during her tête-à-tête with Mullah Abdul Salam Zaeef as they subsequently became, or if the oil interest and Osama bin Laden topped her list. A US State Department official commented that difficulties in communication with the Taliban were "not because of the lack of relations", so with the UN having denounced them, in the month preceding 9/11 what made the mullahs more friend than foe? "We describe the meeting of Rocca and some Taliban leaders in Islamabad in August 2001. There are documents to support it. At the same time in Washington there are lots of meetings of the energy policy task force and lots of oil company representatives around Dick Cheney. The task force's conclusion was that Central Asia oil is a very important goal", said Guillaume Dasquié.

On May 17, 2001, Vice President Cheney's energy task force presented the recommendations upon which the administration's energy policy was formulated. Eighteen of the energy industry's top twenty-five benefactors to the Republican Party and the Bush/Cheney ticket participated in the process, including those who coveted the Gwich'in's sacred land the most – BP Amoco, Exxon-Mobil, Phillips Petroleum and Enron. Being amongst the largest financial contributors, Enron attended six task force meetings. Officials from Peabody Energy, the world's largest coal mining company and the corporation which sits at the center of the Navajo-Hopi Land Dispute and the Big Mountain tragedy, were among industry officials briefed by the task force. "I can not think of a time when we have had a region emerge as suddenly to become as strategically significant as the Caspian", Cheney proclaimed in 1998, while serving as CEO of Halliburton, the US's largest oil services company.

The problem, it seemed, was transporting the fuel without bolstering Russia's political and economic influence on the Central Asian Republics, which left Afghanistan as the only route to market and the waiting Asian economies of India, Pakistan and China. To that end, as the Clinton administration severed 'official' dialogue with the Taliban, Unocal negotiated with them, inviting the mullahs to Texas to discuss construction of the Central Asia Gas (CentGas) pipeline. The 1,005-mile oil pipeline was to run from Turkmenistan, across Afghanistan and into Pakistan. It was reported that Enron sought to link their natural gas interests in Uzbekistan to Unocal's operation, but Unocal stalled 'until a recognized government' was in Kabul. With the Taliban's retreat, former Unocal consultants Hamid Karzai and Zalmay Khalilzad became Afghanistan's interim leader and US Special Envoy respectively.

"When I saw the few photos of the destruction and killings caused by US bombs in Afghanistan, I immediately thought of what Acoma and the other pueblos would look like if the same hellish madness was visited upon them", said Simon Ortiz, the esteemed Acoma Pueblo poet. "People standing amidst the ruins and rubble of their adobe and stone homes. Children and old men

and women stunned, weeping quietly. It is horrible to envision. This is victory over the enemy? I think of 1599 when Acoma was laid to waste and hundreds of Acomas died at the hands of Spanish conquistadors under Don Juan de Onate. That was victory of the enemy? No, that was an obscenity of death and conquest committed so that Native land and its resources could be gained, just like in Afghanistan. An obscenity of death and conquest committed so that control over oil resources can be gained."

As the War on Terror entered its sixth month, the Congressional General Accounting Office litigated against Vice President Cheney for access to documentation and disclosure of the participants in the energy task force. President Bush vowed to fight all the way up to the US Supreme Court to prevent divulgence, but a President appointed by the US Supreme Court should be as accountable as a President elected by the people. Didn't the Savior of the Union say that history is the one thing from which there is no escape? A cursory glance at the Ronald Reagan/George Bush administrations of the 1980s reveals that if dictators and fanatics with a propensity for genocide are armed, trained and the beneficiaries of aid because it serves the national economic interest, it should come as no surprise when in the 'blowback' these 'statesmen' are redefined as despots and the one time 'freedom fighters' top the FBI's most wanted list of terrorists – the chimera doesn't change. In the Western Hemisphere, throughout that era and into the next, the New World Order pattern was stitched onto the Doctrine of Discovery flag and flown from Alaska to Chile. A veritable 'Who's-Who' of Latin American tyrants and terrorists were trained at the US Army's School of the Americas at Fort Benning, Georgia, the graduates butchering Native peoples in El Salvador, Nicaragua, Panama, Colombia, Guatemala . . . Between 1962 and 1996 over 83 per cent of the victims in Guatemala were Maya Indians. A war on terror should dictate that the School of the Americas* requires more than its name changed. In January 2002, the Guarani and Kaiowá Indians in Brazil faced that New World Order phrase but Old World tactic – ethnic cleansing.

"All Indians are subversives", declared General Ephraím Rios-Montt, the Reagan/Bush sponsored dictator who came to power in Guatemala in 1982. Three years later, then Secretary of State George Schultz said, "We are fighting for our way of life", when justifying US involvement in El Salvador and Nicaragua. With the CIA now predicting 'an indigenous uprising' by 2015, how much more familiar will that theme become? Where the messenger once broadcast the message in talking pictures to be replayed in the worldwide brain, that in these distant forests and jungles and uncivilized wastelands 'civil wars' and 'guerrilla uprisings' were actually insurgent Reds marching towards the border, in the world post 9/11 they will be categorized as terrorists. In TV's colonization of the consciousness, the reality of indigenous peoples resisting annihilation as opposed to passively accepting their fate beneath the weight of the World Bank and the WTO-IMF-NAFTA-led-acronym-army is erased. It will be good for business, fighting terrorists in Latin America will reduce the

* *In January 2001, the School of the Americas was renamed the Western Hemisphere Institute for Security Cooperation.*

necessity for a 'War on Drugs' to legitimize pouring military 'aid' into the region. Similarly, when government officials and broadcasters present the Arctic National Wildlife Refuge as a desolate wilderness they again render Native people invisible because Western society, replete with its computer Darwinism, doesn't associate human beings with wilderness, therefore cannot compute that people will be affected by whatever befalls it – but they will. With 'Ya Basta!' the Zapatistas say it all, 'enough is enough'. When human life is collateral damage the sacred lies amidst the ruins. Who will restore it?

In the fall of 2001, the twenty-four-hour TV news channels neglected history yet again; those who suffered due to anthrax were not the first casualties of bio-terrorism within North America's shores, as during the French and Indian War Lord Jeffrey Amherst introduced the much followed practice of distributing smallpox-infected blankets to the continent's Native people. On the Fox News Channel, the only surprise when retired general, Don Edwards, described the mountainous hold-outs of the Taliban and Al-Qaeda as 'Indian Country' was that one of the presenters didn't interject, 'Oh, so that's where all the Indians went that used to be here'. News anchors intemperate from the cocktail of sanctimony and jingoism struggle to contribute to 'fair and balanced' reports. On February 14, 2002, citing post 9/11 'homeland security' within his rationalization, Department of Energy (DOE) Secretary, Spencer Abraham, 'compelled' President Bush to approve Yucca Mountain as the US's burial ground for nuclear waste. After expending twenty years and billions of government and energy industry dollars in trying, it took the President approximately twelve hours to consider Abraham's conclusions and send his own letter to Congress recommending a 'Yucca Mountain repository'.

"Yucca Mountain is a place of deep spiritual significance to Shoshone and Paiute peoples", explained Corbin Harney, a Western Shoshone spiritual leader. "The government has no right to use Yucca Mountain this way. *Newe Sogobia*, the land guaranteed to the Western Shoshone by treaty, includes Yucca Mountain. Even the study of the site has been a violation. Because of US nuclear testing over Nevada, the Western Shoshone Nation is already one of the most bombed nations on earth. Western Shoshone people suffer from widespread cancer and other diseases as a result of fallout from those explosions."

In his letter to President Bush, DOE Secretary Abraham wrote that 'A repository at Yucca Mountain is indispensable' to the 'maintenance and potential growth' of nuclear power, describing it as an 'environmentally efficient source of energy' – an opinion that might meet dissension around Chernobyl and the Western Shoshone Nation. "Yucca Mountain is Shoshone land by the Treaty of Ruby Valley. The government offered to buy it but the tribe voted not to accept the money. Now it looks like they're planning on sending the nuclear waste to the Goshutes until Yucca Mountain is ready", said Sac and Fox elder, Grace Thorpe, the author of *Our Homes are not Dumps: Creating Nuclear*

Free Zones. "They've targeted Indian tribes for nuclear waste for years because they have isolated lands and because of the high poverty levels among many tribes. The utilities think tribes will struggle to fight off the pressure to put nuclear waste on their lands because of the finance it will bring but Yucca Mountain is a treaty issue, a sovereignty issue. And my goodness, we are talking about an earthquake zone here!" A 5.6-magnitude earthquake caused some $400,000 damage to the DOE's office at Yucca Mountain in 1992 and the area is crossed by thirty-four fault lines, but White House officials say they still expect 77,000 tons of radioactive nuclear waste to be buried there. A delegation of Western Shoshone traditionalists traveled to Geneva in August 2001 to testify before the UN Subcommission on the Protection and Promotion of Human Rights, where they raised a series of violations pertaining to the Treaty of Ruby Valley.

"Our lands are not a library which, if destroyed, you can simply go to another one. These sites are our religion, we cannot simply go somewhere else", said Lorey Cachora, a Quechan tribal historian. One of the Quechan's sacred sites, Indian Pass, is threatened by Glamis Gold Ltd.'s Imperial Mine excavation, a proposed 1,571 acre open-pit cyanide process gold mine. The prospective inventory of American Indian sacred sites to be included in the desecration portfolios of realtors, property developers, energy companies and state agencies is not limited to: Mount Shasta, Shasta Dam and the McCloud River, Rainbow Bridge, Zuni Salt Lake, the San Francisco Peaks, Woodruff Butte, Gobernador Knob, Medicine Lake Highlands, Petroglyph National Monument, Badger/Two Medicine, the Sweetgrass Hills and the Bear's Lodge (Devil's Tower). Weatherman Draw in southeastern Montana is cataloged by the Bureau of Land Management (BLM) as Federal Lease MTM-74615 and $1 per acre buys a prospector the mineral rights to the area for a year. To the Crow, Comanche, Blackfeet, Northern Cheyenne, Eastern Shoshone, Kiowa, Lakota and Northern Arapaho it is The Valley of the Chiefs, a sacred canyon sheltering one of the highest concentrations of Native rock art in North America. Within two weeks of taking office, the Bush administration approved the Anschutz Exploration Corporation's exploratory permit to drill for oil in The Valley of the Chiefs. A billionaire Republican Party donor, Phil Anschutz's company holds Federal Lease MTM-74615. The Crow and the Blackfeet, both nations which struggle with high poverty and unemployment, offered Anschutz Exploration the opportunity to drill on their reservations to save The Valley of the Chiefs.

"I think about the hundreds of people who came to use this sacred valley for more than a thousand years", said Crow historian, Howard Boggess. "The Valley of the Chiefs holds our burial sites, our prayer sites and vision quest sites. This art is consecrated here by those who put their blood and sweat into each piece of work. The Bush administration's energy plan would destroy any cultural or religious site just for a gallon of oil. If there is oil here it would only supply enough oil for the United States for less than one half of a day."

Secretary of the Interior, Gale Norton, could re-evaluate the resource management plan for The Valley of the Chiefs (Weatherman Draw), just as she could close the slurry pipeline constructed by Enron that consumes 3.3 million gallons of water daily in the process of shifting coal from Peabody Energy's stripmine on Big Mountain to its destination, the Mohave Generating Station near Laughlin, Nevada. However, her comments to tribal leaders at the National Indian Energy Summit in December 2001 provided little basis for optimism as she expressed her determination to 'better capture' the 'land's bounty', quoted Ronald Reagan, and then gave a hard sell on ANWR with a dash of divide and conquer. Big Mountain is at the center of Black Mesa and there a female deity blesses the desert with rain and purifies the waters that run to this critical aquifer through her liver, the coal mined by Peabody that prompted *Healing v. Jones* and established land partition and relocation as the final solution to the 'Navajo-Hopi Land Dispute'. Big Mountain holds 222 Navajo sacred sites, while for the duration of her tenure Secretary Norton holds the remit that could destroy them and many others. On October 25, 2001, the Bush administration's Solicitor of the Interior, William Myers, chose to rescind the opinion of his predecessor, John Leshy, which had protected sacred sites from mining operations. In issuing his opinion, Leshy had observed former President Clinton's Executive Order on American Indian Religious Freedom, but the Bush/Myers reversal left the Quechan first in a long line to suffer the corporate consequences. 150 years later, the 'gold' rush to Indian land is still on.

When it would appear that Western society's most prevalent point of reference with regard to the five-hundred-and-fifty-seven federally recognised sovereign Native Nations (and the additional two hundred or so who are seeking recognition) is still the Hollywood western, it isn't a great surprise that the vast majority of the media and the public they purport to serve remain adrift on John Wayne island, where every landscape is Monument Valley, every Indian wears leather and feathers, and the only good ones are dead or soon will be. Among others, the peerless Vine Deloria, Jr has analyzed the media's presentation of Native America and the points of influence within popular Western culture, religion and academia that have spawned and continually regurgitate the misconceptions that are placed before the public. In that context, a society that seeks to deny its own history isn't one that will readily perceive Native issues within a global context, or vice-versa.

"Can we forget about the horror of places like Wounded Knee and Sand Creek and the Washita? Can we forget about being literally herded onto reservations and having to live in the kind of poverty that we have been locked into for centuries? Or the loss of an entire continent that is constantly being desecrated and violated?" asked respected Cheyenne elder and educator, Dr Henrietta Mann. "This is part of history and the whole evolution of this country called America that, unfortunately, has a history of religious suppression and persecution of American Indians. I think forgetting would further prolong this society's existing state of denial and enable individuals to ignore their own history and a situation that could be likened to the holocaust."

A new Native stereotype reached the copy writers with the entrepreneurial success of the Mashantucket Pequot Tribal Nation – 'Indians Hit The Jackpot!' – but before the wagons are circled around Las Vegas and Atlantic City, only 177 tribes participate in gaming and out of those the Mashantucket Pequot's 'Foxwoods' and the Mdewakanton Dakota's 'Mystic Lake' facilities generate 40 per cent of all tribal gaming revenue. Perpetuating stereotypes old and new, littered with the same old derogatory terms – racial slurs that would be deemed unacceptable in relation to any other race – continues to be the chosen mainstream editorial option. Rather that than expose readers or viewers to the discomfort of reality and scenes of Third World poverty. On the Oglala Lakota Nation, unemployment hovers around 85 to 90 per cent across the Pine Ridge reservation; approximately 30 per cent of people are homeless and of those that have homes about 60 per cent are substandard and over 20 per cent are without indoor plumbing. Pine Ridge isn't every reservation but its features are more familiar than those in Mashantucket, Connecticut or Shakopee, Minnesota.

If the total annual Indian gaming revenue was divided equally between all of the Native people in the US, the amount distributed would not raise Indian per capita income to half of the national average. In 2002, American Indian per capita income was $4,500 and national statistics indicated that: over 40 per cent of Native people living on reservations lived below the poverty line; that unemployment ranged from 40 to 90 per cent; that the three poorest counties in the US were consistently on the Pine Ridge, Rosebud and Cheyenne River Lakota reservations; that at 48 years old, Indian people had the lowest life expectancy of any ethnic group in the US but had the highest suicide rate; highest incidence of diabetes; levels of disease five to six times higher than the national average; and chronic rates of alcohol and substance addiction, with children as young as four years old 'huffing' glue and gasoline. That's not Cabazon or the Choctaw Nation in Mississippi but it's reality for many. "It's clearly a budget. It's got a lot of numbers in it", George W. Bush observed. In 2002 when those numbers had been calculated Indian programs from health care to education were in peril, Indian job training programs were slated to be cut from ten to one, and the entire trust responsibility was threatened. In the New World Order the twins of wealth and poverty appear to be siamese – the rich are worthy of their wealth and tax cuts and the poor earn their right to misery and malnutrition.

"The reservation is a microcosm of the future of the world", observed Russell Means, whose uncompromising and at times maverick flair has sustained headlines since Wounded Knee in 1973. "Everything is going to be poisoned and everyone is going to be poor, except those few – those who seek to officially globalize the economy of the world and make environmental laws and national laws ineffective. In other words, the corporations are taking over the world and anything that interferes with corporate economics will be illegal."

The preservation of treaty rights and repelling attempts to undermine tribal sovereignty remain 21st Century imperatives, undiminished since September 17, 1778 when the Delaware signed the first treaty between a Native Nation and the vestigial United States. "The treaties that were signed are still alive and I'm ready to debate the issue with anyone, even the smartest attorneys", asserted revered Oglala Lakota elder Johnson Holy Rock, whose father witnessed the Battle of the Little Bighorn as a ten-year-old boy. "We must move forward to protect our treaties. They are the supreme law of the land, as noted in Article Six of the United States Constitution. The trust they create must be upheld and mere acts of Congress and government agencies do not and will not amend them." However, the US Government's approach to Yucca Mountain demonstrates the nature of the conflict; the government refuses to recognize the Treaty of Ruby Valley and argues that all rights to Western Shoshone ancestral lands have been extinguished. Western Shoshone territory was also the backdrop for one of the most pernicious US Supreme Court rulings ever with regard to undermining tribal sovereignty. In 2001, in *Nevada v. Hicks*, the US Supreme Court abandoned precedent and Congressional statutes by reversing a lower court ruling that upheld tribal sovereignty, and found that the Fallon Paiute-Shoshone Tribal Court did not have jurisdiction to hear a case brought by tribal member, Floyd Hicks, against two state game wardens. In the same vein, the US Supreme Court ruled against the Navajo Nation in the occupancy tax case, *Atkinson Trading Co. v Shirley et al*.

"The genocide of our people, whether it's physical, spiritual or cultural is still there but we're still very much a part of this land. We're still very much alive and we have not been driven to extinction or vanished. I think it troubles society that we are still very identifiably Indian and it has certainly astounded and confounded those policy-makers that we didn't disappear. They came with their concepts and doctrines of Manifest Destiny and Imperialism. They wanted the land – but we are still very much a part of that land – and they still want it. I guess it's still Manifest Destiny: subdue the Earth, take what you want and never mind its impact upon those children yet unborn", reflected Dr Henri Mann. "This is a very voracious society that is taking the natural resources from the ground that most of us look upon as our Mother, and those resources represent the internal organs of our Mother Earth. We sit here living within this great circle of life in an inter-dependent relationship with stewardship responsibilities for the land and all that is on it, above it and below it. We live by that mutuality and reciprocity. If you're going to take something then you give, but with all of this coal, oil and gas extraction – the plundering of the Earth's natural resources – what are *they* giving back?"

Columbus was wrong from first contact. A people of Earth – *una gente de tierra* – is closer than his *una gente in Dios*.

<div align="right">

SERLE L. CHAPMAN,
MARCH 2002.

</div>

www.sacredland.org www.ezln.org
www.indiantrust.com www.narf.org
www.alaska.net/-gwichin www.shundahai.org
www.intertribalbison.org www.survival.org.uk

S E R L E About C H A P M A N

Serle Chapman's first book, *The Trail of Many Spirits*, received a 1996 Book of the Year accolade in Europe and his second, *Of Earth and Elders: Visions and Voices from Native America*, achieved both outstanding mainstream reviews and approval in the Native community. Chapman's work has frequently been highlighted on national TV and radio, and one of the world's premier arts complexes, London's Barbican Center, described him in their *Written America* series as 'a critically acclaimed writer and one of the world's leading photographers'. His photography is on permanent display in various museums and visitors' centers in North and Central America –including the Biosphere Reserve in Mexico – and his work has been endorsed by the National Geographic Society.

In the capacity of both author and photographer, Chapman's work has appeared in numerous national and international publications, including *The Sunday Times*, *The Guardian/Observer*, *The Daily Express*, *The Mail on Sunday*, *The Navajo Times*, *Indian Country Today*, *The Lakota Times*, *Aboriginal Voices* and various US city and statewide newspapers such as *The Denver Post* and *The Rapid City Journal*. His work for the Inter-Tribal Bison Cooperative featured in *Audubon Magazine* and he has been recognized in both *The Washington Post* and *Le Monde*. His first US royalties from *The Trail of Many Spirits* were donated to the Head Start program located in Martin on the Pine Ridge Indian Reservation and his author royalty from *Of Earth and Elders* was committed to the American Indian College Fund.

Chapman has undertaken extensive public speaking engagements in the US and UK; being invited to lecture at both Oxford and Cambridge Universities; and to read his poetry for the British Poetry Society. Since 1996 he has led cultural awareness tours on reservations in the Northern Plains and the Southwest. Following the publication of *Of Earth and Elders*, in recognition of his literary efforts and philanthropic activities in Native America, Chapman received a letter of commendation from Nelson Mandela.

We, The People, Volume II of Chapman's *Of Earth and Elders* sequence, was published in Europe in November 2001 and in the US in March 2002. Described as '. . . a stunning 352 page visual and literary portrait of indigenous existence past and present', critics in Europe acclaimed Chapman's portraiture in *We, The People* as 'A contemporary equivalent to the work of Edward S. Curtis'. Former President of the United States, Bill Clinton, contributed the foreword remarks to *We, The People*, the association between the author and former President dating back to Clinton's July 1999 visit to the Pine Ridge Indian Reservation.

For information about Serle's work and the Trail of Many Spirits journeys to Native America, please visit:

www.gonativeamerica.com

JOHN About TRUDELL

With his 'Radio Free Alcatraz' broadcasts, John Trudell became the voice of the Indians of All Tribes Occupation of Alcatraz Island. Some seven months before the occupation closed, Trudell painted Plymouth Rock red during a national day of Indian mourning on Thanksgiving, 1970, and from the rocks of Alcatraz and Plymouth to the present day, the juxtaposition of art and activism for which he is recognized continues to resonate throughout the Indigenous Rights movement. 'To me that whole Alcatraz and AIM time was about idealism. It was a very energizing time. Our identity is coming back to us in much stronger ways now and it was slipping away from us before that all happened. It was a rekindling of the spirit.'

As National Chairman of the American Indian Movement John Trudell brought an eloquence and intellectual dexterity to AIM's leadership platform, a quality that did not escape the FBI which, in the 17,000 page file it compiled bearing his name, reported 'Trudell is an intelligent individual and is an eloquent speaker who has the ability to stimulate people into action'. On February 11, 1979, he burnt the Stars and Stripes outside the J. Edgar Hoover building in Washington, D.C., during a protest against the US Government and the FBI's modus operandi in Native America; some twelve hours later, John Trudell's wife Tina, their three children and Tina's mother, were killed in a fire 'of suspicious origin' that destroyed the family's home.

Amidst the loss and devastation, Trudell began to write and many now consider him to be one of the finest poets in America. 'About six months after the fire the lines came. The lines were my bombs, my explosions and my tears. They were my everything.' Those lines became a series of books and albums, the former beginning with *Living in Reality*, the latter including the 1999 Jackson Browne produced *Blue Indians*. Through his association with Browne, Trudell met guitarist Jesse Ed Davis (Kiowa), known for his work with John Lennon and Bob Dylan, and the two forged a vigorous creative partnership until Jesse Ed's untimely passing. Bob Dylan described Trudell's *AKA Grafitti Man* as 'the best album of 1986' and with his band, 'Bad Dog', he continues to tour extensively. In 2000 he received the Native American Music Awards 'NAMMY' in the category of 'Artist of the Year'.

In the role of Jimmy Looks Twice in the movie *Thunderheart*, Trudell gave an award-winning performance opposite Val Kilmer. In conjunction with Oscar-winning actress Angelina Jolie, Trudell is establishing the 'All Tribes Foundation'. Their first artistic collaboration was the 2002 release of John Trudell's 13-song collection, *Bone Days* – Angelina Jolie being the CD's Executive Producer.

For information about John's work, tour schedules, complete discography and availability, please visit:

www.johntrudell.com

WE, THE PEOPLE

OF EARTH AND ELDERS VOLUME II

WE, THE PEOPLE

OF EARTH AND ELDERS VOLUME II

SERLE L. CHAPMAN

preface by
KAREN TESTERMAN

introduction
GWICH'IN NIINTSYAA

Including

TANTOO CARDINAL

VINE DELORIA, Jr.

JOY HARJO

JOHNSON HOLY ROCK

Dr. HENRIETTA MANN

JOE MEDICINE CROW

N. SCOTT MOMADAY

SIMON J. ORTIZ

BUFFY SAINTE-MARIE

JOANNE SHENANDOAH

KEVIN RED STAR

STEVE REEVIS

WES STUDI

JOHN TRUDELL

FLOYD WESTERMAN

AMERICAN INDIAN MOVEMENT

Foreword remarks by the former President of the United States
WILLIAM JEFFERSON CLINTON

postscript by
LORI POURIER

Photographed, Edited and Compiled by
SERLE L. CHAPMAN

'A literary wolf in sheep's clothing, *We, the People: Of Earth and Elders Volume II* is a deceptively glossy production that wouldn't look out of place on any designer coffee-table. But Chapman has compiled a biting oral and visual record . . . From the Trail of Tears in the 1830s to the siege of Wounded Knee in the 1970s, Chapman allows America's indigenous people to speak for themselves . . . The 100-plus contributors range from Pulitzer prize-winner N. Scott Momaday, to the great-grandchildren of Cochise, and actor Wes Studi.'

THE GUARDIAN (UK)

'Here is the rarest of things, a large, glossy coffee-table book with urgent relevance, prescient wisdom and straight-talking bite . . . a weighty multi-picture odyssey through the present and past of Native American Indian culture . . . a beautifully crafted summation, this is both a visual portrait and oral history of the "First Americans". *We, the People* gives voice to indigenous Americans and reveals that the people who were almost wiped out by ethnic cleansing may have the answers to the current travails of America and beyond . . . Chapman's ravishing photography draws you into what is essentially a compilation of voices and page after beautifully illustrated page, their views seem alarmingly pertinent.'

THE SCOTSMAN (UK)

'A remarkable "Who's-Who" of Native American leaders, artists and actors contribute through interview and prose to create a unique literary experience, tied together by Serle Chapman's breathtaking photography and compelling narrative. An essential window to Native America, a powerful, wonderful read.'

ABORIGINAL VOICES

Mountain Press Publishing Co. Toll Free 1-800-234-5308
mtnpress@montana.com bearprint@tiscali.co.uk
www.mountainpresspublish.com

ISBN 0-9528607-5-9

A portion of the proceeds from OF EARTH AND ELDERS and WE, THE PEOPLE benefit the tribal colleges supported by the American Indian College Fund.

www.collegefund.org